Designing with type

A Basic Course in Typography

Also by James Craig Production for the Graphic Designer
Basic Typography
Graphic Design Career Guide
Thirty Centuries of Graphic Design
Working with Graphic Designers

Also by William Bevington Typography: The Principles
Concise Information

By James Craig and William Bevington

Edited by Susan E. Meyer

Designing with type

A Basic Course in Typography

Fourth Edition

Watson-Guptill Publications

New York

Dedicated to every student
who had to take typography,
hated it at first,
but learned to love it.

Copyright © 1971, 1980, 1992, 1999
by James Craig

This revised edition first published in 1999 in New York by
Watson-Guptill Publications,
a division of BPI Communications, Inc.
1515 Broadway, New York, N.Y. 10036

Library of Congress Cataloging-in-Publication Data
Craig, James.
 Designing with type : a basic course in typography / by James Craig
 and William Bevington; edited by Susan E. Meyer.—4th ed.
 p. cm.
 Includes bibliographical references and index.
 ISBN 0-8230-1347-2
 1. Graphic design (Typography) I. Bevington, William
 II. Meyer, Susan E. III. Title.
Z246.C69 1999
686.2'24—dc21 98-53402
 CIP

Manufactured in Singapore

1 2 3 4 5 6 7 8 / 06 05 04 03 02 01 00 99

Contents

Introduction

As we begin this new millennium, the field of information and visual communication is taking its place as one of the major industries of the twenty-first century. A significant part of that industry involves typography: the style and arrangement of typeset matter.

Typography is probably the most important subject design students will study in art school. As professionals, graphic designers are called upon to perform many tasks, from designing magazines to packaging, marketing, advertising, and digital communication. There are many specialties within the field, but all require knowledge of typography. In fact, few assignments will be devoid of type, and many jobs will consist entirely of type.

Words, and therefore typographic skill, will always remain central to communication. Graphic design students will be the typographers of the future, and their success will be determined by how well they are educated to work with letterforms.

Digital typography provides a freedom never before experienced: the ability to create and manipulate design elements with unforeseen speed and ease, limited only by the student's imagination. Although results can be created in fractions of seconds, even the most sophisticated system is only a tool, for without design knowledge and typographic skills, the student is doomed to fail.

What technology has not changed is how we read. There are twenty-six letters and we still read them from left to right, one line at a time. So while typesetting methods, typeface designs, and fashions in typographic layout may continue to evolve, we must never lose sight of two facts: type is still meant to be read, and typography, by its very nature, is a conservative art. After all, we work with an alphabet that has evolved slowly over thousands of years. We are accustomed to reading and writing with these letterforms, so that even the most adventurous among us does not wish to see the basic shapes of the alphabet redesigned or tampered with.

Does this mean that all typography must be predictable? Certainly not. Type is wonderfully versatile: it can be altogether unobtrusive, solemn, serious, businesslike, playful, or downright silly, depending on the subject matter and the audience. The student should learn to embrace all forms, all possibilities.

The Fourth Edition

Although typography can be taught in a number of ways, instructors around the country generally agree that the most successful curricula are those built around a knowledge of metal type (because it is the source of typographic vocabulary), comping (which trains the eye through tracing letterforms), copyfitting (which teaches the special relationship between typewritten copy and typeset text), and the fundamentals of typography combined with computer technology.

Designing with Type provides this rich foundation from which the student can develop an understanding of typography and a personal esthetic.

This fourth edition represents a major revision. For this endeavor I have invited a colleague, William Bevington, to join me in updating the material. Mr. Bevington and I taught typography together for fifteen years.

In response to student needs and the contemporary marketplace, we have completely reorganized the contents and added much new information without omitting the features that have made this book such a valuable tool for the student.

In addition to the above, the book has been completely redesigned with new typefaces throughout. For example, the five classic typefaces that have served the book so well in the past are no longer set in metal type. Beautiful as they were, the faces no longer seemed relevant. In their place we have used digital fonts set on an Apple Macintosh system.

Designing with Type was first published over a quarter of a century ago. Despite the changes in technology during this period, the book has sold well over a quarter million copies and has been adopted by design schools around the world. All this would suggest that in spite of dramatic changes in the typesetting industry, *Designing with Type* continues to educate and inspire students. We believe this fourth edition will be a most useful companion to a new generation of designers. □

Typography, the art of designing with type, began in the West around 1455 when Johannes Gutenberg perfected the craft of printing from individual pieces of type. From this early technology we draw a great deal of our current terminology. This section introduces the origins of the alphabet, defines the terms and measurements that will form the basis of your typographic vocabulary, and examines how we read. Once you are familiar with this information, you will be able to communicate your ideas clearly and work efficiently with type.

1. Origins of the Alphabet

1. The pictograph is a symbol representing an object. On the left is an early symbol that represents an ox; on the right is the symbol for house.

2. The ideograph is a symbol that represents an idea. The skull and crossbones can represent death, pirates, or poison.

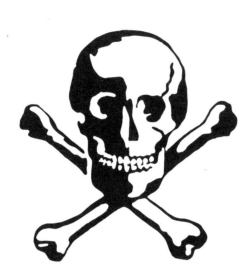

Before proceeding with the more practical aspects of typography, let's first consider the twenty-six letters we call our alphabet. We tend to forget that the alphabet is composed of symbols, each representing sounds made in speech. The symbols we use today are derived from those used thousands of years ago. However, the ancient forms did not represent sounds but were pictures of things or symbols for ideas.

Pictographs

At some point in time, people began to communicate visually. They made simple drawings of the things that existed in their world: people, animals, and tools, for example. These images, called *pictographs*, were symbols representing an object (**1**).

Ideographs

As the need developed to communicate more abstract thoughts, the symbols began to take on multiple meanings: ox, for example, could also mean food. The new symbol would represent not an object but an idea. These idea symbols are called *ideographs*. Abstract thoughts could also be communicated by combining different pictographs: for example, to communicate the concept of rest, the pictographs for man and tree might be combined. A contemporary example of the ideograph is the warning symbol for poison. The skull and crossbones is not seen for what it is but for what it represents: danger, death, pirates, or poison (**2**).

This evolution from pictographs to ideographs represented a major step in the development of a written language. It was with this system of picture-writing, combining symbols for the concrete (pictographs) and for the abstract (ideographs), that early cultures communicated and kept records. (Today the Chinese still use an evolved version of this system.)

There are some disadvantages to the picto-ideographic system: not only are the symbols complex, but their numbers run into the tens of thousands, making learning more difficult and writing slow.

Phoenician Alphabet

As a nation of traders and merchants, the ancient Phoenicians needed a simplified writing form that would allow them to keep ledgers and communicate business transactions. Around 1200 B.C., a new concept in written communication evolved *using symbols to represent the sounds of speech rather than ideas or objects.*

To better understand how this change came about, let's look at the first two letters of our alphabet, A and B, and see how they evolved (**3**). One of the primary spoken sounds the Phoenicians recorded was "A." This sound occurred at the beginning of their word *aleph*, meaning ox. Instead of devising a new symbol for the sound, they simply took the existing symbol for the object. They did the same for the sound "B," which was found in their word *beth*, meaning house. Again, they took the existing symbol for the object and applied it to the sound. This process was continued until the Phoenicians had assigned a symbol for each sound. In all cases the symbols were of common objects or parts of the body, such as water, door, fish, hand, eyes, or mouth (see page 145).

The Phoenician alphabet required far fewer symbols than the picto-ideographic system. Furthermore, the simplified letterforms could be written more rapidly, were easier to learn, and provided an ideal means of communication. By developing a standardized phonetic alphabet, the Phoenicians made a major contribution to Western civilization.

Greek Alphabet

The ancient Greek civilization gradually adopted the Phoenician alphabet for their use around 800 B.C. They recognized something quite different in the potential of this new system: in addition to its usefulness as a tool of trade, the alphabet also offered a valuable means of preserving knowledge. Along with the alphabet, the Greeks adopted the Phoenician names for the letters, altering them only slightly. For example, *aleph* became *alpha*, *beth* became *beta* (**4**). From these two letters we derive our word *alphabet*.

The Phoenician-derived alphabet contained no vowels, only consonants. Words formed from this alphabet would have looked similar to our abbreviations—Blvd., Mr., St. Although this system worked well for business ledgers, its broader use was limited. Therefore the Greeks added five vowels and formalized the letterforms. A revised alphabet of only capital letters was adopted officially by Athens in 403 B.C.

Roman Alphabet

Just as the Greeks had altered the Phoenician alphabet, the Romans adopted and modified the Greek alphabet (**5**). Thirteen letters were left unchanged from the Greek: *A, B, E, H, I, K, M, N, O, T, X, Y, Z*. Eight letters were revised: *C, D, G, L, P, R, S, V*. Two letters were added: *F* and *Q*.

3. The first two letters of the Phoenician alphabet. On the left is the symbol *aleph,* which was their word for ox; on the right is the symbol *beth,* which meant house.

4. Borrowed from the Phoenicians, the first two letters of the alphabet were modified by the Greeks, who called them *alpha* and *beta.*

5. The first two letters of the Roman alphabet show further refinement. The Romans dropped the Greek names for the simpler *A, B, C's.*

6. Prior to printing in northern Europe, letterforms were written in a dense, compressed manner, referred to as Black Letter.

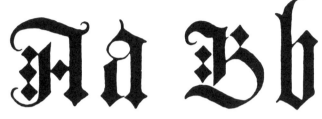

7. The Black Letter alphabet formed the basis for Gutenberg's typeset letterforms.

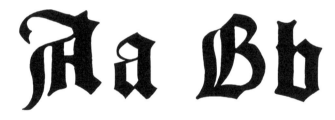

8. During the early development of printing, a writing style called Humanistic was used in Italy.

This gave the Romans a total of twenty-three letters. The Romans also dropped the Greek designations for the letters, such as *alpha*, *beta*, and *gamma*, and substituted simpler sounds to represent the letters, such as our *A*, *B*, *C*'s of today. The letters *U* and *W* were added to the alphabet about a thousand years ago, and *J* added five centuries later.

Small Letters

Up to now, we have been discussing capital (majuscule) letters only. Small (minuscule) letters were a natural outgrowth of writing and rewriting capital letters with a pen. At first only a few minuscules were consistently written, but eventually a full set of majuscules and minuscules was being used. As writing became common, greater economy was desired, and letters were compressed so that more words could fit on a line. These dense letters are called Gothic or Black Letter.

Prior to Gutenberg's invention of printing from movable type in the mid-fifteenth century, there were two popular schools of writing in western Europe: Black Letter in Germany and the North and the round Humanistic hand in Italy. It was the Black Letter forms that were used as the models for the typeface designed by Gutenberg in 1455 (**6, 7**). The Humanistic hand was a revival of the Carolingian minuscule of the ninth century and is the basis of our small letters (**8**). A flowing form of this same hand is the basis of our italic. Examples of all three writing styles can be seen on the opposite page.

Punctuation

In early Greek and Roman writing, there was no punctuation as we know it. Words were either run together or separated with a dot or slash. This can be seen in the handwritten specimens of the Rustica, Half-Uncials, and Carolingian minuscules shown on the opposite page. It was not until the fifteenth century, with the advent of printing, that the rules of punctuation began to become formalized.

The Alphabet

As illustrated opposite, our alphabet is made up of distinct symbols that represent thousands of years of evolution. As a designer, you can simplify or embellish the letterforms, but if you alter their basic shapes you will reduce their ability to communicate efficiently. Even within this seemingly fixed structure, you will find these symbols provide a lifetime of creative possibilities. □

YꞳWꟿ9ΦꟼꞀ)O‡Yˠⵏꟼꓘꝲ⅄⊕ꟀIY∃◁1ꟼꟻ

W T SH R Q TS P MUTE KS N M L K J TH H Z F H D G B A

Phoenician alphabet (c.1000 B.C.) reads from right to left; the letters below indicate the sounds they represented.

ΑΒΓΔΕΖΗΘΙΚΛΜΝΞΟΠΡΣΤΥΦΧΨΩ

ALPHA BETA GAMMA DELTA EPSILON ZETA ETA THETA IOTA KAPPA LAMBDA MU NU XI OMICRON PI RHO SIGMA TAU UPSILON PHI CHI PSI OMEGA

Greek alphabet (c.403 B.C.) originally adapted from the Phoenician c.900 B.C.

ABCDEFGHIKLMNOPQRSTVXYZ

The twenty-three characters of the Roman alphabet, most adapted from the Greek.

AIQILLVMINPRAECEPSREMIGIISSV

Square capitals (fourth century), written with a reed pen.

FELICESOPERVM·QVINIAMCOEVMOVE·LA

Rustica (fifth century), written more freely with reed pen. The dots represent the beginning of punctuation.

instauratio·nullatranslati·nonaurum

Half-Uncials (seventh century), written with reed pen. Slashes indicate punctuation.

buab quad uuéitent· ersie thar tho mán

Carolingian minuscule (ninth century), written with reed pen.

seniaam nutiga dans pecta in secula seculorum ant

Black Letter (fifteenth-century German), written with reed pen.

uid loquar de sech hominibz· tū aphus paulus:uas de

Printed line from Gutenberg's Bible c.1455. The design was derived from written Black Letter.

igitur habet potestatem·cesse est eum qu

Humanistic writing (fifteenth-century Italian), based on the Carolingian minuscule.

Quidā eius libros nō ipsius esse sed Dionysii &Zophiri lophoniorū

Printed line of type, Venice, 1475. The design by Nicholas Jensen was derived from Humanistic writing.

P abula parua legens,nidisˊq; loquacibus escas, E t nunc porticibus

Printed line of the first italic type. Also based on Humanistic writing.

2. A Typographic Overview

1. Letters normally appear as black shapes. When the image is reversed, the white areas become black and new shapes become apparent.

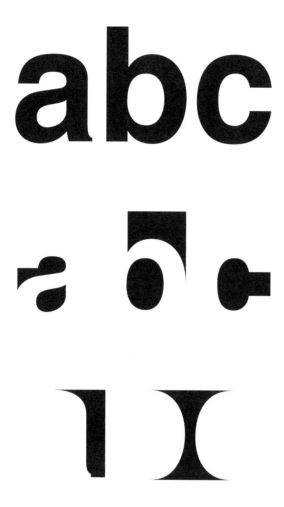

As readers, we tend to see words in terms of the messages they convey, and are rarely conscious of the actual shape of individual letterforms. Only when we examine letters closely do we see how complex and visually elegant they are.

Have you ever examined a letter closely? Let's start right now by considering the many intricate shapes inside and around the letterforms. Notice how the black shapes and the white spaces interrelate (**1**).

Anatomy of Type

Letterforms consist of many parts, and each has a specific name (**2, 3, 4**). You should familiarize yourself with these names and with other typographic terms used by designers. The following are the most common.

Characters. The individual letters, punctuation, numerals, and other elements that are used when setting type.

Uppercase. The capital letters, or caps, of the alphabet. The term derives from the early days of handset type when capital letters were stored in the upper section of the typecase. The small letters were kept in the lower portion and called *lowercase.* When abbreviated, capital letters are indicated as *Caps, U.C.* or simply *C.*

Lowercase. The small letters of the alphabet, often indicated as *lc.* When combined with uppercase, they are indicated as *U/lc* or *C/lc.*

Baseline. An imaginary line upon which the characters seem to be standing.

Meanline. An imaginary line that runs along the top of most lowercase letters, such as *a, c, e, i, m, n, u, v, w* and *x.*

X-height. The height of the body, or main element, of the lowercase letterform, which falls between the meanline and baseline. This measurement is called the x-height because the strokes of the lowercase *x* end at the baseline and the meanline.

Ascender. The part of some lowercase letters, such as the strokes on the letters *b, d,* or *h,* that rises above the meanline.

Descender. The part of some lowercase letters that falls below the baseline, such as the strokes on the letters *p, y,* and *g.*

Counter. The space entirely or partially enclosed within a letterform, such as the enclosed "bowl" of the letters *b, d,* and *p.*

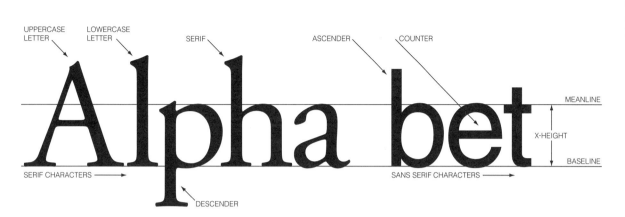

UPPERCASE LETTER
LOWERCASE LETTER
SERIF
ASCENDER
COUNTER
MEANLINE
X-HEIGHT
BASELINE
SERIF CHARACTERS
SANS SERIF CHARACTERS
DESCENDER

2. The principal terms used to identify parts of serif and sans serif letterforms.

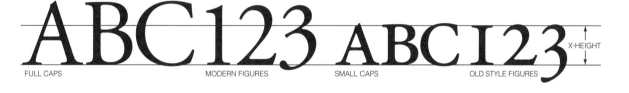

FULL CAPS
MODERN FIGURES
SMALL CAPS
OLD STYLE FIGURES
X-HEIGHT

3. Capitals, or caps, with modern figures compared to small caps with old style figures.

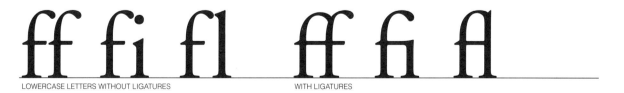

LOWERCASE LETTERS WITHOUT LIGATURES
WITH LIGATURES

4. Ligatures are available with some of the more traditional serif typefaces.

5. The names of nine popular typefaces, each set in its own typeface.

Baskerville

Bodoni

Caslon

Caledonia

Helvetica

Futura

Eurostyle

Modern

Century

Serif and Sans Serif. The finishing strokes that project from the main stroke of a letter are called the serifs. Serifs originated with the Roman masons, who terminated each stroke of a letter carved into a slab of stone with a serif to enhance its appearance. Not all type has serifs; type having no serifs at all is called *sans serif*, meaning without serif.

Small Caps. A complete alphabet of caps that are the same size as the body, or x-height, of the lowercase letters: A, B, C, D, E, F, G, etc. Often used in text settings where regular capitals are required but might create unwanted emphasis. Small caps are compatible with lowercase letterforms in the weight of the strokes of the letter. A typical use is for acronyms like NASA or NATO.

Modern Figures. Also called *lining figures*, these are numbers that resemble caps by being uniform in height: 1, 2, 3, 4, 5, 6, 7, 8, 9, 0. Modern figures are most often used for annual reports, charts, tables, and any application where numbers are meant to stand out or supply critical information. Another feature of modern figures is that they align vertically, making them preferable for setting tables and charts.

Old Style Figures. Also called *nonlining figures*, these are similar to lowercase characters in the way they vary in size and may have ascenders and descenders: 1, 2, 3, 4, 5, 6, 7, 8, 9, 0. Primarily used when less obtrusive numerals are required, such as within the body of text. For the same reason, old style figures are often combined with small caps, for example, PT-109, or 1998 C.E.

Ligatures. Two or more characters joined as a single unit. Ligatures are a typographic refinement that compensates for certain letters that set poorly when combined, such as fi, ff, fl, ffi, ffl.

Typefaces

Typeface refers to the specific design of an alphabet (**5**). The difference between one typeface and another is often very subtle, no more than a slight modification in the shape of the serifs or the length of the ascenders and descenders. Regardless of how subtle the difference, the typeface you choose will greatly affect the appearance of the entire printed page.

Each typeface is identified by a name. A typeface may be named after the individual who designed it (Baskerville, Bodoni, Caslon) or refer to a country (Caledonia, Helvetica), or be named to describe its appearance or character (Futura, Eurostyle, Modern). The type you are now read-

ing is Century Expanded. This is an American typeface based on an earlier type design called Century, which was created for the late nineteenth-century magazine *The Century.*

Typestyles

Today an incredible number of typestyles are available to graphic designers. The number and variety have developed over time to accommodate diverse trends and uses. Most of these typestyles are distinguished by variations in the weight or width of the letterforms (**6, 7, 8, 9**). Although some typefaces are available in a wide variety of styles, the majority offer only a few variations, such as roman, italic, and bold.

Roman. The upright letterforms derived from the historic characters developed by the Romans. The majority of typeset copy is roman. It is the first typestyle we learn and the most comfortable to read. The letterforms of this sentence are set as roman.

Italic. The second most common typestyle. A true italic typeface is not merely roman characters slanted to the right but is specifically created to be a companion to the roman. Italic is used mainly for quiet emphasis. *These words are set in italic.* If a roman typeface is simply slanted to the right (or left), it is referred to as *oblique. These words are oblique.*

Regular. The standard weight of a typeface, also referred to as *normal.* Regular is the basic form and weight from which all the other variations are derived.

Bold. A thicker, heavier version of the regular typeface, commonly used for increased emphasis. Among the various designations for bold typestyles and heavier weights are *semibold, heavy, black, extrabold,* and *ultra.*

Light. A lighter or thinner version of the regular typeface. An extremely light version is often referred to as *thin.*

Condensed. A narrower version of the regular typeface. Condensed type is particularly desirable if it is important to fit more letters or a larger type size into a given space. Also referred to as *compressed.*

Extended. A wider version of the regular typeface. Also known as *expanded.*

Roman
Italic

6. Roman and italic are the two most frequently used typestyles.

Thin
Light
Regular
Semibold
Bold
Extrabold

7. Most typefaces, particularly sans serif like Helvetica, are designed in a variety of weights.

Condensed
Extended

8. After variations in weight, variations in width provide additional typographic options.

Light Condensed
Semibold Condensed
Bold Extended

9. By combining weight and width, an extensive number of typestyle variations can be created.

10. Traditionally, a font was one size of one typestyle. Today a font refers to all sizes of one style of type.

ABCDEFGHIJKL
MNOPQRSTUV
WXYZ&
abcdfghijklmnopq
rstuvwxyz
1234567890
1234567890
ff fi fl ffi ffl .,'' -:;!?

11. Combine all the fonts of all the typestyles available, and you have the family of type.

Garamond Roman
Garamond Roman Italic
Garamond Semibold
Garamond Semibold Italic
Garamond Bold
Garamond Bold Italic

Fonts

Traditionally, a font was one size of one type style in a particular typeface (**10**). Garamond roman was one font and Garamond italic another. A font consisted of all the characters required to set type in a single size: uppercase and lowercase letters, punctuation marks, numerals, and special reference marks. A familiar example of a font is the keyboard of a typewriter. If you were to strike every key a single time, you would produce a font.

Today the term *font* is used more loosely. A font still refers to a specific typeface and typestyle but no longer refers to a particular type size. This is because digital typesetters generate type in any number of sizes.

Fonts may vary in both the number and variety of characters they contain. In addition to the alphabet and punctuation marks, some fonts are drawn to include special characters, such as small caps, ligatures, old style figures, mathematical symbols, and diacritical marks.

Type Families

If we combine all the fonts of all the typestyles of a given typeface (roman, italic, bold, condensed, etc.) we have a family of type (**11**). By selecting fonts within the same family, a designer maintains typographic consistency. Since all typestyles within a family share common characteristics, such as design, x-height, cap height, and length of ascenders and descenders, they will appear harmonious when combined.

Most type families are relatively small, containing roman, italic, and bold typestyles. Some families—Helvetica, for example—are exceptionally large, with variations ranging from thin condensed to bold extended, plus unique display faces such as outline and drop shadow. For a few of the many Helvetica variations, see pages 15 and 156.

Type Classifications

In an effort to bring some measure of order to the thousands of typefaces created over the centuries, scholars and historians of typography have placed all typefaces within several categories or classifications. A typical type classification contains typefaces sharing similar visual characteristics. The most familiar type classifications are Old Style, Transitional, Modern, Slab Serif, Sans Serif, Script, Black Letter, and Decorative. (These classifications are discussed in detail in Parts Two and Seven.) □

3. Type Measurements

Just as a great deal of our typographic terminology is derived from the early days of printing, so too is our system of measuring type. For this reason, a knowledge of metal type provides an excellent means of understanding the terminology and measuring systems still in use today.

Points and Picas

You should be familiar with two basic units of measurement: *points* and *picas*. These measurements are to the designer what inches and feet are to the architect, and with these measurements the designer determines the appearance of a printed piece.

Points are very small units used to measure both the type size and the size of the space between lines of type. Picas, which are the larger unit, are used to measure the length of a line of type. *There are 12 points in 1 pica and approximately 6 picas in 1 inch.* By comparing a point to a pica, and a pica to an inch, you can see how these units of measurement relate to one another (**1**).

Measuring Type in Points

Our present method of measuring type in points is derived from the traditional typesetting practice in which each character was cast as an individual block of metal. (See *Handsetting* on page 161.) Two dimensions of a piece of type are relevant to today's designer: the width and the depth (**2**).

The width, called the *set-width*, is determined by the particular letterform itself. The *M* and *W* are the widest, and the *i* and punctuation marks are the most narrow. Digital typesetting systems still use set-widths in determining the amount of space characters occupy (see *Units*, page 23).

It is the depth of the block that designates the size of metal type. This dimension is generally referred to as *type size* or *point size*. So if a piece of metal type measures 10 points, then the type size is 10 points. If the metal type measures 60 points, the type size is 60 points. The type you are now reading is 10 points.

To see the relationship between the point size of a piece of type and the character it produces, study the three pieces of type along with the three printed letters they produce (**3**). Notice that although the body size of the metal type is consistent, the printed letters themselves vary in size. Since no individual letter fills the entire body, you can see why merely measuring the printed letter will not reveal the point size.

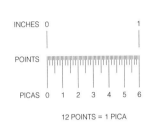

1. Points and picas are the standard measurements used by designers working with type.

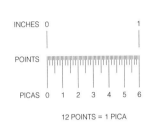

INCHES 0 1
POINTS
PICAS 0 1 2 3 4 5 6

12 POINTS = 1 PICA

2. Originally, every character was cast as a block of metal type. Two dimensions are of particular interest to today's designer: set-width and point size.

POINT SIZE

|SET-WIDTH|SET-WIDTH| SET-WIDTH |

3. Since no individual letter fills the entire body of a piece of metal type, you can never determine the point size by measuring printed letters.

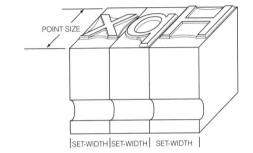

METAL TYPE 60 POINTS PRINTED LETTERS

4. Text type set in traditional sizes includes those that are below 16 points.

5 point type
6 point type
7 point type
8 point type
9 point type
10 point type
11 point type
12 point type
14 point type

5. Display type set in traditional sizes includes those that are 16 points and above.

16 point type

18 point type

20 point type

24 point type

30 point type

36 point type

42 point typ

48 point ty

58 point

60 point

72 poir

There is no question that the present system of measuring type can be puzzling. This is not a problem when you are working on the computer, as the point size is always indicated. However, it becomes a problem when you wish to determine the point size of a printed letter, in which case you must experiment by outputting and comparing samples from your own equipment. Alternatively, you may confirm the point size by comparing it to specimens supplied by the manufacturer.

Traditional Type Sizes

Metal type was cast in a range of specific sizes between 5 and 72 points. Sizes below 5 points were extremely difficult to cast (and extremely difficult to read), and type sizes above 72 points weighed too much when cast. If type sizes larger than 72 points were required, the letterforms were carved on lighter wooden blocks.

Type sizes were divided into two categories: *text type* and *display type* (**4, 5**). The text type sizes, designed for general reading, were 5, 6, 7, 8, 9, 10, 11, 12, and 14 points. Although the size difference of a single point may generally seem insignificant, in smaller type sizes it can be very noticeable. The traditional display sizes, designed for headlines and large type usage, were 16, 18, 20, 24, 30, 36, 42, 48, 54, 60, and 72 points.

With today's digital equipment, type is no longer limited to these specific sizes but can be generated in any size or fraction thereof. However, the terms *text* and *display* are still used in a general way for type sizes below and above 14 points. Furthermore, type manufacturers still use the traditional sizes when displaying type specimens.

X-height

In Chapter 2 we learned that the x-height is the height of the lowercase letter exclusive of ascenders and descenders. Although the x-height is not a fixed unit of measurement, as are points and picas, it is of great significance to the designer because the x-height—not the point size of a typeface—conveys the visual impression of the type size.

Different typefaces in the same point size may appear larger or smaller because of variations in their x-height. To understand this, compare the five display type specimens on the opposite page (**6**). Although they are all 60 points, the x-height of each typeface varies. Some have smaller x-heights (Garamond and Bodoni), while others have larger x-heights (Century Expanded and

hpx hpx hpx hpx hpx

GARAMOND BASKERVILLE BODONI CENTURY EXPANDED HELVETICA

GARAMOND

The x-height is the height of the lowercase letter exclusive of ascenders and descenders. Although this is not a unit of measurement, it is significant because it is the x-height of the letter that conveys the visual impact of the type size. Therefore typefaces that are the same point size may appear smaller or larger because of variations in the x-height. Study these five samples closely: Garamond, with its small x-height, appears much smaller than Century Expanded and Helvetica with their larger x-heights. The x-height is the height of the lowercase letter exclusive of ascenders

BASKERVILLE

The x-height is the height of the lowercase letter exclusive of ascenders and descenders. Although this is not a unit of measurement, it is significant because it is the x-height of the letter that conveys the visual impact of the type size. Therefore typefaces that are the same point size may appear smaller or larger because of variations in the x-height. Study these five samples closely: Garamond, with its small x-height, appears much smaller than Century Expanded and Helvetica with their larger x-heights. The x-height

BODONI

The x-height is the height of the lowercase letter exclusive of ascenders and descenders. Although this is not a unit of measurement, it is significant because it is the x-height of the letter that conveys the visual impact of the type size. Therefore typefaces that are the same point size may appear smaller or larger because of variations in the x-height. Study these five samples closely: Garamond, with its small x-height, appears much smaller than Century Expanded and Helvetica with their larger x-heights. The x-height is

CENTURY EXPANDED

The x-height is the height of the lowercase letter exclusive of ascenders and descenders. Although this is not a unit of measurement, it is significant because it is the x-height of the letter that conveys the visual impact of the type size. Therefore typefaces that are the same point size may appear smaller or larger because of variations in the x-height. Study these five samples closely: Garamond, with its small x-height, appears much smaller than Century Expanded and Helvetica with their larger x-heights.

HELVETICA

The x-height is the height of the lowercase letter exclusive of ascenders and descenders. Although this is not a unit of measurement, it is significant because it is the x-height of the letter that conveys the visual impact of the type size. Therefore typefaces that are the same point size may appear smaller or larger because of variations in the x-height. Study these five samples closely: Garamond, with its small x-height, appears much smaller than Century Expanded and Helvetica with their larger x-heights.

6. Five different typefaces set in 60-point display and 11-point text type. Notice how they appear to be different in size because of variations in x-height.

7. Traditionally, line-spacing was obtained by inserting pieces of lead, measured in points, between lines of type.

1/4 POINT (HAIRLINE)

1/2 POINT

1 POINT

2 POINTS

3 POINTS

4 POINTS

5 POINTS

6 POINTS

8 POINTS

10 POINTS

12 POINTS

Helvetica). Notice that typefaces with a small x-height generally have longer ascenders and descenders, while typefaces with a large x-height have shorter ascenders and descenders. Design decisions regarding this relationship were made by the type designers for both practical and esthetic reasons.

The size difference in x-height is very noticeable when you compare certain text typefaces. Notice the five typefaces set in blocks of 10-point text type. The Garamond appears smaller than either the Century Expanded or the Helvetica with their larger x-heights. Also notice how the x-height affects the number of characters per line and the amount of space between lines. Typefaces with small x-heights appear to have more space between lines than do typefaces with large x-heights.

Linespacing, Leading

Points are used not only to measure the type size but also to measure the space between lines of type. Traditional metal typesetting demonstrates this clearly. When metal type was set with one line stacked over the other to create a column of type, this was called setting the type *solid*. If the setting appeared too dense, additional space was added between the lines of type to make the printed text more open and therefore easier to read.

To add space between lines, the typesetter placed strips of metal between the lines of type (**7**). This process was called *leading* (pronounced ledding). The metal strips, or *leads* (pronounced leds), were measured in points. The metal strips were lower in height than the type and therefore did not print; their function was merely to separate the lines of type. Today leading is commonly referred to as *linespacing*; in this book, we will consider the terms interchangeable.

To help you understand linespacing and its effect on a setting, we have set 18-point Helvetica with varying amounts of leading (**8**). The first is set solid, that is, with no linespacing. This setting is called 18 on 18 (written 18/18). The first figure indicates the point size of the type; the second number indicates the point size plus any additional linespace. In this example, the figure is the same, which indicates that no additional linespacing has been added. Therefore the lines of type measure 18 points from *baseline to baseline*, or *B-to-B*.

The next block is set with 6 points of linespacing, which is indicated as 18/24. This setting measures 24 points from baseline to baseline.

Again, the first number indicates the point size of the type and the second indicates the point size plus the linespacing. Although leading does not print, we have indicated the leading here by printing a black rule of 6 points between the first two lines to better demonstrate the amount of space added.

The third block is set with minus 2 points of linespacing. Since typesetting is no longer constrained by the mechanics of metal type, lines of type can be set even closer than solid: this is referred to as *minus leading* or *minus linespacing*, such as 18/16. Be aware that there is a limit to just how close lines of type can be set before the ascenders and descenders start overlapping.

Note that adding space between the lines does not affect the type size or the length of the line; it merely moves the lines farther apart. Leading does, however, greatly affect the appearance of the entire setting. As a general rule, when more linespacing is added, the blocks of text appear lighter and more open on the page. This can be seen more clearly in the type specimens shown throughout Part Two.

The type you are now reading is 10/12.25 Century Expanded and therefore has 2.25 points of linespacing.

Letterspacing and Wordspacing

The terms *letterspacing* and *wordspacing* refer to the space between letters and words respectively. Adjusting the spacing will affect the number of characters that can be set on a given line: the looser the setting, the fewer characters per line; the tighter the setting, the more characters per line (**9**). In turn, this adjustment affects the amount of space copy will occupy and the "color" of the printed piece. The tighter the setting, the darker the line appears on the page and vice versa.

Spacing was traditionally specified with the following general terms: *normal, loose* (or *open*), *tight, very tight,* or *touching.* There is even a setting called *tight-but-not-touching.* Today many designers use the same vocabulary when referring to letterspacing and wordspacing.

Normal spacing, as the name suggests, is the standard setting of most software programs, with no extra space added or deleted. Normal spacing is generally the easiest to read and the recommended setting for most applications. With loose settings, space is added; with tight, very tight, and touching, space is deleted.

Points, and fractions of points, are used to separate lines of type.

18 POINTS BASELINE TO BASELINE

18-POINT TYPE, SET SOLID, 18/18

Points, and fractions of points, are used to separate lines of type.

24 POINTS BASELINE TO BASELINE

18-POINT TYPE WITH 6 POINTS LEADING, 18/24

Points, and fractions of points, are used to separate lines of type.

16 POINTS BASELINE TO BASELINE

18-POINT TYPE MINUS 2 POINTS LEADING, 18/16

9. Most text type is set with either normal or tight spacing.

Letterspacing and wordspacing can drastically affect readability, the number of characters per line, and the "color" of the setting.

LOOSE SETTING

Letterspacing and wordspacing can drastically affect readability, the number of characters per line, and the "color" of the setting.

NORMAL SETTING

Letterspacing and wordspacing can drastically affect readability, the number of characters per line, and the "color" of the setting.

TIGHT SETTING

10. Some letter combinations, especially those that overhang, may require adjustment. This is referred to as kerning.

Wo Te V.

WITHOUT KERNING

Wo Te V.

STANDARD KERNING

Wo Te V.

EXTRA KERNING

11. While points are used to measure type size, picas are used to measure linelength.

Lines are measured in picas.

PICAS 0 1 2 3 4 5 6 7 8 9 10 11 12 13 14 15

The letterspacing and wordspacing of a setting can be modified to affect the entire page, a line, or only the space between specific letters. Text to be changed is highlighted or "selected" before spacing refinements are applied. You can easily alter spacing through most programs by altering the tracking in the appropriate dialog box.

Adjusting the spacing between specific letters is referred to as *kerning* (**10**). Generally, only a minimal adjustment is required because most fonts are supplied with a kerning table that automatically corrects for problematic letter combinations such as *Wo, Te, AT*, etc. See page 99 for more on letterspacing and wordspacing.

Linelength in Picas
The pica is used to indicate the length of a line of type—called the *linelength* or *measure* (**11**). Although inches and centimeters may also be employed to measure linelengths, picas remain the standard. The column you are now reading is set in 10-point type on 12.25 points by 18 picas. This is written as 10/12.25 x 18.

Just as the type size you select is important, so too is the linelength. It is the type size in conjunction with the linelength that determines, to a great degree, the ease with which you read.

Em-Quads, Units, and Set-Widths
Today set-width, letterspacing, and wordspacing are all automatically measured in units. Here again, the concept of units is based on a metal type measurement called an *em-quad*, or simply an *em*.

Em-Quads. The em-quad is the square of a specific type size and therefore varies according to type size (**12**). For example, if the type is 10 points, the em-quad is a square that occupies a space of 10 points by 10 points. If the type is 72 points, the em-quad is 72 points square. As the em varies with the type size, any visual effect created by a 1-em space will be consistent regardless of type size.

In traditional metal typesetting, em-quads, like leads, did not print but were simply used for spacing. Since 1-em was too much to leave between words, the em-quad was subdivided to produce smaller spaces for wordspacing (see page 165). With the exception of the em, these metal type designations for spacing are no longer used.

A 1-em space is still utilized as the standard paragraph indent and is called a 1-em indent.

Paragraphs can also be indented in multiple ems, such as 2 ems or more. To get an idea of what a 1-em space looks like, just check the beginning of this paragraph. Since the type size is 10 points, the 1-em indent is also 10 points.

Units. For today's technologies the em-quad was further subdivided into segments called *units* (**13**). The number of units varies with the typesetting system. One of the most popular used to be 72-units-to-the-em. Today the unit number is much higher. The greater the number of units to the em, the greater the possibilities of typographic refinement. There is a point, however, beyond which extreme refinement is neither necessary nor noticeable.

Perhaps the best way to understand the unit is to refer to the old-fashioned typewriter. The typewriter is a one-unit system with a simple counting mechanism: every letter, space, or punctuation mark occupies exactly one unit of space (see page 131). When margins are set on a typewriter, it simply determines a fixed number of keystrokes. Once that number is typed, a bell rings. It makes no difference whether you type *m*'s, *t*'s, *i*'s, periods, or press the space bar; each character registers as a single space.

Set-Width. In computer typesetting programs, every character occupies a specific amount of space, measurable in units. This dimension, called the *set-width* of the character, includes a small amount of space on either side. This space prevents the characters from touching one another.

The wider the character, the greater the set-width; hence, more units are occupied by wide characters. In this example (**14**), based upon a 36-unit system, a cap *T* may be 22 units wide, while a lowercase *y* is 18 units wide and a lowercase *e* is 20 units wide. A period might require 10 units. The set-width, when expressed in units, is referred to as the *unit value* of the character.

Design programs that involve typography allow you to make fine adjustments in the spacing between letters and words. It is the unit system that provides the means to accomplish this. By typing in positive unit figures (to add space) or negative unit figures (to delete space), text and headlines can be visually refined. Because the unit is an extremely fine measure, the designer has complete control over spacing between letters and words. □

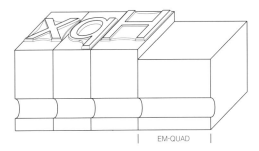

EM-QUAD

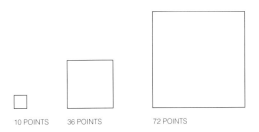

10 POINTS 36 POINTS 72 POINTS

12. The em-quad is the square of the type size. In metal type, it sat lower than the type so that it did not print.

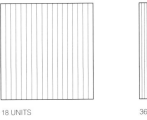

18 UNITS 36 UNITS

13. The em is then subdivided into units, which vary from system to system.

22 18 20 20 10

14. Based on a 36-unit system, each character occupies a specific amount of space, called the unit-value or set-width.

4. Grids

1. For hundreds of years, books printed in Europe were designed with generous margins and classical proportions. The relationship between the text and the white space was determined by geometric formulas.

2. Pages filled with text are usually uninviting. Without adequate margins or white space, the type overwhelms the page.

3. The same text set in a reduced column width is more inviting to the eye and therefore easier to read.

If you examine a well-designed book, magazine, or brochure, you will probably notice a strong sense of unity and a logic to the placement of design elements. To achieve this effect, the designer first creates a *grid*, which is a set of guidelines indicating horizontal and vertical divisions within the page. This grid is used as a guide for laying out the text, headlines, folios, captions, and illustrations. Although grids may seem restrictive, they can allow for great individuality. Even when using the same grid, no two designers will produce the same results.

The success or failure of a design lies less in the grid than in the skill of the designer who arranges the elements within it. Generally speaking, good designers use grids like recipes, following them only as long as they work. If some element of the design seems awkward within an otherwise well-designed grid, it may be repositioned to look correct visually—even if doing so "breaks" the format of the grid. If you need to make exceptions continually, however, it may be time to reconsider the initial grid. It does not make sense to force a design into an inappropriate format.

Grids can range from the simple to the complex. The following are the most common.

One-Column Grids

A one-column grid is actually very simple; it is composed of a single column that contains both text and illustrations. In a single-column grid, the designer's main concern is selecting a suitable typeface and establishing a linelength that ensures readability.

A single-column grid allows white space to function as a quiet margin, a format suitable for lengthy reading. In classic text proportions, the outside margin is greater than the inside margin, and the top (head) margin is less than the bottom (foot) margin (**1**). This lends balance to the page. Books such as novels and biographies are designed with variations on this format.

If a single column is too wide for comfortable reading (**2**), it is possible to reduce the column width slightly and reposition it on the right or left side of the page (**3**). Although this offers a smaller text area, readability is enhanced and the page has a more open feeling.

Two- and Three-Column Grids

Multiple-column grids allow for more flexibility and creative use of space (**4, 5**). Most magazines as well as illustrated books are designed around two- and three-column grids. Text and images

4. Most magazines have grids with two or more columns. The greater the number of columns, the greater the possibilities for organizing the text and illustrations.

5. As long as the text sets well on a given linelength, columns may be any width. The vertical placement of elements such as heads and folios must be carefully determined.

1. Origins of the Alphabet

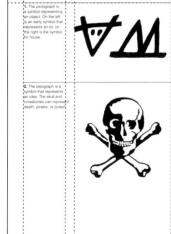

1. The pictograph is a symbol representing an object. On the left is an early symbol that represents an ox; on the right is the symbol for house.

2. The ideograph is a symbol that represents an idea. The skull and crossbones can represent death, pirates, or poison.

Before proceeding with the more practical aspects of typography, let's first consider the twenty-six letters we call our alphabet. We tend to forget that the alphabet is composed of symbols, each representing sounds made in speech. The symbols we use today are derived from those used thousands of years ago. However, the ancient forms did not represent sounds but were pictures of things or symbols for ideas.

Pictographs
At some point in time, people began to communicate visually. They made simple drawings of the things that existed in their world: people, animals, and tools, for example. These images, called *pictographs*, were symbols representing an object (**1**).

Ideographs
As the need developed to communicate more abstract thoughts, the symbols began to take on multiple meanings: ox, for example, could also mean food. The new symbol would represent not an object but an idea. These idea symbols are called *ideographs*. Abstract thoughts could also be communicated by combining different pictographs: for example, to communicate the concept of rest, the pictographs for man and tree might be combined. A contemporary example of the ideograph is the warning symbol for poison. The skull and crossbones is not seen for what it is but for what it represents: danger, death, pirates, or poison (**2**).

This evolution from pictographs to ideographs represented a major step in the development of a written language. It was with the development of picture-writing, combining symbols for the concrete (pictographs) and for the abstract (ideographs), that early cultures communicated and kept records. (Today the Chinese still use an evolved version of this system.)

There are some disadvantages to the picto-ideographic system: not only are the symbols complex, but their numbers run into the tens of thousands, making learning more difficult and writing slow.

Phoenician Alphabet
As a nation of traders and merchants, the ancient Phoenicians needed a simplified writing form that would allow them to keep ledgers and communicate business transactions. Around 1200 B.C., a new concept in written communication evolved *using symbols to represent the sounds of speech rather than ideas or objects.*

To better understand how this change came about, let's look at the first two letters of our alphabet, A and B, and see how they evolved (**3**). One of the primary spoken sounds the Phoenicians recorded was "A." This sound occurred at the beginning of their word *aleph*, meaning ox. Instead of devising a new symbol for the sound, they simply took the existing symbol for the object. They did the same for the sound "B," which was found in their word *beth*, meaning house. Again, they took the existing symbol for the object and applied it to the sound. This process was continued until the Phoenicians had assigned a symbol for each sound. In all cases the symbols were of common objects or parts of the body, such as water, door, fish, hand, eyes, or mouth (see page 145).

The Phoenician alphabet required far fewer symbols than the picto-ideographic system. Furthermore, the simplified letterforms could be written more rapidly, were easier to learn, and provided an ideal means of communication. By developing a standardized phonetic alphabet, the Phoenicians made a major contribution to Western civilization.

Greek Alphabet
The ancient Greek civilization gradually adopted the Phoenician alphabet for their use around 800 B.C. They recognized something quite different in the potential of this new system: in addition to its usefulness as a tool of trade, the alphabet also offered a valuable means of preserving knowledge. Along with the alphabet, the Greeks adopted the Phoenician names for the letters, altering them only slightly. For example, *aleph* became *alpha*, *beth* became *beta* (**4**). From these two letters we derive our word *alphabet*.

The Phoenician-derived alphabet contained no vowels, only consonants. Words formed from this alphabet would have looked similar to our abbreviations—Blvd., Mr., St. Although this system worked well for business ledgers, its broader use was limited. Therefore the Greeks added five vowels and formalized the letterforms. A revised alphabet of only capital letters was adopted officially by Athens in 403 B.C.

Roman Alphabet
Just as the Greeks had altered the Phoenician alphabet, the Romans adopted and modified the Greek alphabet (**5**). Thirteen letters were left unchanged from the Greek: A, B, E, H, I, K, M, N, O, T, X, Y, Z. Eight letters were revised: C, D, G, L, P, R, S, V. Two letters were added: F and Q.

3. The first two letters of the Phoenician alphabet. On the left is the symbol *aleph* which was their word for ox, on the right is the symbol *beth*, which meant house.

4. Borrowed from the Phoenicians, the first two letters of the alphabet were modified by the Greeks, who called them *alpha* and *beta*.

5. The first two letters of the Roman alphabet show further refinement. The Romans dropped the Greek names for the simpler *A, B, C's.*

6. This book was designed with a three-column grid. Ample space is reserved at the top for chapter heads. Two columns are used for text or illustrations, and the third, narrow column is used for captions.

7. Grids may be designed with a greater emphasis on horizontal divisions than on standard vertical columns. These grids tend to be used for technical or special-interest publications.

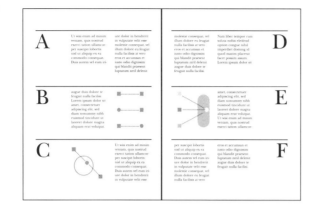

8. Some publications use more than one grid. Generally, certain margins are shared in these formats to provide visual consistency.

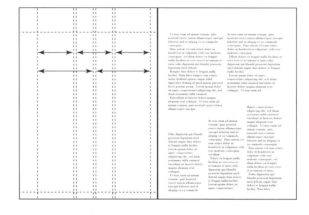

9. Working without a grid may look easy but requires a great number of design decisions to be effective.

may occupy one or more columns; illustrations may even run off the page (*bleed*). Column widths may also vary: for instance, a two-column grid may have a wide column for text and a narrow one for captions and callouts. The grid for this book is three-columns (**6**), two for text and illustrations and one for captions.

Complex Grids

Some grids designed for specific applications are very complex, having multiple columns that vary in width. Technical books, for example, may require a grid with special columns for data or charts as well several horizontal page divisions for organizing information (**7**). Other grids may be designed with columns that can be shifted or overlapped to afford even greater design flexibility (**8**). Some publications have one grid format for feature articles and another for classified ads or listings.

Working Without a Grid

Perhaps the most challenging approach of all is to work without a grid (**9**). In this case, layouts are basically free-form, with each spread designed according to its own rules. With this method, the entire publication is held together by a common style or design concept. Cutting-edge publications often use this approach to achieve a free-form energy that can be dynamic and appealing.

To design several pages without the unifying properties of a grid may seem quite easy. But for any lengthy publication, the "no grid" approach can be very demanding on the designer as well as the reader. Students should begin by understanding the attributes of the grid before attempting to design without one.

Parts of a Page

There are a number of terms used by editors and designers to refer to all the elements that make up a printed page (**10**). Simple books usually contain *body text*, *heads*, and *folios*. More complex publications may contain many typographic details that provide additional information, such as *running heads* or *running feet*, *callouts*, or *footnotes*. Sometimes slightly different terms are used in different fields—a *callout* in a book is referred to as a *deck* in a magazine. Short passages that accompany a central story, called *sidebars*, are popular in newspapers today. □

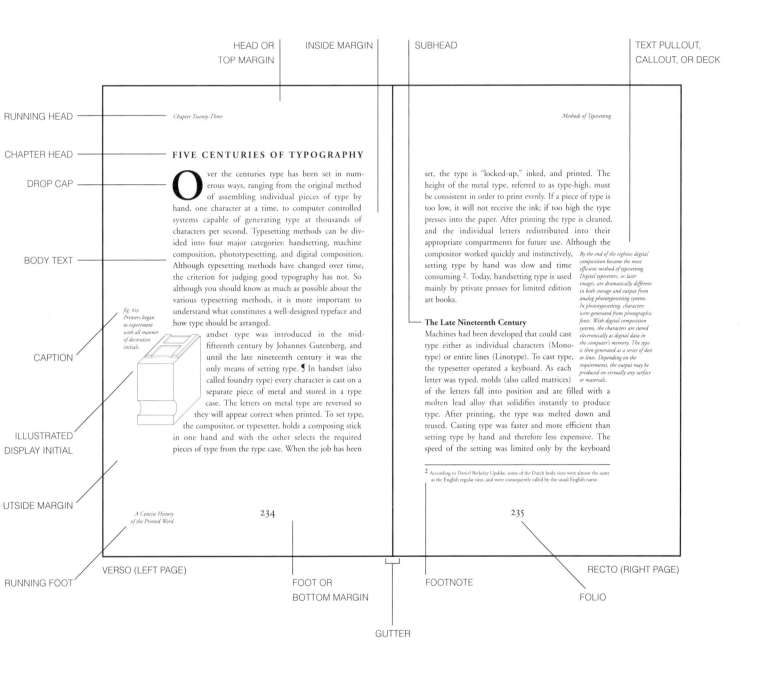

HEAD OR TOP MARGIN

INSIDE MARGIN

SUBHEAD

TEXT PULLOUT, CALLOUT, OR DECK

RUNNING HEAD

CHAPTER HEAD

DROP CAP

BODY TEXT

CAPTION

ILLUSTRATED DISPLAY INITIAL

UTSIDE MARGIN

RUNNING FOOT

VERSO (LEFT PAGE)

FOOT OR BOTTOM MARGIN

GUTTER

FOOTNOTE

RECTO (RIGHT PAGE)

FOLIO

The content shown within the diagram:

Chapter Twenty-Three

FIVE CENTURIES OF TYPOGRAPHY

Over the centuries type has been set in numerous ways, ranging from the original method of assembling individual pieces of type by hand, one character at a time, to computer controlled systems capable of generating type at thousands of characters per second. Typesetting methods can be divided into four major categories: handsetting, machine composition, phototypesetting, and digital composition. Although typesetting methods have changed over time, the criterion for judging good typography has not. So although you should know as much as possible about the various typesetting methods, it is more important to understand what constitutes a well-designed typeface and how type should be arranged.

fig. 619 Printers began to experiment with all manner of decorative initials.

andset type was introduced in the mid-fifteenth century by Johannes Gutenberg, and until the late nineteenth century it was the only means of setting type. ¶ In handset (also called foundry type) every character is cast on a separate piece of metal and stored in a type case. The letters on metal type are reversed so they will appear correct when printed. To set type, the compositor, or typesetter, holds a composing stick in one hand and with the other selects the required pieces of type from the type case. When the job has been

A Concise History of the Printed Word

234

Methods of Typesetting

set, the type is "locked-up," inked, and printed. The height of the metal type, referred to as type-high, must be consistent in order to print evenly. If a piece of type is too low, it will not receive the ink; if too high the type presses into the paper. After printing the type is cleaned, and the individual letters redistributed into their appropriate compartments for future use. Although the compositor worked quickly and instinctively, setting type by hand was slow and time consuming [2]. Today, handsetting type is used mainly by private presses for limited edition art books.

By the end of the eighties digital composition became the most efficient method of typesetting. Digital typesetters, or laser images, are dramatically different in both storage and output from analog phototypesetting systems. In phototypesetting, characters were generated from photographic fonts. With digital composition systems, the characters are stored electronically as digital data in the computer's memory. The type is then generated as a series of dots or lines. Depending on the requirements, the output may be produced on virtually any surface or materials.

The Late Nineteenth Century
Machines had been developed that could cast type either as individual characters (Monotype) or entire lines (Linotype). To cast type, the typesetter operated a keyboard. As each letter was typed, molds (also called matrices) of the letters fall into position and are filled with a molten lead alloy that solidifies instantly to produce type. After printing, the type was melted down and reused. Casting type was faster and more efficient than setting type by hand and therefore less expensive. The speed of the setting was limited only by the keyboard

[2] According to Daniel Berkeley Updike, some of the Dutch body sizes were almost the same as the English regular sizes, and were consequently called by the usual English name.

235

5. How Do We Read?

1. Reading the upper half
of a line of type is far
easier than reading the
bottom half.

how do we read?

how do we read?

2. Words set in lower-
case have a more distinct
outline and are therefore
more quickly recognizable
than words in caps.

how do we read?

HOW DO WE READ?

Since we learn to read at such an early age, we often take this valuable asset for granted. We generally give little thought to how spoken words and ideas are converted into the twenty-six letters of the alphabet and arranged on the page to communicate effectively. For the casual reader, this lack of awareness is acceptable, but a graphic designer must understand that our reading habits are formed early in life and are not easily modified.

How we read, and therefore how we design, involves subtle and complex factors based on our eyesight and conditioning. Most of the type we consider comfortable reading is clearly seen at arm's length. Given normal eyesight, this distance will dictate a preferred text type size and linelength, usually 9-, 10-, 11-, or 12-point type and 35 to 70 characters on a line.

Our conditioning determines how we prefer to read. Early in life we are introduced to letterforms, memorize the basic shapes, and learn to read from left to right, line by line, top to bottom. As we mature, these reading habits are formulated, modified, and reinforced until we have formed specific preferences.

Generally speaking, we tend to be very conservative in our reading habits, regardless of how radical we may be in other aspects of our lives. For serious reading, we prefer what is familiar: black type on white paper, roman typefaces in regular weight, and upper and lowercase. Anytime a designer departs from these criteria, the reader may be challenged.

We generally expect to be able to read an entire passage effortlessly, without being distracted by poorly conceived or self-conscious typography. In other words, the type should not call attention to itself, intruding between the reader and the thought expressed on the printed page.

The following topics, based on our reading habits, are presented only as thought-provoking guidelines meant to provide a point of departure for design decisions. In all cases, when designing with type, ask yourself this basic question: how much copy is being read and under what conditions? Reading one or two words on a billboard is a far different activity from reading a novel or a full-page advertisement in a magazine.

Caps and lowercase
To better understand the mechanics of reading, we have taken a line of type and split it through the center (**1**). Notice that reading the upper half is relatively easy, while the bottom half is far more difficult to discern. The eye scans the upper

half of the letters and recognizes them almost instinctively.

The more distinct the outline, the more easily the eye recognizes the words. When words of a similiar size are set in both uppercase and lowercase, the lowercase words are more quickly recognizable and more comfortable to read (**2**). For this reason, most of what we read is set in uppercase and lowercase.

Serif and Sans Serif

Next, we compare Century Expanded, a serif typeface, with Helvetica, a sans serif typeface (**3**). Which one do you find easier to read? Some find that the serifs on a typeface facilitate the horizontal flow necessary to comfortable reading. This may be why most novels are still set with serif typefaces. While this is true, it is important to realize that there are generations of adults who have grown accustomed to reading sans serif typefaces and often prefer them to the serif, particularly when reading small type such as a telephone directory.

Regular and Bold

Bold type can be very effective when used for emphasis or in small quantities. The designer must determine if the excessive blackness of the bold type promotes or detracts from readability (**4**). Often the heavy strokes of the letters cause the counters and the white spaces between the letters to fill in, reducing legibility and creating a sparkling quality in the type that inhibits comfortable reading.

White on Black vs. Black on White

We are accustomed to reading black type on a white background. The majority of text we read is set in this fashion. Type that is "reversed," that is, white type on a black background, is readable but has drawbacks (**5**). White type on a black ground has a tendency to sparkle, making it harder on the eyes. Studies have shown that long passages of reversed type may go unread.

Condensed and Expanded

Many type families include variations in which the regular typeface has been modified to create a condensed and an expanded version. The condensed version is specified primarily where conserving space is necessary, while the expanded version is used more for emphasis or display purposes. Neither is recommended for lengthy reading matter. ☐

typography

typography

3. In general, serifs promote the horizontal flow of reading and the quick identification of the individual letters.

Bold type can be very effective when used for emphasis or in small quantities. When using bold type in large quantities, the designer must determine if the excessive blackness of the type is affecting readability. The heavy strokes of the letters cause the counters and the white spaces between the letters to fill in, creating a sparkling quality in the type that inhibits comfortable reading.

9/12 HELVETICA BOLD

4. Bold type set in large quantities can inhibit comfortable reading.

Is it more difficult to read white type on a black background or black type on a white background? White type on a black background has a tendency to sparkle, which distracts the eye and makes reading difficult. We must ask how much type is being read and under what conditions — reading one or two words on a billboard is certainly different from reading a full-page advertisement in a magazine.

9/11 HELVETICA

5. Because we are accustomed to reading black type on white paper, we tend to prefer it. However, a small block of reversed type can be visually effective.

Legible

Less
Legible

Illegible

To supplement your basic understanding of typography, you should become familiar with a few of the standard design terms and concepts used throughout this book. A more complete listing of graphic design terms can be found in the glossary on pages 163–171.

Comprehensive. A *comprehensive*, or comp, is an accurate presentation of a design showing type and illustrations in position and indicating the use of color. Comps range from inexpensive pencil renderings to digitally generated color printouts. A successful comp allows both the designer and the client to see how the proposed design will look before any major production expenses are incurred.

From the client's point of view, comps fall into three categories: acceptable, not acceptable, and acceptable with changes. If a client finds a comp acceptable, the design is ready to go into production. Designs that are totally unacceptable must be reconsidered. In most cases designs fall into the third category: the concept is acceptable but some alterations are required before approval is granted.

Figure/Ground. *Figure/ground* (also referred to as *positive* and *negative* space) is a term used frequently when analyzing designs. The figure is the dominant, or "positive," element that appears to come forward, while the ground is the "negative" element that seems to recede. In most cases the black type (and illustrations) are the figure, while the white space is the ground. To create a successful design, you should become sensitive to the figure-ground relationship.

Justified and Unjustified. When type is set so that all the lines are of equal length, the type is said to be set justified. The type you are now reading is justified. Type can also be set unjustified (flush left, ragged—or rag—right or flush right, rag left). For more details on justification, see page 100.

Legibility and Readability. As a rule, the definitions of *legibility* and *readability* are interchangeable. For our purpose, however, we will use them to distinguish between the design of a specific typeface, which we will call *legibility*, and how a typeface is arranged on the page, which we will call *readability*.

Legibility refers to the individual letterforms and how easy it is to distinguish one character from another—regardless of size and settings. A legible typeface is therefore easy to read. Classic designs such as Garamond, Baskerville, and Century are excellent examples of legible typefaces.

Readability is determined by how type is arranged on the page. Size, setting, color, and endless other factors determine how readable a typeface becomes when it is composed into words, sentences, paragraphs, and pages. Readability is the determining quality that makes a page inviting and easy to read.

Thumbnails. The term *thumbnail* originates from the size and speed by which small sketches are created to capture an idea. Many designers prefer to begin the creative process by creating thumbnails. These small pencil sketches allow the exploration of many design possibilities in a quick, efficient manner, without the distraction of details. Once you are satisfied with the general position of the various elements, you can work confidently toward a final layout. Thumbnails are also an excellent means of communicating ideas between designers and clients.

White Space. The space that surrounds type or illustrations is referred to as white space and is critical to effective design. White space is one of the most difficult concepts for the beginning designer to comprehend. It is often seen as "empty" space, an area in which nothing seems to be happening. In truth, white space has an impact on every aspect of the design, not just the space around blocks of text but also the space between letters, words, lines, paragraphs, heads, and images. Properly utilized, white space brings harmony to the page. Any adjustments to white space—anywhere—will affect the overall design. □

Until now we have dealt with the vocabulary of typography as well as the common characteristics and structure of typefaces. Now we will study five classic typefaces in detail in order to learn what distinguishes one typeface from another. At first you may be able to identify typefaces only by their more obvious characteristics. In time you will recognize typefaces by their individuality and by the texture they create on the printed page, which will eventually lead to an improved awareness of type design and confidence in your type selection.

7. Historical Classifications

1. Garamond, an Old Style typeface, has relatively thick strokes and heavily bracketed serifs.

2. Baskerville, a Transitional typeface, has refined serifs and greater contrast between thick and thin strokes.

3. Bodoni, a Modern typeface, has very fine serifs and extreme contrast between thick and thin strokes.

There is no better way to train the eye to typographic subtleties than by studying the changing forms in typeface design through the centuries. In this section you will be introduced to five typefaces, each representing a distinct stage in the evolution of type. Although many were designed centuries ago, these typefaces remain among the most popular and widely used today.

Below are listed the names of five classic typefaces along with their historical classification and approximate date of design.

Old Style	Garamond (France)	1617
Transitional	Baskerville (England)	1757
Modern	Bodoni (Italy)	1788
Slab Serif	Century Expanded (U.S.)	1895
Sans Serif	Helvetica (Switzerland)	1957

Understanding these historical divisions is not as important as appreciating the significance of how seemingly small changes in type design can affect both the character of the typeface and how each typeface appears as text on a page.

Old Style, Transitional, and Modern

Perhaps the easiest way to understand the various historical classifications is to consider the first three as one group: Old Style, Transitional, and Modern (**1, 2, 3**).

Old Style. In Claude Garamond's time (the early 1600s), all papers were handmade and printing technology was still somewhat primitive. A typestyle that we now call "Old Style" was created. The Old Style typefaces had relatively thick strokes and heavily bracketed serifs (*bracketed* refers to the curved part where the serif connects with the main stroke).

Transitional. By John Baskerville's time (around 1750), technological advances made it possible to produce smoother papers, better printing presses, and improved inks. Therefore Transitional typefaces reflect a trend toward greater refinement; there is an increased contrast between the thick and thin strokes, and the serifs are more sculpted.

Modern. The extremes of typographic refinement were achieved in the late eighteenth century when the Italian typographer Giambattista Bodoni further reduced the thin strokes and serifs to fine hairlines and virtually eliminated the brackets. This modification created an

elegant typeface with extreme contrast between the thin and thick strokes.

It is important to note that Claude Garamond did not consider himself a designer of Old Style typefaces, any more than Baskerville considered himself a designer of Transitional typefaces. It is only by studying these faces in retrospect that type scholars came to categorize Garamond as an Old Style typeface and Bodoni as a Modern typeface. Therefore Baskerville, which bridged the gap between Old Style and Modern, became a Transitional typeface.

Slab Serif: Egyptian

After Bodoni, type design became eclectic. In search of new forms of typographic expression, often to satisfy the need of advertisers, designers began experimenting. They created bold, extended, and condensed typefaces, producing a greater variety than in any previous century.

One of the typestyles to emerge was Egyptian, now referred to as slab serif or square serif, in which the letterforms are characterized by heavy slab serifs (**4**). These typefaces show a return to very little contrast between the thick and thin strokes.

Century Expanded, based on an 1895 design by L. B. Benton, is a refined version of this style. The heavy slab serifs are lighter in weight and modified by the addition of brackets. (Specimens of true slab serif typefaces can be found on page 154.)

Century Expanded, the typeface you are now reading, was chosen for this book because of its popularity and legibility.

Sans Serif

Prior to the twentieth century, sans serif typefaces were seldom used, and then usually limited to display purposes and classified advertising only. By the mid-twentieth century, however, sans serif typefaces became popular. New sans serif designs were contemporary and streamlined in appearance, but still considered inappropriate for general text purposes. Today sans serif typefaces are commonly used for text as well as for display.

Helvetica, developed in 1957 by Max Miedinger and Edouard Hoffman, is a well-designed, popular sans serif typeface (**5**). Helvetica is the most widely used of all sans serif typefaces, and the Helvetica family of typestyles is probably the most diverse.

Additional type specimens of these five classifications can be found on pages 151 through 156.

4. Century Expanded is a modified slab serif typeface with heavily bracketed serifs. Most slab-serif faces have no bracket at all.

5. Helvetica is a well-balanced, widely used sans serif typeface.

Common Characteristics

On the opposite page, specific letterforms of the five classic typefaces are illustrated. Let's study these typefaces closely. They all have certain characteristics in common that, when modified, can greatly affect the way the type appears on the printed page. These characteristics fall into three categories: variations in stress, strokes, and serifs. Let's look at each of these in detail.

Variations in Stress. Basing their designs on the written letterforms of the scribes, early type designers tried to capture as much of the character of this written form as possible. Study the letter *O* at left, which has been drawn with a calligraphy pen. Notice how the pen has created a thick stroke in the upper right and the lower left, and a thin stroke in the upper left and the lower right of the letter. This distribution of weight creates a diagonal stress through the thin parts of the letterform (as indicated by the dotted line).

This feature was one of the characteristics early type designers followed when designing typefaces, as can be seen quite clearly in Garamond. As type evolved and designers were less influenced by handwriting, the stress became more vertical—as can be seen in Baskerville. Later, with Bodoni, the stress became totally vertical. Century Expanded shows a return to a slight diagonal stress. In Helvetica you will find no noticeable stress at all.

Variations in Strokes. Typefaces also vary in the weight of the strokes, that is, in the degree of contrast between the thick and thin parts of the letters. In Garamond we see a prominent characteristic of Old Style faces: relatively little contrast between the weight of the thick and thin strokes of a letter. As we move toward Transitional typefaces, there is a tendency toward refinement and a greater contrast between the thicks and thins. Modern typefaces, such as Bodoni, present the maximum contrast between thick and thin strokes.

After the Modern typefaces, there was a return to less contrast between thick and thin strokes, as can be seen in Century Expanded. In Helvetica there is an absence of any noticeable variation; there is uniformity of strokes.

A PENNED LETTER CREATES
A DIAGONAL STRESS

Variations in Serifs. Serifs also vary from one typeface to the next in their weight and in the way they are bracketed, that is, in the way in which the serif meets the vertical stroke of the letter. Once again you can see the evolution of type from the heavy Old Style serif of Garamond through the Transitional serif of Baskerville to the hairline serif of Bodoni.

While Modern typefaces demonstrated the most extreme serif refinement, Century Expanded marked a return to the use of heavy serifs. Helvetica and other trend-setting sans serif typefaces of the twentieth century eliminated serifs altogether.

Individual Characteristics

Although the common characteristics of a typeface allow designers to place it in its historic classification, it is also true that individual characteristics enable us to identify specific typefaces. As you become more familiar with typefaces, you will be able to distinguish the subtle differences that give a typeface its individuality and character.

When trying to identify an unknown typeface, always look to the individual characters that contain the most design information, such as the uppercase *R*, *T*, or *W* and the lowercase *a*, *e*, or *g*. These characters provide more visual clues than such letters as the uppercase *L* or the lowercase *i*.

Take the time to study the five specimens provided here and familiarize yourself with the individual characteristics that make each face unique.

Notes on Typeface Design

The design of a specific typeface may vary from one manufacturer to another. For this reason, one Garamond may look quite different from another Garamond, not only in design but also in x-height and the number of characters per pica. Just as the design of a typeface may differ, so too may the name. A typeface identical to Helvetica may be named Helios, Vega, or ITC Helvetica, depending on the manufacturer.

Generally speaking, this lack of standardization can be a problem, especially if you need to share files with other designers, service bureaus, or clients. To minimize this problem, always be certain that everyone working on your project is using exactly the same fonts produced by the same manufacturer. Keep in mind that specific fonts are protected by copyright. Everyone working on the project should purchase their own fonts from the manufacturer. □

ANGLED STROKE OVERLAPPING V'S SHARP SLANT

SMALL COUNTER FLAT EAR

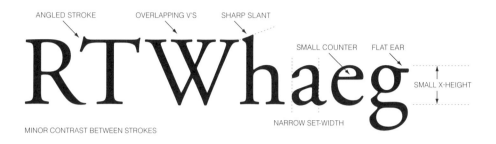

SMALL X-HEIGHT

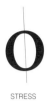

MINOR CONTRAST BETWEEN STROKES

NARROW SET-WIDTH

STRESS

MORE REFINED SERIFS

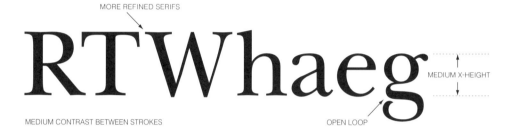

MEDIUM X-HEIGHT

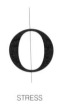

MEDIUM CONTRAST BETWEEN STROKES

OPEN LOOP

STRESS

OVERLAPPING V'S

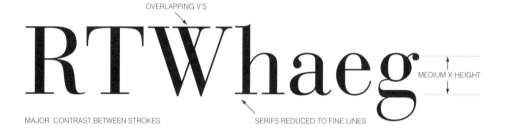

MEDIUM X-HEIGHT

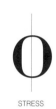

MAJOR CONTRAST BETWEEN STROKES

SERIFS REDUCED TO FINE LINES

STRESS

FLOPPY EAR

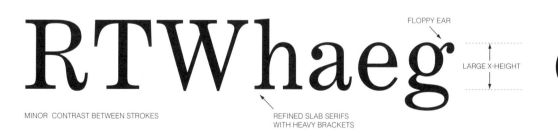

LARGE X-HEIGHT

MINOR CONTRAST BETWEEN STROKES

REFINED SLAB SERIFS
WITH HEAVY BRACKETS

STRESS

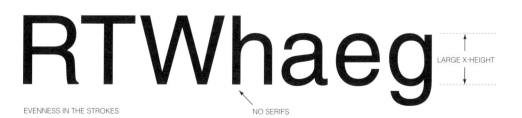

LARGE X-HEIGHT

EVENNESS IN THE STROKES

NO SERIFS

NO STRESS

8. How to Use this Section

The five typefaces displayed in this section, Garamond, Baskerville, Bodoni, Century Expanded, and Helvetica, are the backbone of your course in typography. You will use this section when selecting a typeface or previewing a setting when designing with type.

On the following pages you will find the complete alphabets in sizes ranging from 7 points through 72 points. On the opening spread of each section is also shown the following: historical data, individual characteristics, and the names of other typefaces that are similar in style.

All text and display sizes are shown in roman and italic. At the bottom of the text type pages are charts providing the number of characters that can be set to a given linelength measured in picas. (This is also an accurate pica rule.) Although stated as lowercase, the figure does allow for the occasional cap. In Chapter 24 you will use these charts for copyfitting.

The text type specimens in this section have been set justified to a 36-pica measure (except in smaller type sizes, which have been set by 18 picas). Each type size is shown in five settings with linespacing ranging from minus 1 point to plus 4 points. To ensure even settings, we took liberties with word breaks and hyphenation where necessary. In each setting the name Johannes Gutenberg has been set in caps and small caps.

All type specimens used in this section of the book are Adobe™ Fonts, which are some of the most popular and widely used by designers around the world. The passage used for these settings was written by Frederic W. Goudy, an American typographer and designer.

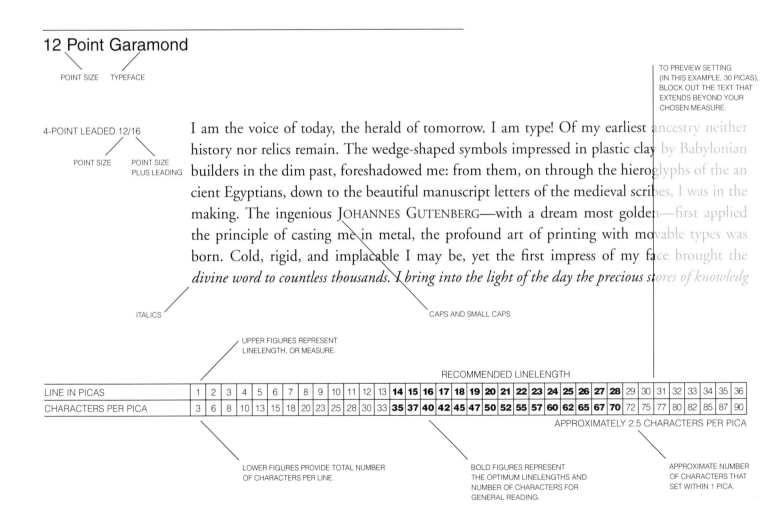

12 Point Garamond

POINT SIZE TYPEFACE

TO PREVIEW SETTING
(IN THIS EXAMPLE, 30 PICAS),
BLOCK OUT THE TEXT THAT
EXTENDS BEYOND YOUR
CHOSEN MEASURE.

4-POINT LEADED 12/16

POINT SIZE POINT SIZE PLUS LEADING

I am the voice of today, the herald of tomorrow. I am type! Of my earliest ancestry neither history nor relics remain. The wedge-shaped symbols impressed in plastic clay by Babylonian builders in the dim past, foreshadowed me: from them, on through the hieroglyphs of the ancient Egyptians, down to the beautiful manuscript letters of the medieval scribes, I was in the making. The ingenious JOHANNES GUTENBERG—with a dream most golden—first applied the principle of casting me in metal, the profound art of printing with movable types was born. Cold, rigid, and implacable I may be, yet the first impress of my face brought the *divine word to countless thousands. I bring into the light of the day the precious stores of knowledg*

ITALICS

CAPS AND SMALL CAPS

UPPER FIGURES REPRESENT
LINELENGTH, OR MEASURE.

RECOMMENDED LINELENGTH

LINE IN PICAS	1	2	3	4	5	6	7	8	9	10	11	12	13	**14**	**15**	**16**	**17**	**18**	**19**	**20**	**21**	**22**	**23**	**24**	**25**	**26**	**27**	**28**	29	30	31	32	33	34	35	36
CHARACTERS PER PICA	3	6	8	10	13	15	18	20	23	25	28	30	33	**35**	**37**	**40**	**42**	**45**	**47**	**50**	**52**	**55**	**57**	**60**	**62**	**65**	**67**	**70**	72	75	77	80	82	85	87	90

APPROXIMATELY 2.5 CHARACTERS PER PICA

LOWER FIGURES PROVIDE TOTAL NUMBER
OF CHARACTERS PER LINE.

BOLD FIGURES REPRESENT
THE OPTIMUM LINELENGTHS AND
NUMBER OF CHARACTERS FOR
GENERAL READING.

APPROXIMATE NUMBER
OF CHARACTERS THAT
SET WITHIN 1 PICA.

Garamond is an Old Style typeface. Claude Garamond, who died in 1561, was originally credited with the design of this elegant French typeface; however, it has recently been discovered that this typeface was designed by Jean Jannon in 1615. Many of the present-day versions of this typeface are based on Jannon's design, although they are all called Garamond. This is a typical Old Style face, having very little contrast between the thicks and thins, heavily bracketed serifs, and oblique stress. The letterforms are open and round, making the face extremely readable. The capital letters are shorter than the ascenders of the lowercase letters.

18-POINT GARAMOND, 6-POINT LEADED

Other popular
Old Style typefaces.

ABCDEFGHIJKLMNOPQRSTUVWXYZ
abcdefghijklmnopqrstuvwxyz
BEMBO

ABCDEFGHIJKLMNOPQRSTUVWXYZ
abcdefghijklmnopqrstuvwxyz
CENTAUR

ABCDEFGHIJKLMNOPQRSTUVWXYZ
abcdefghijklmnopqrstuvwxyz
GALLIARD

ABCDEFGHIJKLMNOPQRSTUVWXYZ
abcdefghijklmnopqrstuvwxyz
PLANTIN

ABCDEFGHIJKLMNOPQRSTUVWXYZ
abcdefghijklmnopqrstuvwxyz
SABON

ABCDEFGHIJKL
MNOPQRSTUV
WXYZ&

abcdefghijklmn
opqrstuvwxyz

1234567890

LINING FIGURES

1234567890

OLD STYLE FIGURES

ﬀ ﬃ ﬁ ﬀ ﬂ ﬀ ﬃ ﬃ ﬁ ﬃ

LIGATURES

. , ' ' ` - : ; ! ?

PUNCTUATION

ABCDEFGHIJKL
MNOPQRSTUV
WXYZ&

abcdefghijklmn
opqrstuvwxyz

1234567890
LINING FIGURES

1234567890
OLD STYLE FIGURES

ff ffi fl fl ffl ffi ffl *., '' - .:,!?*

LIGATURES PUNCTUATION

60-POINT GARAMOND

ABCDEFGHIJKL
MNOPQRSTUV
WXYZ&abcdefghi
jklmnopqrstuvwxyz
1234567890.,"-:;!?

60-POINT GARAMOND ITALIC

ABCDEFGHIJKL
MNOPQRSTUV
WXYZ&abcdefghij
klmnopqrstuvwxyz
1234567890.,"-:;!?

ABCDEFGHIJKLMN
OPQRSTUVWXYZ&
abcdefghijklmnopqrstuv
wxyz1234567890.,"-:;!?

ABCDEFGHIJKLMN
OPQRSTUVWXYZ&
abcdefghijklmnopqrstuvw
xyz1234567890.,"-:;!?

ABCDEFGHIJKLMNOPQRS
TUVWXYZ&abcdefghijklmno
pqrstuvwxyz1234567890.,"-:;!?

ABCDEFGHIJKLMNOPQRS
TUVWXYZ&abcdefghijklmnop
qrstuvwxyz1234567890.,"-:;!?

30-POINT GARAMOND

ABCDEFGHIJKLMNOPQRSTUV
WXYZ&abcdefghijklmnopqrstuvwxyz
1234567890.,"'-:;!?

30-POINT GARAMOND ITALIC

*ABCDEFGHIJKLMNOPQRSTUVW
XYZ&abcdefghijklmnopqrstuvwxyz
1234567890.,"'-:;!?*

24-POINT GARAMOND

ABCDEFGHIJKLMNOPQRSTUVWXYZ&
abcdefghijklmnopqrstuvwxyz
1234567890.,"'-:;!?

24-POINT GARAMOND ITALIC

*ABCDEFGHIJKLMNOPQRSTUVWXYZ&
abcdefghijklmnopqrstuvwxyz
1234567890.,"'-:;!?*

18-POINT GARAMOND

ABCDEFGHIJKLMNOPQRSTUVWXYZ&
abcdefghijklmnopqrstuvwxyz
1234567890.,"'-:;!?

18-POINT GARAMOND ITALIC

*ABCDEFGHIJKLMNOPQRSTUVWXYZ&
abcdefghijklmnopqrstuvwxyz
1234567890.,"'-:;!?*

I am the voice of today, the herald of tomorrow. I am type! Of my earliest ances try neither history nor relics remain. The wedge-shaped symbols impressed in plastic clay by Babylonian builders in the dim past, foreshadowed me: from th em, on through the hieroglyphs of the ancient Egyptians, down to the beautiful manuscript letters of the medieval scribes, I was in the making. The ingenious JOHANNES GUTENBERG—with a dream most golden—first applied the princi *ple of casting me in metal, the profound art of printing with movable types was born*

MINUS LEADING 14/13

I am the voice of today, the herald of tomorrow. I am type! Of my earliest ances try neither history nor relics remain. The wedge-shaped symbols impressed in plastic clay by Babylonian builders in the dim past, foreshadowed me: from th em, on through the hieroglyphs of the ancient Egyptians, down to the beautiful manuscript letters of the medieval scribes, I was in the making. The ingenious JOHANNES GUTENBERG—with a dream most golden—first applied the princi *ple of casting me in metal, the profound art of printing with movable types was born*

SOLID 14/14

I am the voice of today, the herald of tomorrow. I am type! Of my earliest ances try neither history nor relics remain. The wedge-shaped symbols impressed in plastic clay by Babylonian builders in the dim past, foreshadowed me: from th em, on through the hieroglyphs of the ancient Egyptians, down to the beautiful manuscript letters of the medieval scribes, I was in the making. The ingenious JOHANNES GUTENBERG—with a dream most golden—first applied the princi *ple of casting me in metal, the profound art of printing with movable types was born*

1-POINT LEADED 14/15

I am the voice of today, the herald of tomorrow. I am type! Of my earliest ances try neither history nor relics remain. The wedge-shaped symbols impressed in plastic clay by Babylonian builders in the dim past, foreshadowed me: from th em, on through the hieroglyphs of the ancient Egyptians, down to the beautiful manuscript letters of the medieval scribes, I was in the making. The ingenious JOHANNES GUTENBERG—with a dream most golden—first applied the princi *ple of casting me in metal, the profound art of printing with movable types was born*

2-POINT LEADED 14/16

I am the voice of today, the herald of tomorrow. I am type! Of my earliest ances try neither history nor relics remain. The wedge-shaped symbols impressed in plastic clay by Babylonian builders in the dim past, foreshadowed me: from th em, on through the hieroglyphs of the ancient Egyptians, down to the beautiful manuscript letters of the medieval scribes, I was in the making. The ingenious JOHANNES GUTENBERG—with a dream most golden—first applied the princi *ple of casting me in metal, the profound art of printing with movable types was born*

4-POINT LEADED 14/18

RECOMMENDED LINELENGTH

1	2	3	4	5	6	7	8	9	10	11	12	13	14	15	16	17	18	19	20	21	22	23	24	25	26	27	28	29	30	31	32	33	34	35	36	LINE IN PICAS
2	4	7	9	11	13	15	18	20	22	24	26	28	31	33	35	37	39	41	44	46	48	50	52	52	56	59	61	63	65	67	69	72	74	76	78	CHARACTERS PER PICA

APPROXIMATELY 2.2 CHARACTERS PER PICA

12 Point Garamond

MINUS LEADING 12/11

I am the voice of today, the herald of tomorrow. I am type! Of my earliest ancestry neither history nor relics remain. The wedge-shaped symbols impressed in plastic clay by Babylonian builders in the dim past, foreshadowed me: from them, on through the hieroglyphs of the ancient Egyptians, down to the beautiful manuscript letters of the medieval scribes, I was in the making. The ingenious JOHANNES GUTENBERG—with a dream most golden—first applied the principle of casting me in metal, the profound art of printing with movable types was born. Cold, rigid, and implacable I may be, yet the first impress of my face brought the divine word *to countless thousands. I bring into the light of the day the precious stores of knowledge and wisdom*

SOLID 12/12

I am the voice of today, the herald of tomorrow. I am type! Of my earliest ancestry neither history nor relics remain. The wedge-shaped symbols impressed in plastic clay by Babylonian builders in the dim past, foreshadowed me: from them, on through the hieroglyphs of the ancient Egyptians, down to the beautiful manuscript letters of the medieval scribes, I was in the making. The ingenious JOHANNES GUTENBERG—with a dream most golden—first applied the principle of casting me in metal, the profound art of printing with movable types was born. Cold, rigid, and implacable I may be, yet the first impress of my face brought the divine word *to countless thousands. I bring into the light of the day the precious stores of knowledge and wisdom*

1-POINT LEADED 12/13

I am the voice of today, the herald of tomorrow. I am type! Of my earliest ancestry neither history nor relics remain. The wedge-shaped symbols impressed in plastic clay by Babylonian builders in the dim past, foreshadowed me: from them, on through the hieroglyphs of the ancient Egyptians, down to the beautiful manuscript letters of the medieval scribes, I was in the making. The ingenious JOHANNES GUTENBERG—with a dream most golden—first applied the principle of casting me in metal, the profound art of printing with movable types was born. Cold, rigid, and implacable I may be, yet the first impress of my face brought the divine word *to countless thousands. I bring into the light of the day the precious stores of knowledge and wisdom*

2-POINT LEADED 12/14

I am the voice of today, the herald of tomorrow. I am type! Of my earliest ancestry neither history nor relics remain. The wedge-shaped symbols impressed in plastic clay by Babylonian builders in the dim past, foreshadowed me: from them, on through the hieroglyphs of the ancient Egyptians, down to the beautiful manuscript letters of the medieval scribes, I was in the making. The ingenious JOHANNES GUTENBERG—with a dream most golden—first applied the principle of casting me in metal, the profound art of printing with movable types was born. Cold, rigid, and implacable I may be, yet the first impress of my face brought the divine word *to countless thousands. I bring into the light of the day the precious stores of knowledge and wisdom*

4-POINT LEADED 12/16

I am the voice of today, the herald of tomorrow. I am type! Of my earliest ancestry neither history nor relics remain. The wedge-shaped symbols impressed in plastic clay by Babylonian builders in the dim past, foreshadowed me: from them, on through the hieroglyphs of the ancient Egyptians, down to the beautiful manuscript letters of the medieval scribes, I was in the making. The ingenious JOHANNES GUTENBERG—with a dream most golden—first applied the principle of casting me in metal, the profound art of printing with movable types was born. Cold, rigid, and implacable I may be, yet the first impress of my face brought the divine word *to countless thousands. I bring into the light of the day the precious stores of knowledge and wisdom*

RECOMMENDED LINELENGTH

LINE IN PICAS	1	2	3	4	5	6	7	8	9	10	11	12	13	**14**	**15**	**16**	**17**	**18**	**19**	**20**	**21**	**22**	**23**	**24**	**25**	**26**	**27**	**28**	**29**	**30**	31	32	33	34	35	36
CHARACTERS PER PICA	3	6	8	10	13	15	18	20	23	25	28	30	33	**35**	**37**	**40**	**42**	**45**	**47**	**50**	**52**	**55**	**57**	**60**	**62**	**65**	**67**	**70**	**72**	**75**	77	80	82	85	87	90

APPROXIMATELY 2.5 CHARACTERS PER PICA

11 Point Garamond

I am the voice of today, the herald of tomorrow. I am type! Of my earliest ancestry neither history nor relics remain. The wedge-shaped symbols that were impressed in plastic clay by Babylonian builders in the dim past, foreshadowed me: from them, on through the hieroglyphs of the ancient Egyptians down to the beautiful manuscript letters of the medieval scribes, I was in the making. The ingenious JOHANNES GUTENBERG—with a dream most golden—first applied the principle of casting me in metal, the profound art of printing with movable types was born. Cold, rigid, and implacable I may be, yet the first impress of my face brought the divine word to countless thousands. I bring into the *light of the day the precious stores of knowledge and wisdom long hidden in the grave of ignorance. I coin*

MINUS LEADING 11/10

I am the voice of today, the herald of tomorrow. I am type! Of my earliest ancestry neither history nor relics remain. The wedge-shaped symbols that were impressed in plastic clay by Babylonian builders in the dim past, foreshadowed me: from them, on through the hieroglyphs of the ancient Egyptians down to the beautiful manuscript letters of the medieval scribes, I was in the making. The ingenious JOHANNES GUTENBERG—with a dream most golden—first applied the principle of casting me in metal, the profound art of printing with movable types was born. Cold, rigid, and implacable I may be, yet the first impress of my face brought the divine word to countless thousands. I bring into the *light of the day the precious stores of knowledge and wisdom long hidden in the grave of ignorance. I coin*

SOLID 11/11

I am the voice of today, the herald of tomorrow. I am type! Of my earliest ancestry neither history nor relics remain. The wedge-shaped symbols that were impressed in plastic clay by Babylonian builders in the dim past, foreshadowed me: from them, on through the hieroglyphs of the ancient Egyptians down to the beautiful manuscript letters of the medieval scribes, I was in the making. The ingenious JOHANNES GUTENBERG—with a dream most golden—first applied the principle of casting me in metal, the profound art of printing with movable types was born. Cold, rigid, and implacable I may be, yet the first impress of my face brought the divine word to countless thousands. I bring into the *light of the day the precious stores of knowledge and wisdom long hidden in the grave of ignorance. I coin*

1-POINT LEADED 11/12

I am the voice of today, the herald of tomorrow. I am type! Of my earliest ancestry neither history nor relics remain. The wedge-shaped symbols that were impressed in plastic clay by Babylonian builders in the dim past, foreshadowed me: from them, on through the hieroglyphs of the ancient Egyptians down to the beautiful manuscript letters of the medieval scribes, I was in the making. The ingenious JOHANNES GUTENBERG—with a dream most golden—first applied the principle of casting me in metal, the profound art of printing with movable types was born. Cold, rigid, and implacable I may be, yet the first impress of my face brought the divine word to countless thousands. I bring into the *light of the day the precious stores of knowledge and wisdom long hidden in the grave of ignorance. I coin*

2-POINT LEADED 11/13

I am the voice of today, the herald of tomorrow. I am type! Of my earliest ancestry neither history nor relics remain. The wedge-shaped symbols that were impressed in plastic clay by Babylonian builders in the dim past, foreshadowed me: from them, on through the hieroglyphs of the ancient Egyptians down to the beautiful manuscript letters of the medieval scribes, I was in the making. The ingenious JOHANNES GUTENBERG—with a dream most golden—first applied the principle of casting me in metal, the profound art of printing with movable types was born. Cold, rigid, and implacable I may be, yet the first impress of my face brought the divine word to countless thousands. I bring into the *light of the day the precious stores of knowledge and wisdom long hidden in the grave of ignorance. I coin*

4-POINT LEADED 11/15

RECOMMENDED LINELENGTH

1	2	3	4	5	6	7	8	9	10	11	12	**13**	**14**	**15**	**16**	**17**	**18**	**19**	**20**	**21**	**22**	**23**	**24**	**25**	**26**	**27**	28	29	30	31	32	33	34	35	36	LINE IN PICAS
3	6	8	11	14	17	19	22	25	28	30	33	**36**	**38**	**41**	**44**	**47**	**49**	**52**	**55**	**58**	**60**	**63**	**66**	**68**	**71**	**74**	77	79	82	85	88	90	93	96	99	CHARACTERS PER PICA

APPROXIMATELY 2.7 CHARACTERS PER PICA

10 Point Garamond

MINUS LEADING 10/9

I am the voice of today, the herald of tomorrow. I am type! Of my earliest ancestry neither history nor relics remain. The wedge-shaped symbols impressed in plastic clay by Babylonian builders in the dim past, foresha dowed me: from them, on through the hieroglyphs of the ancient Egyptians, down to the beautiful manuscript letters of the medieval scribes, I was in the making. The ingenious JOHANNES GUTENBERG—with a dream most golden—first applied the principle of casting me in metal, the profound art of printing with movable types was born. Cold, rigid, and implacable I may be, yet the first impress of my face brought the divine word to countless thousands. I bring into the light of the day the precious stores of knowledge and wisdom long hidden in the grave of ignorance. I coin for you the enchanting tale, the philosopher's moralizing, and the poet's phantasies; I *enable you to exchange the irksome hours that come, at times, to every one, for sweet and happy hours with books—go*

SOLID 10/10

I am the voice of today, the herald of tomorrow. I am type! Of my earliest ancestry neither history nor relics remain. The wedge-shaped symbols impressed in plastic clay by Babylonian builders in the dim past, foresha dowed me: from them, on through the hieroglyphs of the ancient Egyptians, down to the beautiful manuscript letters of the medieval scribes, I was in the making. The ingenious JOHANNES GUTENBERG—with a dream most golden—first applied the principle of casting me in metal, the profound art of printing with movable types was born. Cold, rigid, and implacable I may be, yet the first impress of my face brought the divine word to countless thousands. I bring into the light of the day the precious stores of knowledge and wisdom long hidden in the grave of ignorance. I coin for you the enchanting tale, the philosopher's moralizing, and the poet's phantasies; I *enable you to exchange the irksome hours that come, at times, to every one, for sweet and happy hours with books—go*

1-POINT LEADED 10/11

I am the voice of today, the herald of tomorrow. I am type! Of my earliest ancestry neither history nor relics remain. The wedge-shaped symbols impressed in plastic clay by Babylonian builders in the dim past, foresha dowed me: from them, on through the hieroglyphs of the ancient Egyptians, down to the beautiful manuscript letters of the medieval scribes, I was in the making. The ingenious JOHANNES GUTENBERG—with a dream most golden—first applied the principle of casting me in metal, the profound art of printing with movable types was born. Cold, rigid, and implacable I may be, yet the first impress of my face brought the divine word to countless thousands. I bring into the light of the day the precious stores of knowledge and wisdom long hidden in the grave of ignorance. I coin for you the enchanting tale, the philosopher's moralizing, and the poet's phantasies; I *enable you to exchange the irksome hours that come, at times, to every one, for sweet and happy hours with books—go*

2-POINT LEADED 10/12

I am the voice of today, the herald of tomorrow. I am type! Of my earliest ancestry neither history nor relics remain. The wedge-shaped symbols impressed in plastic clay by Babylonian builders in the dim past, foresha dowed me: from them, on through the hieroglyphs of the ancient Egyptians, down to the beautiful manuscript letters of the medieval scribes, I was in the making. The ingenious JOHANNES GUTENBERG—with a dream most golden—first applied the principle of casting me in metal, the profound art of printing with movable types was born. Cold, rigid, and implacable I may be, yet the first impress of my face brought the divine word to countless thousands. I bring into the light of the day the precious stores of knowledge and wisdom long hidden in the grave of ignorance. I coin for you the enchanting tale, the philosopher's moralizing, and the poet's phantasies; I *enable you to exchange the irksome hours that come, at times, to every one, for sweet and happy hours with books—go*

4-POINT LEADED 10/14

I am the voice of today, the herald of tomorrow. I am type! Of my earliest ancestry neither history nor relics remain. The wedge-shaped symbols impressed in plastic clay by Babylonian builders in the dim past, foresha dowed me: from them, on through the hieroglyphs of the ancient Egyptians, down to the beautiful manuscript letters of the medieval scribes, I was in the making. The ingenious JOHANNES GUTENBERG—with a dream most golden—first applied the principle of casting me in metal, the profound art of printing with movable types was born. Cold, rigid, and implacable I may be, yet the first impress of my face brought the divine word to countless thousands. I bring into the light of the day the precious stores of knowledge and wisdom long hidden in the grave of ignorance. I coin for you the enchanting tale, the philosopher's moralizing, and the poet's phantasies; I *enable you to exchange the irksome hours that come, at times, to every one, for sweet and happy hours with books—go*

RECOMMENDED LINELENGTH

LINE IN PICAS	1	2	3	4	5	6	7	8	9	10	11	12	13	14	15	16	17	18	19	20	21	22	23	24	25	26	27	28	29	30	31	32	33	34	35	36
CHARACTERS PER PICA	3	6	9	12	15	17	21	24	27	30	33	36	39	42	45	48	50	53	56	59	62	65	68	71	74	77	80	83	86	89	92	95	98	101	104	107

APPROXIMATELY 3.0 CHARACTERS PER PICA

9 Point Garamond

MINUS LEADING 9/8

I am the voice of today, the herald of tomorrow. I am type! Of my earliest ancestry neither history nor relics remain. The wedge-shaped symbols impressed in plastic clay by Babylonian builders in the dim past, foreshadowed me: from them, on through the hieroglyphs of the ancient Egyptians, down to the beautiful manuscript letters of the medieval scribes, I was in the making. The ingenious JOHANNES GUTENBERG—with a dream most golden—first applied the principle of casting me in metal, the profound art of printing with movable types was born. Cold, rigid, and implacable I may be, yet the first impress of my face brought the divine word to countless thousands. I bring into the light of the day the precious stores of knowledge and wisdom long hidden in the grave of ignorance. I coin for you the enchanting tale, the philosopher's moralizing, and the poet's phantasies, I enable you to exchange the irksome hours that come, at times, to everyone, for sweet and happy hours *with books—golden urns filled with all the manna of the past. In books, I present to you a portion of the eternal mind caught in*

SOLID 9/9

I am the voice of today, the herald of tomorrow. I am type! Of my earliest ancestry neither history nor relics remain. The wedge-shaped symbols impressed in plastic clay by Babylonian builders in the dim past, foreshadowed me: from them, on through the hieroglyphs of the ancient Egyptians, down to the beautiful manuscript letters of the medieval scribes, I was in the making. The ingenious JOHANNES GUTENBERG—with a dream most golden—first applied the principle of casting me in metal, the profound art of printing with movable types was born. Cold, rigid, and implacable I may be, yet the first impress of my face brought the divine word to countless thousands. I bring into the light of the day the precious stores of knowledge and wisdom long hidden in the grave of ignorance. I coin for you the enchanting tale, the philosopher's moralizing, and the poet's phantasies, I enable you to exchange the irksome hours that come, at times, to everyone, for sweet and happy hours *with books—golden urns filled with all the manna of the past. In books, I present to you a portion of the eternal mind caught in*

1-POINT LEADED 9/10

I am the voice of today, the herald of tomorrow. I am type! Of my earliest ancestry neither history nor relics remain. The wedge-shaped symbols impressed in plastic clay by Babylonian builders in the dim past, foreshadowed me: from them, on through the hieroglyphs of the ancient Egyptians, down to the beautiful manuscript letters of the medieval scribes, I was in the making. The ingenious JOHANNES GUTENBERG—with a dream most golden—first applied the principle of casting me in metal, the profound art of printing with movable types was born. Cold, rigid, and implacable I may be, yet the first impress of my face brought the divine word to countless thousands. I bring into the light of the day the precious stores of knowledge and wisdom long hidden in the grave of ignorance. I coin for you the enchanting tale, the philosopher's moralizing, and the poet's phantasies, I enable you to exchange the irksome hours that come, at times, to everyone, for sweet and happy hours *with books—golden urns filled with all the manna of the past. In books, I present to you a portion of the eternal mind caught in*

2-POINT LEADED 9/11

I am the voice of today, the herald of tomorrow. I am type! Of my earliest ancestry neither history nor relics remain. The wedge-shaped symbols impressed in plastic clay by Babylonian builders in the dim past, foreshadowed me: from them, on through the hieroglyphs of the ancient Egyptians, down to the beautiful manuscript letters of the medieval scribes, I was in the making. The ingenious JOHANNES GUTENBERG—with a dream most golden—first applied the principle of casting me in metal, the profound art of printing with movable types was born. Cold, rigid, and implacable I may be, yet the first impress of my face brought the divine word to countless thousands. I bring into the light of the day the precious stores of knowledge and wisdom long hidden in the grave of ignorance. I coin for you the enchanting tale, the philosopher's moralizing, and the poet's phantasies, I enable you to exchange the irksome hours that come, at times, to everyone, for sweet and happy hours *with books—golden urns filled with all the manna of the past. In books, I present to you a portion of the eternal mind caught in*

4-POINT LEADED 9/13

I am the voice of today, the herald of tomorrow. I am type! Of my earliest ancestry neither history nor relics remain. The wedge-shaped symbols impressed in plastic clay by Babylonian builders in the dim past, foreshadowed me: from them, on through the hieroglyphs of the ancient Egyptians, down to the beautiful manuscript letters of the medieval scribes, I was in the making. The ingenious JOHANNES GUTENBERG—with a dream most golden—first applied the principle of casting me in metal, the profound art of printing with movable types was born. Cold, rigid, and implacable I may be, yet the first impress of my face brought the divine word to countless thousands. I bring into the light of the day the precious stores of knowledge and wisdom long hidden in the grave of ignorance. I coin for you the enchanting tale, the philosopher's moralizing, and the poet's phantasies, I enable you to exchange the irksome hours that come, at times, to everyone, for sweet and happy hours *with books—golden urns filled with all the manna of the past. In books, I present to you a portion of the eternal mind caught in*

RECOMMENDED LINELENGTH

1	2	3	4	5	6	7	8	9	10	**11**	**12**	**13**	**14**	**15**	**16**	**17**	**18**	**19**	**20**	**21**	**22**	23	24	25	26	27	28	29	30	31	32	33	34	35	36	LINE IN PICAS
4	7	10	14	17	20	24	27	30	34	**37**	**40**	**44**	**47**	**50**	**54**	**57**	**60**	**64**	**67**	**71**	**74**	77	81	84	87	91	94	97	101	104	107	111	114	117	121	CHARACTERS PER PICA

APPROXIMATELY 3.3 CHARACTERS PER PICA

8 and 7 Point Garamond

MINUS LEADING

I am the voice of today, the herald of tomorrow. I am type! Of my ear liest ances try neither history nor relics remain. The wedge-shaped sy mbols impressed in plastic clay by Babylonian builders in the dim past, foreshadowed me: from them, on through the hieroglyphs of the anc ient Egyptians, down to the beautiful manuscript letters of the med ieval scribes, I was in the making. The ingenious JOHANNES GUTEN BERG—with a dream most golden—first applied the principle of cast ing me in metal, the profound art of printing with movable types was born. Cold, rigid, and implacable I may be, yet the first impress of my *face brought the divine word to countless thousands. I bring into the light*
8/7

I am the voice of today, the herald of tomorrow. I am type! Of my earliest ances try neither history nor relics remain. The wedge-shaped symbols impressed in plastic clay by Babylonian builders in the dim past foreshadowed me: from them, on through the hieroglyphs of the ancient Egyptians, down to the beau tiful manuscript letters of the medieval scribes, I was in the making. The ingen ious JOHANNES GUTENBERG—with a dream most golden—first applied the prin ciple of casting me in metal, the profound art of printing with movable types was born. Cold, rigid, and implacable I may be, yet the first impress of my face brought the divine word to countless thousands. I bring into the light of the day the precious stores of knowledge and wisdom long hidden in the grave of *ignorance. I coin for you the enchanting tale, the philosopher's moralizing, and the*
7/6

SOLID

I am the voice of today, the herald of tomorrow. I am type! Of my ear liest ances try neither history nor relics remain. The wedge-shaped sy mbols impressed in plastic clay by Babylonian builders in the dim past, foreshadowed me: from them, on through the hieroglyphs of the anc ient Egyptians, down to the beautiful manuscript letters of the med ieval scribes, I was in the making. The ingenious JOHANNES GUTEN BERG—with a dream most golden—first applied the principle of cast ing me in metal, the profound art of printing with movable types was born. Cold, rigid, and implacable I may be, yet the first impress of my *face brought the divine word to countless thousands. I bring into the light*
8/8

I am the voice of today, the herald of tomorrow. I am type! Of my earliest ances try neither history nor relics remain. The wedge-shaped symbols impressed in plastic clay by Babylonian builders in the dim past foreshadowed me: from them, on through the hieroglyphs of the ancient Egyptians, down to the beau tiful manuscript letters of the medieval scribes, I was in the making. The ingen ious JOHANNES GUTENBERG—with a dream most golden—first applied the prin ciple of casting me in metal, the profound art of printing with movable types was born. Cold, rigid, and implacable I may be, yet the first impress of my face brought the divine word to countless thousands. I bring into the light of the day the precious stores of knowledge and wisdom long hidden in the grave of *ignorance. I coin for you the enchanting tale, the philosopher's moralizing, and the*
7/7

1-POINT LEADED

I am the voice of today, the herald of tomorrow. I am type! Of my ear liest ances try neither history nor relics remain. The wedge-shaped sy mbols impressed in plastic clay by Babylonian builders in the dim past, foreshadowed me: from them, on through the hieroglyphs of the anc ient Egyptians, down to the beautiful manuscript letters of the med ieval scribes, I was in the making. The ingenious JOHANNES GUTEN BERG—with a dream most golden—first applied the principle of cast ing me in metal, the profound art of printing with movable types was born. Cold, rigid, and implacable I may be, yet the first impress of my *face brought the divine word to countless thousands. I bring into the light*
8/9

I am the voice of today, the herald of tomorrow. I am type! Of my earliest ances try neither history nor relics remain. The wedge-shaped symbols impressed in plastic clay by Babylonian builders in the dim past foreshadowed me: from them, on through the hieroglyphs of the ancient Egyptians, down to the beau tiful manuscript letters of the medieval scribes, I was in the making. The ingen ious JOHANNES GUTENBERG—with a dream most golden—first applied the prin ciple of casting me in metal, the profound art of printing with movable types was born. Cold, rigid, and implacable I may be, yet the first impress of my face brought the divine word to countless thousands. I bring into the light of the day the precious stores of knowledge and wisdom long hidden in the grave of *ignorance. I coin for you the enchanting tale, the philosopher's moralizing, and the*
7/8

2-POINT LEADED

I am the voice of today, the herald of tomorrow. I am type! Of my ear liest ances try neither history nor relics remain. The wedge-shaped sy mbols impressed in plastic clay by Babylonian builders in the dim past, foreshadowed me: from them, on through the hieroglyphs of the anc ient Egyptians, down to the beautiful manuscript letters of the med ieval scribes, I was in the making. The ingenious JOHANNES GUTEN BERG—with a dream most golden—first applied the principle of cast ing me in metal, the profound art of printing with movable types was born. Cold, rigid, and implacable I may be, yet the first impress of my *face brought the divine word to countless thousands. I bring into the light*
8/10

I am the voice of today, the herald of tomorrow. I am type! Of my earliest ances try neither history nor relics remain. The wedge-shaped symbols impressed in plastic clay by Babylonian builders in the dim past foreshadowed me: from them, on through the hieroglyphs of the ancient Egyptians, down to the beau tiful manuscript letters of the medieval scribes, I was in the making. The ingen ious JOHANNES GUTENBERG—with a dream most golden—first applied the prin ciple of casting me in metal, the profound art of printing with movable types was born. Cold, rigid, and implacable I may be, yet the first impress of my face brought the divine word to countless thousands. I bring into the light of the day the precious stores of knowledge and wisdom long hidden in the grave of *ignorance. I coin for you the enchanting tale, the philosopher's moralizing, and the*
7/9

4-POINT LEADED

I am the voice of today, the herald of tomorrow. I am type! Of my ear liest ances try neither history nor relics remain. The wedge-shaped sy mbols impressed in plastic clay by Babylonian builders in the dim past, foreshadowed me: from them, on through the hieroglyphs of the anc ient Egyptians, down to the beautiful manuscript letters of the med ieval scribes, I was in the making. The ingenious JOHANNES GUTEN BERG—with a dream most golden—first applied the principle of cast ing me in metal, the profound art of printing with movable types was born. Cold, rigid, and implacable I may be, yet the first impress of my *face brought the divine word to countless thousands. I bring into the light*
8/12

I am the voice of today, the herald of tomorrow. I am type! Of my earliest ances try neither history nor relics remain. The wedge-shaped symbols impressed in plastic clay by Babylonian builders in the dim past foreshadowed me: from them, on through the hieroglyphs of the ancient Egyptians, down to the beau tiful manuscript letters of the medieval scribes, I was in the making. The ingen ious JOHANNES GUTENBERG—with a dream most golden—first applied the prin ciple of casting me in metal, the profound art of printing with movable types was born. Cold, rigid, and implacable I may be, yet the first impress of my face brought the divine word to countless thousands. I bring into the light of the day the precious stores of knowledge and wisdom long hidden in the grave of *ignorance. I coin for you the enchanting tale, the philosopher's moralizing, and the*
7/11

RECOMMENDED LINELENGTH

LINE IN PICAS	1	2	3	4	5	6	7	8	9	10	11	12	13	14	15	16	17	18
CHARACTERS PER PICA	4	8	12	15	19	23	27	31	34	38	42	46	50	53	57	61	65	69

APPROXIMATELY 3.8 CHARACTERS PER PICA

RECOMMENDED LINELENGTH

LINE IN PICAS	1	2	3	4	5	6	7	8	9	10	11	12	13	14	15	16	17	18
CHARACTERS PER PICA	5	9	13	17	21	26	30	35	39	43	47	52	56	60	64	69	73	77

APPROXIMATELY 4.3 CHARACTERS PER PICA

Baskerville

Baskerville, an elegant, well-designed typeface created by the Englishman John Baskerville in 1757, is an excellent example of a Transitional typeface. Transitional typefaces are so called because they form a bridge between the Old Style and the Modern face. Compared to the Old Style, Baskerville shows greater contrast between the thicks and thins, serifs are less heavily bracketed, and the stress is almost vertical. The letters are very wide for their x-height, are closely fitted, and are of excellent proportions—making Baskerville one of the most pleasant and readable typefaces.

18-POINT BASKERVILLE, 6-POINT LEADED

Other well-drawn
Transitional typefaces.

ABCDEFGHIJKLMNOPQRSTUVWXYZ
abcdefghijklmnopqrstuvwxyz
COCHIN

ABCDEFGHIJKLMNOPQRSTUVWXYZ
abcdefghijklmnopqrstuvwxyz
STONE SERIF

ABCDEFGHIJKLMNOPQRSTUVWXYZ
abcdefghijklmnopqrstuvwxyz
VELJOVIC

ABCDEFGHIJKLMNOPQRSTUVWXYZ
abcdefghijklmnopqrstuvwxyz
PERPETUA

ABCDEFGHIJKLMNOPQRSTUVWXYZ
abcdefghijklmnopqrstuvwxyz
TIMES ROMAN

ABCDEFGHIJKL
MNOPQRSTUV
WXYZ&
abcdefghijklmn
opqrstuvwxyz
1234567890

LINING FIGURES

fi fl .,''-:;!?

LIGATURES

PUNCTUATION

ABCDEFGHIJKL

MNOPQRSTUV

WXYZ&

abcdefghijklmn

opqrstuvwxyz

1234567890

LINING FIGURES

fi fl . , ' ' - : ; ! ?

LIGATURES PUNCTUATION

ABCDEFGHIJKL
MNOPQRSTUV
WXYZ&abcdefgh
ijklmnopqrstuvwx
yz1234567890.,"-:;!?

ABCDEFGHIJKL
MNOPQRSTUV
WXYZ&abcdefghij
klmnopqrstuvwxyz
1234567890.,"-:;!?

ABCDEFGHIJKLMN
OPQRSTUVWXYZ&
abcdefghijklmnopqrstu
vwxyz1234567890.,"-:;!?

*ABCDEFGHIJKLMN
OPQRSTUVWXYZ&
abcdefghijklmnopqrstuv
wxyz1234567890.,"-:;!?*

ABCDEFGHIJKLMNOPQRS
TUVWXYZ&abcdefghijklmno
pqrstuvwxyz1234567890.,"-:;!?

*ABCDEFGHIJKLMNOPQRS
TUVWXYZ&abcdefghijklmno
pqrstuvwxyz1234567890.,"-:;!?*

30-POINT BASKERVILLE

ABCDEFGHIJKLMNOPQRSTUV
WXYZ&abcdefghijklmnopqrstuvw
xyz1234567890.,''-:;!?

30-POINT BASKERVILLE ITALIC

*ABCDEFGHIJKLMNOPQRSTUVW
XYZ&abcdefghijklmnopqrstuvwxyz
1234567890.,''-:;!?*

24-POINT BASKERVILLE

ABCDEFGHIJKLMNOPQRSTUVWXYZ&
abcdefghijklmnopqrstuvwxyz
1234567890.,''-:;!?

24-POINT BASKERVILLE ITALIC

*ABCDEFGHIJKLMNOPQRSTUVWXYZ&
abcdefghijklmnopqrstuvwxyz
1234567890.,''-:;!?*

18-POINT BASKERVILLE

ABCDEFGHIJKLMNOPQRSTUVWXYZ&
abcdefghijklmnopqrstuvwxyz
1234567890.,''-:;!?

18-POINT BASKERVILLE ITALIC

*ABCDEFGHIJKLMNOPQRSTUVWXYZ&
abcdefghijklmnopqrstuvwxyz
1234567890.,''-:;!?*

I am the voice of today, the herald of tomorrow. I am type! Of my ear
liest ancestry neither history nor relics remain. The wedge-shaped sym
bols impressed in plastic clay by Babylonian builders in the dim past,
foreshadowed me: from them, on through the hieroglyphs of the anci
ent Egyptians, down to the beautiful manuscript letters of the medieval
scribes, I was in the making. The ingenious JOHANNES GUTENBERG—
with a dream most golden—first applied the principle of casting me in metal,

MINUS LEADING 14/14

I am the voice of today, the herald of tomorrow. I am type! Of my ear
liest ancestry neither history nor relics remain. The wedge-shaped sym
bols impressed in plastic clay by Babylonian builders in the dim past,
foreshadowed me: from them, on through the hieroglyphs of the anci
ent Egyptians, down to the beautiful manuscript letters of the medieval
scribes, I was in the making. The ingenious JOHANNES GUTENBERG—
with a dream most golden—first applied the principle of casting me in metal,

SOLID 14/14

I am the voice of today, the herald of tomorrow. I am type! Of my ear
liest ancestry neither history nor relics remain. The wedge-shaped sym
bols impressed in plastic clay by Babylonian builders in the dim past,
foreshadowed me: from them, on through the hieroglyphs of the anci
ent Egyptians, down to the beautiful manuscript letters of the medieval
scribes, I was in the making. The ingenious JOHANNES GUTENBERG—
with a dream most golden—first applied the principle of casting me in metal,

1-POINT LEADED 14/15

I am the voice of today, the herald of tomorrow. I am type! Of my ear
liest ancestry neither history nor relics remain. The wedge-shaped sym
bols impressed in plastic clay by Babylonian builders in the dim past,
foreshadowed me: from them, on through the hieroglyphs of the anci
ent Egyptians, down to the beautiful manuscript letters of the medieval
scribes, I was in the making. The ingenious JOHANNES GUTENBERG—
with a dream most golden—first applied the principle of casting me in metal,

2-POINT LEADED 14/16

I am the voice of today, the herald of tomorrow. I am type! Of my ear
liest ancestry neither history nor relics remain. The wedge-shaped sym
bols impressed in plastic clay by Babylonian builders in the dim past,
foreshadowed me: from them, on through the hieroglyphs of the anci
ent Egyptians, down to the beautiful manuscript letters of the medieval
scribes, I was in the making. The ingenious JOHANNES GUTENBERG—
with a dream most golden—first applied the principle of casting me in metal,

4-POINT LEADED 14/18

RECOMMENDED LINELENGTH

1	2	3	4	5	6	7	8	9	10	11	12	13	14	15	16	17	18	19	20	21	22	23	24	25	26	27	28	29	30	31	32	33	34	35	36	LINE IN PICAS
2	4	6	8	10	12	14	16	17	19	21	23	25	27	29	31	33	35	37	38	40	42	44	46	48	50	52	54	56	57	59	61	63	65	67	69	CHARACTERS PER PICA

APPROXIMATELY 1.9 CHARACTERS PER PICA

MINUS LEADING 12/11

I am the voice of today, the herald of tomorrow. I am type! Of my earliest ancestry neither history nor relics remain. The wedge-shaped symbols impressed in plastic clay by Babylonian builders in the dim past, foreshadowed me: from them, on thro ugh the hieroglyphs of the ancient Egyptians, down to the beautiful manuscript letters of the medieval scribes, I was in the making. The ingenious JOHANNES GUTEN BERG—with a dream most golden—first applied the principle of casting me in metal, the profound art of printing with movable types was born. Cold, rigid, and *implacable I may be, yet the first impress of my face brought the divine word to countless thous*

SOLID 12/12

I am the voice of today, the herald of tomorrow. I am type! Of my earliest ancestry neither history nor relics remain. The wedge-shaped symbols impressed in plastic clay by Babylonian builders in the dim past, foreshadowed me: from them, on thro ugh the hieroglyphs of the ancient Egyptians, down to the beautiful manuscript letters of the medieval scribes, I was in the making. The ingenious JOHANNES GUTEN BERG—with a dream most golden—first applied the principle of casting me in metal, the profound art of printing with movable types was born. Cold, rigid, and *implacable I may be, yet the first impress of my face brought the divine word to countless thous*

1-POINT LEADED 12/13

I am the voice of today, the herald of tomorrow. I am type! Of my earliest ancestry neither history nor relics remain. The wedge-shaped symbols impressed in plastic clay by Babylonian builders in the dim past, foreshadowed me: from them, on thro ugh the hieroglyphs of the ancient Egyptians, down to the beautiful manuscript letters of the medieval scribes, I was in the making. The ingenious JOHANNES GUTEN BERG—with a dream most golden—first applied the principle of casting me in metal, the profound art of printing with movable types was born. Cold, rigid, and *implacable I may be, yet the first impress of my face brought the divine word to countless thous*

2-POINT LEADED 12/14

I am the voice of today, the herald of tomorrow. I am type! Of my earliest ancestry neither history nor relics remain. The wedge-shaped symbols impressed in plastic clay by Babylonian builders in the dim past, foreshadowed me: from them, on thro ugh the hieroglyphs of the ancient Egyptians, down to the beautiful manuscript letters of the medieval scribes, I was in the making. The ingenious JOHANNES GUTEN BERG—with a dream most golden—first applied the principle of casting me in metal, the profound art of printing with movable types was born. Cold, rigid, and *implacable I may be, yet the first impress of my face brought the divine word to countless thous*

4-POINT LEADED 12/16

I am the voice of today, the herald of tomorrow. I am type! Of my earliest ancestry neither history nor relics remain. The wedge-shaped symbols impressed in plastic clay by Babylonian builders in the dim past, foreshadowed me: from them, on thro ugh the hieroglyphs of the ancient Egyptians, down to the beautiful manuscript letters of the medieval scribes, I was in the making. The ingenious JOHANNES GUTEN BERG—with a dream most golden—first applied the principle of casting me in metal, the profound art of printing with movable types was born. Cold, rigid, and *implacable I may be, yet the first impress of my face brought the divine word to countless thous*

RECOMMENDED LINELENGTH

LINE IN PICAS	1	2	3	4	5	6	7	8	9	10	11	12	13	14	15	16	17	18	19	20	21	22	23	24	25	26	27	28	29	30	31	32	33	34	35	36
CHARACTERS PER PICA	3	5	7	9	11	14	16	18	20	23	25	27	29	32	34	36	38	41	43	45	47	50	52	54	56	59	61	63	65	67	70	72	74	76	79	81

APPROXIMATELY 2.2 CHARACTERS PER PICA

I am the voice of today, the herald of tomorrow. I am type! Of my earliest ancestry neither history nor relics remain. The wedge-shaped symbols impressed in plastic clay by Babyloni an builders in the dim past, foreshadowed me: from them, on through the hieroglyphs of the ancient Egyptians, down to the beautiful manuscript letters of the medieval scribes, I was in the making. The ingenious JOHANNES GUTENBERG—with a dream most golden—first applied the principle of casting me in metal, the profound art of printing with movable types was born. Cold, rigid, and implacable I may be, yet the first impress of my face *brought the divine word to countless thousands. I bring into the light of the day the precious stores of*

MINUS LEADING 11/10

I am the voice of today, the herald of tomorrow. I am type! Of my earliest ancestry neither history nor relics remain. The wedge-shaped symbols impressed in plastic clay by Babyloni an builders in the dim past, foreshadowed me: from them, on through the hieroglyphs of the ancient Egyptians, down to the beautiful manuscript letters of the medieval scribes, I was in the making. The ingenious JOHANNES GUTENBERG—with a dream most golden—first applied the principle of casting me in metal, the profound art of printing with movable types was born. Cold, rigid, and implacable I may be, yet the first impress of my face *brought the divine word to countless thousands. I bring into the light of the day the precious stores of*

SOLID 11/11

I am the voice of today, the herald of tomorrow. I am type! Of my earliest ancestry neither history nor relics remain. The wedge-shaped symbols impressed in plastic clay by Babyloni an builders in the dim past, foreshadowed me: from them, on through the hieroglyphs of the ancient Egyptians, down to the beautiful manuscript letters of the medieval scribes, I was in the making. The ingenious JOHANNES GUTENBERG—with a dream most golden—first applied the principle of casting me in metal, the profound art of printing with movable types was born. Cold, rigid, and implacable I may be, yet the first impress of my face *brought the divine word to countless thousands. I bring into the light of the day the precious stores of*

1-POINT LEADED 11/12

I am the voice of today, the herald of tomorrow. I am type! Of my earliest ancestry neither history nor relics remain. The wedge-shaped symbols impressed in plastic clay by Babyloni an builders in the dim past, foreshadowed me: from them, on through the hieroglyphs of the ancient Egyptians, down to the beautiful manuscript letters of the medieval scribes, I was in the making. The ingenious JOHANNES GUTENBERG—with a dream most golden—first applied the principle of casting me in metal, the profound art of printing with movable types was born. Cold, rigid, and implacable I may be, yet the first impress of my face *brought the divine word to countless thousands. I bring into the light of the day the precious stores of*

2-POINT LEADED 11/13

I am the voice of today, the herald of tomorrow. I am type! Of my earliest ancestry neither history nor relics remain. The wedge-shaped symbols impressed in plastic clay by Babyloni an builders in the dim past, foreshadowed me: from them, on through the hieroglyphs of the ancient Egyptians, down to the beautiful manuscript letters of the medieval scribes, I was in the making. The ingenious JOHANNES GUTENBERG—with a dream most golden—first applied the principle of casting me in metal, the profound art of printing with movable types was born. Cold, rigid, and implacable I may be, yet the first impress of my face *brought the divine word to countless thousands. I bring into the light of the day the precious stores of*

4-POINT LEADED 11/15

RECOMMENDED LINELENGTH

1	2	3	4	5	6	7	8	9	10	11	12	13	**14**	**15**	**16**	**17**	**18**	**19**	**20**	**21**	**22**	**23**	**24**	**25**	**26**	**27**	**28**	**29**	**30**	31	32	33	34	35	36		LINE IN PICAS
3	5	8	10	13	15	17	20	22	25	27	30	32	**35**	**37**	**39**	**42**	**44**	**47**	**49**	**52**	**54**	**57**	**59**	**61**	**64**	**66**	**69**	**71**	**74**	76	79	81	83	86	88		CHARACTERS PER PICA

APPROXIMATELY 2.4 CHARACTERS PER PICA

MINUS LEADING 10/9

I am the voice of today, the herald of tomorrow. I am type! Of my earliest ancestry neither history nor relics remain. The wedge-shaped symbols impressed in plastic clay by Babylonian builders in the dim past, foreshadowed me: from them, on through the hieroglyphs of the ancient Egyptians, down to the beautiful manuscript letters of the medieval scribes, I was in the making. The ingenious JOHANNES GUTENBERG—with a dream most golden—first applied the principle of casting me in me tal, the profound art of printing with movable types was born. Cold, rigid, and implacable I may be, yet the first impress of my face brought the divine word to countless thousands. I bring in to the light of the day the precious stores of knowledge and wisdom long hidden in the grave of ignorance. *I coin in the grave of ignorance. I coin for you the enchanting tale, the philosopher's moralizing, and the poet's*

SOLID 10/10

I am the voice of today, the herald of tomorrow. I am type! Of my earliest ancestry neither history nor relics remain. The wedge-shaped symbols impressed in plastic clay by Babylonian builders in the dim past, foreshadowed me: from them, on through the hieroglyphs of the ancient Egyptians, down to the beautiful manuscript letters of the medieval scribes, I was in the making. The ingenious JOHANNES GUTENBERG—with a dream most golden—first applied the principle of casting me in me tal, the profound art of printing with movable types was born. Cold, rigid, and implacable I may be, yet the first impress of my face brought the divine word to countless thousands. I bring in to the light of the day the precious stores of knowledge and wisdom long hidden in the grave of ignorance. *I coin in the grave of ignorance. I coin for you the enchanting tale, the philosopher's moralizing, and the poet's*

1-POINT LEADED 10/11

I am the voice of today, the herald of tomorrow. I am type! Of my earliest ancestry neither history nor relics remain. The wedge-shaped symbols impressed in plastic clay by Babylonian builders in the dim past, foreshadowed me: from them, on through the hieroglyphs of the ancient Egyptians, down to the beautiful manuscript letters of the medieval scribes, I was in the making. The ingenious JOHANNES GUTENBERG—with a dream most golden—first applied the principle of casting me in me tal, the profound art of printing with movable types was born. Cold, rigid, and implacable I may be, yet the first impress of my face brought the divine word to countless thousands. I bring in to the light of the day the precious stores of knowledge and wisdom long hidden in the grave of ignorance. *I coin in the grave of ignorance. I coin for you the enchanting tale, the philosopher's moralizing, and the poet's*

2-POINT LEADED 10/12

I am the voice of today, the herald of tomorrow. I am type! Of my earliest ancestry neither history nor relics remain. The wedge-shaped symbols impressed in plastic clay by Babylonian builders in the dim past, foreshadowed me: from them, on through the hieroglyphs of the ancient Egyptians, down to the beautiful manuscript letters of the medieval scribes, I was in the making. The ingenious JOHANNES GUTENBERG—with a dream most golden—first applied the principle of casting me in me tal, the profound art of printing with movable types was born. Cold, rigid, and implacable I may be, yet the first impress of my face brought the divine word to countless thousands. I bring in to the light of the day the precious stores of knowledge and wisdom long hidden in the grave of ignorance. *I coin in the grave of ignorance. I coin for you the enchanting tale, the philosopher's moralizing, and the poet's*

4-POINT LEADED 10/14

I am the voice of today, the herald of tomorrow. I am type! Of my earliest ancestry neither history nor relics remain. The wedge-shaped symbols impressed in plastic clay by Babylonian builders in the dim past, foreshadowed me: from them, on through the hieroglyphs of the ancient Egyptians, down to the beautiful manuscript letters of the medieval scribes, I was in the making. The ingenious JOHANNES GUTENBERG—with a dream most golden—first applied the principle of casting me in me tal, the profound art of printing with movable types was born. Cold, rigid, and implacable I may be, yet the first impress of my face brought the divine word to countless thousands. I bring in to the light of the day the precious stores of knowledge and wisdom long hidden in the grave of ignorance. *I coin in the grave of ignorance. I coin for you the enchanting tale, the philosopher's moralizing, and the poet's*

RECOMMENDED LINELENGTH

LINE IN PICAS	1	2	3	4	5	6	7	8	9	10	11	12	13	14	15	16	17	18	19	20	21	22	23	24	25	26	27	28	29	30	31	32	33	34	35	36
CHARACTERS PER PICA	3	6	8	11	14	16	19	22	24	27	30	32	35	38	40	43	46	48	50	54	56	59	62	64	67	70	72	75	78	80	83	86	88	91	94	97

APPROXIMATELY 2.7 CHARACTERS PER PICA

9 Point Baskerville

MINUS LEADING 9/8

I am the voice of today, the herald of tomorrow. I am type! Of my earliest ancestry neither history nor relics remain. The wedge-shaped symbols impressed in plastic clay by Babylonian builders in the dim past, foresha dowed me: from them, on through the hieroglyphs of the ancient Egyptians, down to the beautiful manuscript letters of the medieval scribes, I was in the making. The ingenious JOHANNES GUTENBERG—with a dream most golden—first applied the principle of casting me in metal, the profound art of printing with movable types was born. Cold, rigid, and implacable I may be, yet the first impress of my face brought the divine word to countless thousands. I bring into the light of the day the precious stores of knowledge and wisdom long hid den in the grave of ignorance. I coin for you the enchanting tale, the philosopher's moralizing, and the poet's phantasies, I enable you to exchange the irksome hours that come, at times, to everyone, for sweet and happy hours *with books—golden urns filled with all the manna of the past. In books, I present to you a portion of the eternal mind caught*

SOLID 9/9

I am the voice of today, the herald of tomorrow. I am type! Of my earliest ancestry neither history nor relics remain. The wedge-shaped symbols impressed in plastic clay by Babylonian builders in the dim past, foresha dowed me: from them, on through the hieroglyphs of the ancient Egyptians, down to the beautiful manuscript letters of the medieval scribes, I was in the making. The ingenious JOHANNES GUTENBERG—with a dream most golden—first applied the principle of casting me in metal, the profound art of printing with movable types was born. Cold, rigid, and implacable I may be, yet the first impress of my face brought the divine word to countless thousands. I bring into the light of the day the precious stores of knowledge and wisdom long hid den in the grave of ignorance. I coin for you the enchanting tale, the philosopher's moralizing, and the poet's phantasies, I enable you to exchange the irksome hours that come, at times, to everyone, for sweet and happy hours *with books—golden urns filled with all the manna of the past. In books, I present to you a portion of the eternal mind caught*

1-POINT LEADED 9/10

I am the voice of today, the herald of tomorrow. I am type! Of my earliest ancestry neither history nor relics remain. The wedge-shaped symbols impressed in plastic clay by Babylonian builders in the dim past, foresha dowed me: from them, on through the hieroglyphs of the ancient Egyptians, down to the beautiful manuscript letters of the medieval scribes, I was in the making. The ingenious JOHANNES GUTENBERG—with a dream most golden—first applied the principle of casting me in metal, the profound art of printing with movable types was born. Cold, rigid, and implacable I may be, yet the first impress of my face brought the divine word to countless thousands. I bring into the light of the day the precious stores of knowledge and wisdom long hid den in the grave of ignorance. I coin for you the enchanting tale, the philosopher's moralizing, and the poet's phantasies, I enable you to exchange the irksome hours that come, at times, to everyone, for sweet and happy hours *with books—golden urns filled with all the manna of the past. In books, I present to you a portion of the eternal mind caught*

2-POINT LEADED 9/11

I am the voice of today, the herald of tomorrow. I am type! Of my earliest ancestry neither history nor relics remain. The wedge-shaped symbols impressed in plastic clay by Babylonian builders in the dim past, foresha dowed me: from them, on through the hieroglyphs of the ancient Egyptians, down to the beautiful manuscript letters of the medieval scribes, I was in the making. The ingenious JOHANNES GUTENBERG—with a dream most golden—first applied the principle of casting me in metal, the profound art of printing with movable types was born. Cold, rigid, and implacable I may be, yet the first impress of my face brought the divine word to countless thousands. I bring into the light of the day the precious stores of knowledge and wisdom long hid den in the grave of ignorance. I coin for you the enchanting tale, the philosopher's moralizing, and the poet's phantasies, I enable you to exchange the irksome hours that come, at times, to everyone, for sweet and happy hours *with books—golden urns filled with all the manna of the past. In books, I present to you a portion of the eternal mind caught*

4-POINT LEADED 9/13

I am the voice of today, the herald of tomorrow. I am type! Of my earliest ancestry neither history nor relics remain. The wedge-shaped symbols impressed in plastic clay by Babylonian builders in the dim past, foresha dowed me: from them, on through the hieroglyphs of the ancient Egyptians, down to the beautiful manuscript letters of the medieval scribes, I was in the making. The ingenious JOHANNES GUTENBERG—with a dream most golden—first applied the principle of casting me in metal, the profound art of printing with movable types was born. Cold, rigid, and implacable I may be, yet the first impress of my face brought the divine word to countless thousands. I bring into the light of the day the precious stores of knowledge and wisdom long hid den in the grave of ignorance. I coin for you the enchanting tale, the philosopher's moralizing, and the poet's phantasies, I enable you to exchange the irksome hours that come, at times, to everyone, for sweet and happy hours *with books—golden urns filled with all the manna of the past. In books, I present to you a portion of the eternal mind caught*

RECOMMENDED LINELENGTH

1	2	3	4	5	6	7	8	9	10	11	**12**	**13**	**14**	**15**	**16**	**17**	**18**	**19**	**20**	**21**	**22**	**23**	**24**	25	26	27	28	29	30	31	32	33	34	35	36		LINE IN PICAS
3	6	9	12	15	18	21	24	27	30	34	**37**	**40**	**43**	**46**	**48**	**52**	**55**	**58**	**61**	**64**	**67**	**70**	**73**	76	79	82	85	88	91	94	97	100	103	106	109		CHARACTERS PER PICA

APPROXIMATELY 3.0 CHARACTERS PER PICA

8 and 7 Point Baskerville

MINUS LEADING

I am the voice of today, the herald of tomorrow. I am type! Of my earliest ancestry neither history nor relics remain. The we dge-shaped symbols impressed in plastic clay by Babylonian builders in the dim past foreshadowed me: from them, on thr ough the hieroglyphs of the ancient Egyptians, down to the beautiful manuscript letters of the medieval scribes, I was in the making. The ingenious JOHANNES GUTENBERG—with a dre am most golden—first applied the principle of casting me in metal, the profound art of printing with movable types was *born. Cold, rigid, and implacable I may be, yet the first impress of my*

8/7

I am the voice of today, the herald of tomorrow. I am type! Of my ear liest ancestry neither history nor relics remain. The wedge-shaped sym bols impressed in plastic clay by Babylonian builders in the dim past foreshadowed me: from them, on through the hieroglyphs of the anc ient Egyptians, down to the beautiful manuscript letters of the medie val scribes, I was in the making. The ingenious JOHANNES GUTENBERG— with a dream most golden—first applied the principle of casting me in metal, the profound art of printing with movable types was born. Cold, rigid, and implacable I may be, yet the first impress of my face brought the divine word to countless thousands. I bring into the light of the day *the precious stores of knowledge and wisdom long hidden in the grave of ignoran*

7/6

SOLID

I am the voice of today, the herald of tomorrow. I am type! Of my earliest ancestry neither history nor relics remain. The we dge-shaped symbols impressed in plastic clay by Babylonian builders in the dim past foreshadowed me: from them, on thr ough the hieroglyphs of the ancient Egyptians, down to the beautiful manuscript letters of the medieval scribes, I was in the making. The ingenious JOHANNES GUTENBERG—with a dre am most golden—first applied the principle of casting me in metal, the profound art of printing with movable types was *born. Cold, rigid, and implacable I may be, yet the first impress of my*

8/8

I am the voice of today, the herald of tomorrow. I am type! Of my ear liest ancestry neither history nor relics remain. The wedge-shaped sym bols impressed in plastic clay by Babylonian builders in the dim past foreshadowed me: from them, on through the hieroglyphs of the anc ient Egyptians, down to the beautiful manuscript letters of the medie val scribes, I was in the making. The ingenious JOHANNES GUTENBERG— with a dream most golden—first applied the principle of casting me in metal, the profound art of printing with movable types was born. Cold, rigid, and implacable I may be, yet the first impress of my face brought the divine word to countless thousands. I bring into the light of the day *the precious stores of knowledge and wisdom long hidden in the grave of ignoran*

7/7

1-POINT LEADED

I am the voice of today, the herald of tomorrow. I am type! Of my earliest ancestry neither history nor relics remain. The we dge-shaped symbols impressed in plastic clay by Babylonian builders in the dim past foreshadowed me: from them, on thr ough the hieroglyphs of the ancient Egyptians, down to the beautiful manuscript letters of the medieval scribes, I was in the making. The ingenious JOHANNES GUTENBERG—with a dre am most golden—first applied the principle of casting me in metal, the profound art of printing with movable types was *born. Cold, rigid, and implacable I may be, yet the first impress of my*

8/9

I am the voice of today, the herald of tomorrow. I am type! Of my ear liest ancestry neither history nor relics remain. The wedge-shaped sym bols impressed in plastic clay by Babylonian builders in the dim past foreshadowed me: from them, on through the hieroglyphs of the anc ient Egyptians, down to the beautiful manuscript letters of the medie val scribes, I was in the making. The ingenious JOHANNES GUTENBERG— with a dream most golden—first applied the principle of casting me in metal, the profound art of printing with movable types was born. Cold, rigid, and implacable I may be, yet the first impress of my face brought the divine word to countless thousands. I bring into the light of the day *the precious stores of knowledge and wisdom long hidden in the grave of ignoran*

7/8

2-POINT LEADED

I am the voice of today, the herald of tomorrow. I am type! Of my earliest ancestry neither history nor relics remain. The we dge-shaped symbols impressed in plastic clay by Babylonian builders in the dim past foreshadowed me: from them, on thr ough the hieroglyphs of the ancient Egyptians, down to the beautiful manuscript letters of the medieval scribes, I was in the making. The ingenious JOHANNES GUTENBERG—with a dre am most golden—first applied the principle of casting me in metal, the profound art of printing with movable types was *born. Cold, rigid, and implacable I may be, yet the first impress of my*

8/10

I am the voice of today, the herald of tomorrow. I am type! Of my ear liest ancestry neither history nor relics remain. The wedge-shaped sym bols impressed in plastic clay by Babylonian builders in the dim past foreshadowed me: from them, on through the hieroglyphs of the anc ient Egyptians, down to the beautiful manuscript letters of the medie val scribes, I was in the making. The ingenious JOHANNES GUTENBERG— with a dream most golden—first applied the principle of casting me in metal, the profound art of printing with movable types was born. Cold, rigid, and implacable I may be, yet the first impress of my face brought the divine word to countless thousands. I bring into the light of the day *the precious stores of knowledge and wisdom long hidden in the grave of ignoran*

7/9

4-POINT LEADED

I am the voice of today, the herald of tomorrow. I am type! Of my earliest ancestry neither history nor relics remain. The we dge-shaped symbols impressed in plastic clay by Babylonian builders in the dim past foreshadowed me: from them, on thr ough the hieroglyphs of the ancient Egyptians, down to the beautiful manuscript letters of the medieval scribes, I was in the making. The ingenious JOHANNES GUTENBERG—with a dre am most golden—first applied the principle of casting me in metal, the profound art of printing with movable types was *born. Cold, rigid, and implacable I may be, yet the first impress of my*

8/12

I am the voice of today, the herald of tomorrow. I am type! Of my ear liest ancestry neither history nor relics remain. The wedge-shaped sym bols impressed in plastic clay by Babylonian builders in the dim past foreshadowed me: from them, on through the hieroglyphs of the anc ient Egyptians, down to the beautiful manuscript letters of the medie val scribes, I was in the making. The ingenious JOHANNES GUTENBERG— with a dream most golden—first applied the principle of casting me in metal, the profound art of printing with movable types was born. Cold, rigid, and implacable I may be, yet the first impress of my face brought the divine word to countless thousands. I bring into the light of the day *the precious stores of knowledge and wisdom long hidden in the grave of ignoran*

7/11

RECOMMENDED LINELENGTH

LINE IN PICAS	1	2	3	4	5	6	7	8	9	10	11	12	13	14	15	16	17	18
CHARACTERS PER PICA	4	7	10	13	17	20	23	27	30	33	36	40	44	46	49	53	56	59

APPROXIMATELY 3.3 CHARACTERS PER PICA

RECOMMENDED LINELENGTH

	1	2	3	4	5	6	7	8	9	10	11	12	13	14	15	16	17	18
	4	8	12	15	19	23	27	30	34	38	42	45	49	53	57	60	64	68

APPROXIMATELY 3.8 CHARACTERS PER PICA

Bodoni

odoni is a Modern typeface, designed in the late 1700s by the Italian typographer Giambattista Bodoni. At the end of the eighteenth century, a fashion grew for faces with a stronger contrast between the thicks and thins, unbracketed serifs, and a strong vertical stress. These were called Modern faces. All the older faces became known as Old Style, while the more recent faces—just prior to the change—were referred to as Transitional. Although Bodoni has a small x-height, it appears very wide and black. Because of the strong vertical stress, accentuated by its heavy thicks and hairline thins, the horizontal flow necessary for comfortable reading is impaired. To compensate for this effect, Bodoni therefore must be well leaded.

18-POINT BODONI, 6-POINT LEADED

Other well-drawn
Modern typefaces.

ABCDEFGHIJKLMNOPQRSTUVWXYZ
abcdefghijklmnopqrstuvwxyz
DIDOT

ABCDEFGHIJKLMNOPQRSTUVWXYZ
abcdefghijklmnopqrstuvwxyz
WALBUM

ABCDEFGHIJKLMNOPQRSTUVWXYZ
abcdefghijklmnopqrstuvwxyz
MODERN 880 BT

ABCDEFGHIJKLMNOPQRSTUVWXYZ
abcdefghijklmnopqrstuvwxyz
BODONI BOOK

ABCDEFGHIJKLMNOPQRSTUVWXYZ
abcdefghijklmnopqrstuvwxyz
FENICE

ABCDEFGHIJK
LMNOPQRSTU
VWXYZ&
abcdefghijklmn
opqrstuvwxyz
1234567890

LINING FIGURES

fi fl . , ' ' - : ; ! ?

LIGATURES PUNCTUATION

ABCDEFGHIJKL

MNOPQRSTUV

WXYZ&

abcdefghijklmn

opqrstuvwxyz

1234567890

LINING FIGURES

fi fl . , ' ' - : ; ! ?

LIGATURES PUNCTUATION

ABCDEFGHIJKL
MNOPQRSTUVW
XYZ&abcdefghijk
lmnopqrstvwxyz
1234567890.,'":;!?

ABCDEFGHIJKL
MNOPQRSTUVW
XYZ&abcdefghijkl
mnopqrstvwxyz
1234567890.,'"-:;!?

ABCDEFGHIJKLMN
OPQRSTUVWXYZ&
abcdefghijklmnopqrstu
vwxyz1234567890.,"-:;!?

ABCDEFGHIJKLMN
OPQRSTUVWXYZ&
abcdefghijklmnopqrstuv
wxyz1234567890.,"-:;!?

ABCDEFGHIJKLMNOPQRS
TUVWXYZ&abcdefghijklmno
pqrstuvwxyz1234567890.,"-:;!?

ABCDEFGHIJKLMNOPQRS
TUVWXYZ&abcdefghijklmno
pqrstuvwxyz1234567890.,"-:;!?

30-POINT BODONI

ABCDEFGHIJKLMNOPQRSTUV
WXYZ&abcdefghijklmnopqrstuvw
xyz1234567890.,"-:;!?

30-POINT BODONI ITALIC

*ABCDEFGHIJKLMNOPQRSTUV
WXYZ&abcdefghijklmnopqrstuvw
xyz1234567890.,"-:;!?*

24-POINT BODONI

ABCDEFGHIJKLMNOPQRSTUVWXYZ&
abcdefghijklmnopqrstuvwxyz
1234567890.,"-:;!?

24-POINT BODONI ITALIC

*ABCDEFGHIJKLMNOPQRSTUVWXYZ&
abcdefghijklmnopqrstuvwxyz
1234567890.,"-:;!?*

18-POINT BODONI

ABCDEFGHIJKLMNOPQRSTUVWXYZ&
abcdefghijklmnopqrstuvwxyz
1234567890.,"-:;!?

18-POINT BODONI ITALIC

*ABCDEFGHIJKLMNOPQRSTUVWXYZ&
abcdefghijklmnopqrstuvwxyz
1234567890.,'-:;!?*

14 Point Bodoni

I am the voice of today, the herald of tomorrow. I am type! Of my earliest ancestry neither history nor relics remain. The wedge-shaped symbols impressed in plastic clay by Babylonian builders in the dim past foresha dowed me: from them, on through the hieroglyphs of the ancient Egypt ians, down to the beautiful manuscript letters of the medieval scribes, I was in the making. The ingenious JOHANNES GUTENBERG—with a dream *most golden—first applied the principle of casting me in metal, the profo*

MINUS LEADING 14/13

I am the voice of today, the herald of tomorrow. I am type! Of my earliest ancestry neither history nor relics remain. The wedge-shaped symbols impressed in plastic clay by Babylonian builders in the dim past foresha dowed me: from them, on through the hieroglyphs of the ancient Egypt ians, down to the beautiful manuscript letters of the medieval scribes, I was in the making. The ingenious JOHANNES GUTENBERG—with a dream *most golden—first applied the principle of casting me in metal, the profo*

SOLID 14/14

I am the voice of today, the herald of tomorrow. I am type! Of my earliest ancestry neither history nor relics remain. The wedge-shaped symbols impressed in plastic clay by Babylonian builders in the dim past foresha dowed me: from them, on through the hieroglyphs of the ancient Egypt ians, down to the beautiful manuscript letters of the medieval scribes, I was in the making. The ingenious JOHANNES GUTENBERG—with a dream *most golden—first applied the principle of casting me in metal, the profo*

1-POINT LEADED 14/15

I am the voice of today, the herald of tomorrow. I am type! Of my earliest ancestry neither history nor relics remain. The wedge-shaped symbols impressed in plastic clay by Babylonian builders in the dim past foresha dowed me: from them, on through the hieroglyphs of the ancient Egypt ians, down to the beautiful manuscript letters of the medieval scribes, I was in the making. The ingenious JOHANNES GUTENBERG—with a dream *most golden—first applied the principle of casting me in metal, the profo*

2-POINT LEADED 14/16

I am the voice of today, the herald of tomorrow. I am type! Of my earliest ancestry neither history nor relics remain. The wedge-shaped symbols impressed in plastic clay by Babylonian builders in the dim past foresha dowed me: from them, on through the hieroglyphs of the ancient Egypt ians, down to the beautiful manuscript letters of the medieval scribes, I was in the making. The ingenious JOHANNES GUTENBERG—with a dream *most golden—first applied the principle of casting me in metal, the profo*

4-POINT LEADED 14/18

RECOMMENDED LINELENGTH

1	2	3	4	5	6	7	8	9	10	11	12	13	14	15	16	17	**18**	**19**	**20**	**21**	**22**	**23**	**24**	**25**	**26**	**27**	**28**	**29**	**30**	**31**	**32**	**33**	**34**	**35**	**36**	LINE IN PICAS
2	4	6	8	10	12	14	16	18	20	22	24	26	27	29	31	33	**35**	**37**	**39**	**41**	**43**	**45**	**47**	**49**	**51**	**53**	**54**	**57**	**58**	**60**	**62**	**64**	**66**	**68**	**70**	CHARACTERS PER PICA

APPROXIMATELY 1.9 CHARACTERS PER PICA

MINUS LEADING 12/11

I am the voice of today, the herald of tomorrow. I am type! Of my earliest ancestry neither history nor relics remain. The wedge-shaped symbols impressed in plastic clay by Babylonian builders in the dim past, foreshadowed me: from them, on thro ugh the hieroglyphs of the ancient Egyptians, down to the beautiful manuscript let ters of the medieval scribes, I was in the making. The ingenious JOHANNES GUTEN BERG—with a dream most golden—first applied the principle of casting me in metal, the profound art of printing with movable types was born. Cold, rigid, and implac *able I may be, yet the first impress of my face brought the divine word to countless*

SOLID 12/12

I am the voice of today, the herald of tomorrow. I am type! Of my earliest ancestry neither history nor relics remain. The wedge-shaped symbols impressed in plastic clay by Babylonian builders in the dim past, foreshadowed me: from them, on thro ugh the hieroglyphs of the ancient Egyptians, down to the beautiful manuscript let ters of the medieval scribes, I was in the making. The ingenious JOHANNES GUTEN BERG—with a dream most golden—first applied the principle of casting me in metal, the profound art of printing with movable types was born. Cold, rigid, and implac *able I may be, yet the first impress of my face brought the divine word to countless*

1-POINT LEADED 12/13

I am the voice of today, the herald of tomorrow. I am type! Of my earliest ancestry neither history nor relics remain. The wedge-shaped symbols impressed in plastic clay by Babylonian builders in the dim past, foreshadowed me: from them, on thro ugh the hieroglyphs of the ancient Egyptians, down to the beautiful manuscript let ters of the medieval scribes, I was in the making. The ingenious JOHANNES GUTEN BERG—with a dream most golden—first applied the principle of casting me in metal, the profound art of printing with movable types was born. Cold, rigid, and implac *able I may be, yet the first impress of my face brought the divine word to countless*

2-POINT LEADED 12/14

I am the voice of today, the herald of tomorrow. I am type! Of my earliest ancestry neither history nor relics remain. The wedge-shaped symbols impressed in plastic clay by Babylonian builders in the dim past, foreshadowed me: from them, on thro ugh the hieroglyphs of the ancient Egyptians, down to the beautiful manuscript let ters of the medieval scribes, I was in the making. The ingenious JOHANNES GUTEN BERG—with a dream most golden—first applied the principle of casting me in metal, the profound art of printing with movable types was born. Cold, rigid, and implac *able I may be, yet the first impress of my face brought the divine word to countless*

4-POINT LEADED 12/16

I am the voice of today, the herald of tomorrow. I am type! Of my earliest ancestry neither history nor relics remain. The wedge-shaped symbols impressed in plastic clay by Babylonian builders in the dim past, foreshadowed me: from them, on thro ugh the hieroglyphs of the ancient Egyptians, down to the beautiful manuscript let ters of the medieval scribes, I was in the making. The ingenious JOHANNES GUTEN BERG—with a dream most golden—first applied the principle of casting me in metal, the profound art of printing with movable types was born. Cold, rigid, and implac *able I may be, yet the first impress of my face brought the divine word to countless*

RECOMMENDED LINELENGTH

LINE IN PICAS	1	2	3	4	5	6	7	8	9	10	11	12	13	14	15	**16**	**17**	**18**	**19**	**20**	**21**	**22**	**23**	**24**	**25**	**26**	**27**	**28**	**29**	**30**	**31**	**32**	**33**	34	35	36
CHARACTERS PER PICA	3	5	7	9	11	13	16	18	20	23	25	27	29	32	34	**36**	**38**	**40**	**43**	**45**	**47**	**49**	**52**	**54**	**56**	**58**	**61**	**63**	**65**	**67**	**69**	**72**	**74**	76	78	81

APPROXIMATELY 2.2 CHARACTERS PER PICA

I am the voice of today, the herald of tomorrow. I am type! Of my earliest ancestry neither history nor relics remain. The wedge-shaped symbols impressed in plastic clay by Babyloni an builders in the dim past, foreshadowed me: from them, on through the hieroglyphs of the ancient Egyptians, down to the beautiful manuscript letters of the medieval scribes, I was in the making. The ingenious JOHANNES GUTENBERG—with a dream most golden—first applied the principle of casting me in metal, the profound art of printing with movable types was born. Cold, rigid, and implacable I may be, yet the first impress of my face brought the *divine word to countless thousands. I bring into the light of the day the precious stores of kn*

MINUS LEADING 11/10

I am the voice of today, the herald of tomorrow. I am type! Of my earliest ancestry neither history nor relics remain. The wedge-shaped symbols impressed in plastic clay by Babyloni an builders in the dim past, foreshadowed me: from them, on through the hieroglyphs of the ancient Egyptians, down to the beautiful manuscript letters of the medieval scribes, I was in the making. The ingenious JOHANNES GUTENBERG—with a dream most golden—first applied the principle of casting me in metal, the profound art of printing with movable types was born. Cold, rigid, and implacable I may be, yet the first impress of my face brought the *divine word to countless thousands. I bring into the light of the day the precious stores of kn*

SOLID 11/11

I am the voice of today, the herald of tomorrow. I am type! Of my earliest ancestry neither history nor relics remain. The wedge-shaped symbols impressed in plastic clay by Babyloni an builders in the dim past, foreshadowed me: from them, on through the hieroglyphs of the ancient Egyptians, down to the beautiful manuscript letters of the medieval scribes, I was in the making. The ingenious JOHANNES GUTENBERG—with a dream most golden—first applied the principle of casting me in metal, the profound art of printing with movable types was born. Cold, rigid, and implacable I may be, yet the first impress of my face brought the *divine word to countless thousands. I bring into the light of the day the precious stores of kn*

1-POINT LEADED 11/12

I am the voice of today, the herald of tomorrow. I am type! Of my earliest ancestry neither history nor relics remain. The wedge-shaped symbols impressed in plastic clay by Babyloni an builders in the dim past, foreshadowed me: from them, on through the hieroglyphs of the ancient Egyptians, down to the beautiful manuscript letters of the medieval scribes, I was in the making. The ingenious JOHANNES GUTENBERG—with a dream most golden—first applied the principle of casting me in metal, the profound art of printing with movable types was born. Cold, rigid, and implacable I may be, yet the first impress of my face brought the *divine word to countless thousands. I bring into the light of the day the precious stores of kn*

2-POINT LEADED 11/13

I am the voice of today, the herald of tomorrow. I am type! Of my earliest ancestry neither history nor relics remain. The wedge-shaped symbols impressed in plastic clay by Babyloni an builders in the dim past, foreshadowed me: from them, on through the hieroglyphs of the ancient Egyptians, down to the beautiful manuscript letters of the medieval scribes, I was in the making. The ingenious JOHANNES GUTENBERG—with a dream most golden—first applied the principle of casting me in metal, the profound art of printing with movable types was born. Cold, rigid, and implacable I may be, yet the first impress of my face brought the *divine word to countless thousands. I bring into the light of the day the precious stores of kn*

4-POINT LEADED 11/15

RECOMMENDED LINELENGTH

1	2	3	4	5	6	7	8	9	10	11	12	13	**14**	**15**	**16**	**17**	**18**	**19**	**20**	**21**	**22**	**23**	**24**	**25**	**26**	**27**	**28**	**29**	**30**	31	32	33	34	35	36	LINE IN PICAS
3	5	8	10	13	15	18	20	23	25	28	30	33	**35**	**38**	**40**	**43**	**45**	**48**	**50**	**53**	**55**	**58**	**60**	**63**	**65**	**68**	**70**	**73**	**75**	78	80	83	85	88	90	CHARACTERS PER PICA

APPROXIMATELY 2.5 CHARACTERS PER PICA

MINUS LEADING 10/9

I am the voice of today, the herald of tomorrow. I am type! Of my earliest ancestry neither history nor relics remain. The wedge-shaped symbols impressed in plastic clay by Babylonian builders in the dim past, foreshadowed me: from them, on through the hieroglyphs of the ancient Egyptians down to the beautiful manuscript letters of the medieval scribes, I was in the making. The ingenious JOHANNES GUTENBERG—with a dream most golden—first applied the principle of casting me in metal, the profound art of printing with movable types was born. Cold, rigid, and implacable I may be, yet the first impress of my face brought the divine word to countless thousands. I bring in to the light of the day the precious stores of knowledge and wisdom long hidden in the grave of ignorance. I coin for you *the enchanting tale, the philosopher's moralizing, and the poet's phantasies, I enable you to exchang*

SOLID 10/10

I am the voice of today, the herald of tomorrow. I am type! Of my earliest ancestry neither history nor relics remain. The wedge-shaped symbols impressed in plastic clay by Babylonian builders in the dim past, foreshadowed me: from them, on through the hieroglyphs of the ancient Egyptians down to the beautiful manuscript letters of the medieval scribes, I was in the making. The ingenious JOHANNES GUTENBERG—with a dream most golden—first applied the principle of casting me in metal, the profound art of printing with movable types was born. Cold, rigid, and implacable I may be, yet the first impress of my face brought the divine word to countless thousands. I bring in to the light of the day the precious stores of knowledge and wisdom long hidden in the grave of ignorance. I coin for you *the enchanting tale, the philosopher's moralizing, and the poet's phantasies, I enable you to exchang*

1-POINT LEADED 10/11

I am the voice of today, the herald of tomorrow. I am type! Of my earliest ancestry neither history nor relics remain. The wedge-shaped symbols impressed in plastic clay by Babylonian builders in the dim past, foreshadowed me: from them, on through the hieroglyphs of the ancient Egyptians down to the beautiful manuscript letters of the medieval scribes, I was in the making. The ingenious JOHANNES GUTENBERG—with a dream most golden—first applied the principle of casting me in metal, the profound art of printing with movable types was born. Cold, rigid, and implacable I may be, yet the first impress of my face brought the divine word to countless thousands. I bring in to the light of the day the precious stores of knowledge and wisdom long hidden in the grave of ignorance. I coin for you *the enchanting tale, the philosopher's moralizing, and the poet's phantasies, I enable you to exchang*

2-POINT LEADED 10/12

I am the voice of today, the herald of tomorrow. I am type! Of my earliest ancestry neither history nor relics remain. The wedge-shaped symbols impressed in plastic clay by Babylonian builders in the dim past, foreshadowed me: from them, on through the hieroglyphs of the ancient Egyptians down to the beautiful manuscript letters of the medieval scribes, I was in the making. The ingenious JOHANNES GUTENBERG—with a dream most golden—first applied the principle of casting me in metal, the profound art of printing with movable types was born. Cold, rigid, and implacable I may be, yet the first impress of my face brought the divine word to countless thousands. I bring in to the light of the day the precious stores of knowledge and wisdom long hidden in the grave of ignorance. I coin for you *the enchanting tale, the philosopher's moralizing, and the poet's phantasies, I enable you to exchang*

4-POINT LEADED 10/14

I am the voice of today, the herald of tomorrow. I am type! Of my earliest ancestry neither history nor relics remain. The wedge-shaped symbols impressed in plastic clay by Babylonian builders in the dim past, foreshadowed me: from them, on through the hieroglyphs of the ancient Egyptians down to the beautiful manuscript letters of the medieval scribes, I was in the making. The ingenious JOHANNES GUTENBERG—with a dream most golden—first applied the principle of casting me in metal, the profound art of printing with movable types was born. Cold, rigid, and implacable I may be, yet the first impress of my face brought the divine word to countless thousands. I bring in to the light of the day the precious stores of knowledge and wisdom long hidden in the grave of ignorance. I coin for you *the enchanting tale, the philosopher's moralizing, and the poet's phantasies, I enable you to exchang*

RECOMMENDED LINELENGTH

LINE IN PICAS	1	2	3	4	5	6	7	8	9	10	11	12	**13**	**14**	**15**	**16**	**17**	**18**	**19**	**20**	**21**	**22**	**23**	**24**	**25**	**26**	**27**	28	29	30	31	32	33	34	35	36
CHARACTERS PER PICA	3	6	9	11	14	17	20	23	25	28	31	34	**36**	**39**	**42**	**45**	**48**	**50**	**53**	**56**	**59**	**62**	**64**	**67**	**70**	**73**	**75**	78	81	84	87	89	92	95	98	101

APPROXIMATELY 2.8 CHARACTERS PER PICA

9 Point Bodoni

I am the voice of today, the herald of tomorrow. I am type! Of my earliest ancestry neither history nor relics remain. The wedge-shaped symbols impressed in plastic clay by Babylonian builders in the dim past, foreshadowed me: from them, on through the hieroglyphs of the ancient Egyptians, down to the beautiful manuscript letters of the medieval scribes, I was in the making. The ingenious JOHANNES GUTENBERG—with a dream most golden—first applied the principle of casting me in metal, the profound art of printing with movable, types was born Cold, rigid, and implacable I may be, yet the first impress of my face brought the divine word to countless thou sands. I bring into the light of the day the precious stores of knowledge and wisdom long hidden in the grave of *ignorance*. I coin for you the enchanting tale, the philosopher's moralizing, and the poet's phantasies, I enable you to exchange the irksome hours that come, at times, to everyone, for sweet and happy *hours with books—golden urns filled with all the manna of the past. In books, I present to you a portion of the*

I am the voice of today, the herald of tomorrow. I am type! Of my earliest ancestry neither history nor relics remain. The wedge-shaped symbols impressed in plastic clay by Babylonian builders in the dim past, foreshadowed me: from them, on through the hieroglyphs of the ancient Egyptians, down to the beautiful manuscript letters of the medieval scribes, I was in the making. The ingenious JOHANNES GUTENBERG—with a dream most golden—first applied the principle of casting me in metal, the profound art of printing with movable, types was born Cold, rigid, and implacable I may be, yet the first impress of my face brought the divine word to countless thou sands. I bring into the light of the day the precious stores of knowledge and wisdom long hidden in the grave of *ignorance*. I coin for you the enchanting tale, the philosopher's moralizing, and the poet's phantasies, I enable you to exchange the irksome hours that come, at times, to everyone, for sweet and happy *hours with books—golden urns filled with all the manna of the past. In books, I present to you a portion of the*

I am the voice of today, the herald of tomorrow. I am type! Of my earliest ancestry neither history nor relics remain. The wedge-shaped symbols impressed in plastic clay by Babylonian builders in the dim past, foreshadowed me: from them, on through the hieroglyphs of the ancient Egyptians, down to the beautiful manuscript letters of the medieval scribes, I was in the making. The ingenious JOHANNES GUTENBERG—with a dream most golden—first applied the principle of casting me in metal, the profound art of printing with movable, types was born Cold, rigid, and implacable I may be, yet the first impress of my face brought the divine word to countless thou sands. I bring into the light of the day the precious stores of knowledge and wisdom long hidden in the grave of *ignorance*. I coin for you the enchanting tale, the philosopher's moralizing, and the poet's phantasies, I enable you to exchange the irksome hours that come, at times, to everyone, for sweet and happy *hours with books—golden urns filled with all the manna of the past. In books, I present to you a portion of the*

I am the voice of today, the herald of tomorrow. I am type! Of my earliest ancestry neither history nor relics remain. The wedge-shaped symbols impressed in plastic clay by Babylonian builders in the dim past, foreshadowed me: from them, on through the hieroglyphs of the ancient Egyptians, down to the beautiful manuscript letters of the medieval scribes, I was in the making. The ingenious JOHANNES GUTENBERG—with a dream most golden—first applied the principle of casting me in metal, the profound art of printing with movable, types was born Cold, rigid, and implacable I may be, yet the first impress of my face brought the divine word to countless thou sands. I bring into the light of the day the precious stores of knowledge and wisdom long hidden in the grave of *ignorance*. I coin for you the enchanting tale, the philosopher's moralizing, and the poet's phantasies, I enable you to exchange the irksome hours that come, at times, to everyone, for sweet and happy *hours with books—golden urns filled with all the manna of the past. In books, I present to you a portion of the*

I am the voice of today, the herald of tomorrow. I am type! Of my earliest ancestry neither history nor relics remain. The wedge-shaped symbols impressed in plastic clay by Babylonian builders in the dim past, foreshadowed me: from them, on through the hieroglyphs of the ancient Egyptians, down to the beautiful manuscript letters of the medieval scribes, I was in the making. The ingenious JOHANNES GUTENBERG—with a dream most golden—first applied the principle of casting me in metal, the profound art of printing with movable, types was born Cold, rigid, and implacable I may be, yet the first impress of my face brought the divine word to countless thou sands. I bring into the light of the day the precious stores of knowledge and wisdom long hidden in the grave of *ignorance*. I coin for you the enchanting tale, the philosopher's moralizing, and the poet's phantasies, I enable you to exchange the irksome hours that come, at times, to everyone, for sweet and happy *hours with books—golden urns filled with all the manna of the past. In books, I present to you a portion of the*

RECOMMENDED LINELENGTH

1	2	3	4	5	6	7	8	9	10	11	**12**	**13**	**14**	**15**	**16**	**17**	**18**	**19**	**20**	**21**	**22**	**23**	**24**	25	26	27	28	29	30	31	32	33	34	35	36	LINE IN PICAS
3	6	9	13	16	19	22	25	28	31	34	**37**	**40**	**43**	**46**	**49**	**52**	**55**	**58**	**62**	**65**	**68**	**71**	**74**	77	80	83	86	89	92	95	98	101	104	107	111	CHARACTERS PER PICA

APPROXIMATELY 3.0 CHARACTERS PER PICA

8 and 7 Point Bodoni

MINUS LEADING

I am the voice of today, the herald of tomorrow. I am type! Of my earliest ancestry neither history nor relics remain. The wedge-shaped symbols impressed in plastic clay by Babylonian builders in the dim past foreshadowed me: from them, on through the hieroglyphs of the ancient Egyptians, down to the beautiful manuscript letters of the medieval scribes, I was in the making The ingenious JOHANNES GUTENBERG—with a dream most golden—first applied the principle of casting me in metal, the profound art of printing with movable types was born. *Cold, rigid, and implacable I may be, yet the first impress of*
8/7

I am the voice of today, the herald of tomorrow. I am type! Of my earliest ancestry neither history nor relics remain. The wedge-shaped symbols impressed in plastic clay by Babylonian builders in the dim past fore shadowed me: from them, on through the hieroglyphs of the ancient Egyptians, down to the beautiful manuscript letters of the medieval scribes I was in the making. The ingenious JOHANNES GUTENBERG—with a dream most golden—first applied the principle of casting me in metal, the profound art of printing with movable types was born. Cold, rigid, and implacable I may be, yet the first impress of my face brought the divine word to countless thousands. I bring into the light of the day *the precious stores of knowledge and wisdom long hidden in the grave*
7/6

SOLID

I am the voice of today, the herald of tomorrow. I am type! Of my earliest ancestry neither history nor relics remain. The wedge-shaped symbols impressed in plastic clay by Babylonian builders in the dim past foreshadowed me: from them, on through the hieroglyphs of the ancient Egyptians, down to the beautiful manuscript letters of the medieval scribes, I was in the making The ingenious JOHANNES GUTENBERG—with a dream most golden—first applied the principle of casting me in metal, the profound art of printing with movable types was born. *Cold, rigid, and implacable I may be, yet the first impress of*
8/8

I am the voice of today, the herald of tomorrow. I am type! Of my earliest ancestry neither history nor relics remain. The wedge-shaped symbols impressed in plastic clay by Babylonian builders in the dim past fore shadowed me: from them, on through the hieroglyphs of the ancient Egyptians, down to the beautiful manuscript letters of the medieval scribes I was in the making. The ingenious JOHANNES GUTENBERG—with a dream most golden—first applied the principle of casting me in metal, the profound art of printing with movable types was born. Cold, rigid, and implacable I may be, yet the first impress of my face brought the divine word to countless thousands. I bring into the light of the day *the precious stores of knowledge and wisdom long hidden in the grave*
7/7

1-POINT LEADED

I am the voice of today, the herald of tomorrow. I am type! Of my earliest ancestry neither history nor relics remain. The wedge-shaped symbols impressed in plastic clay by Babylonian builders in the dim past foreshadowed me: from them, on through the hieroglyphs of the ancient Egyptians, down to the beautiful manuscript letters of the medieval scribes, I was in the making The ingenious JOHANNES GUTENBERG—with a dream most golden—first applied the principle of casting me in metal, the profound art of printing with movable types was born. *Cold, rigid, and implacable I may be, yet the first impress of*
8/9

I am the voice of today, the herald of tomorrow. I am type! Of my earliest ancestry neither history nor relics remain. The wedge-shaped symbols impressed in plastic clay by Babylonian builders in the dim past fore shadowed me: from them, on through the hieroglyphs of the ancient Egyptians, down to the beautiful manuscript letters of the medieval scribes I was in the making. The ingenious JOHANNES GUTENBERG—with a dream most golden—first applied the principle of casting me in metal, the profound art of printing with movable types was born. Cold, rigid, and implacable I may be, yet the first impress of my face brought the divine word to countless thousands. I bring into the light of the day *the precious stores of knowledge and wisdom long hidden in the grave*
7/8

2-POINT LEADED

I am the voice of today, the herald of tomorrow. I am type! Of my earliest ancestry neither history nor relics remain. The wedge-shaped symbols impressed in plastic clay by Babylonian builders in the dim past foreshadowed me: from them, on through the hieroglyphs of the ancient Egyptians, down to the beautiful manuscript letters of the medieval scribes, I was in the making The ingenious JOHANNES GUTENBERG—with a dream most golden—first applied the principle of casting me in metal, the profound art of printing with movable types was born. *Cold, rigid, and implacable I may be, yet the first impress of*
8/10

I am the voice of today, the herald of tomorrow. I am type! Of my earliest ancestry neither history nor relics remain. The wedge-shaped symbols impressed in plastic clay by Babylonian builders in the dim past fore shadowed me: from them, on through the hieroglyphs of the ancient Egyptians, down to the beautiful manuscript letters of the medieval scribes I was in the making. The ingenious JOHANNES GUTENBERG—with a dream most golden—first applied the principle of casting me in metal, the profound art of printing with movable types was born. Cold, rigid, and implacable I may be, yet the first impress of my face brought the divine word to countless thousands. I bring into the light of the day *the precious stores of knowledge and wisdom long hidden in the grave*
7/9

4-POINT LEADED

I am the voice of today, the herald of tomorrow. I am type! Of my earliest ancestry neither history nor relics remain. The wedge-shaped symbols impressed in plastic clay by Babylonian builders in the dim past foreshadowed me: from them, on through the hieroglyphs of the ancient Egyptians, down to the beautiful manuscript letters of the medieval scribes, I was in the making The ingenious JOHANNES GUTENBERG—with a dream most golden—first applied the principle of casting me in metal, the profound art of printing with movable types was born. *Cold, rigid, and implacable I may be, yet the first impress of*
8/12

I am the voice of today, the herald of tomorrow. I am type! Of my earliest ancestry neither history nor relics remain. The wedge-shaped symbols impressed in plastic clay by Babylonian builders in the dim past fore shadowed me: from them, on through the hieroglyphs of the ancient Egyptians, down to the beautiful manuscript letters of the medieval scribes I was in the making. The ingenious JOHANNES GUTENBERG—with a dream most golden—first applied the principle of casting me in metal, the profound art of printing with movable types was born. Cold, rigid, and implacable I may be, yet the first impress of my face brought the divine word to countless thousands. I bring into the light of the day *the precious stores of knowledge and wisdom long hidden in the grave*
7/11

RECOMMENDED LINELENGTH

LINE IN PICAS	1	2	3	4	5	6	7	8	9	10	11	12	13	14	15	16	17	18
CHARACTERS PER PICA	4	7	11	14	18	21	24	28	31	35	38	42	45	49	52	55	59	62

APPROXIMATELY 3.4 CHARACTERS PER PICA

RECOMMENDED LINELENGTH

	1	2	3	4	5	6	7	8	9	10	11	12	13	14	15	16	17	18
	4	8	12	16	20	24	28	32	36	40	44	47	51	55	59	63	67	71

APPROXIMATELY 4.0 CHARACTERS PER PICA

Century Expanded is an excellent example of a refined Egyptian, or slab serif, typeface. It is based on a type called Century, designed in 1894 by L. B. Benton and T. L. DeVinne for *The Century* magazine. After Bodoni, the type designers began to search for new forms of typographic expression. Around 1815 a typestyle appeared that was characterized by thick slab serifs and thick main strokes with little contrast between the thicks and thins. This style was called Egyptian. Century Expanded has a large x-height and should be leaded. The large letters and simple letterforms combine to make it very legible and especially popular for children's books. Like most members of the slab serif family of typefaces, Century Expanded makes a good display type because of its boldness.

18-POINT CENTURY EXPANDED, 4-POINT LEADED

Other well-drawn
slab serif typefaces.

ABCDEFGHIJKLMNOPQRSTUVWXYZ
abcdefghijklmnopqrstuvwxyz

CLARENDON

ABCDEFGHIJKLMNOPQRSTUVWXYZ
abcdefghijklmnopqrstuvwxyz

MEMPHIS

ABCDEFGHIJKLMNOPQRSTUVWXYZ
abcdefghijklmnopqrstuvwxyz

ROCKWELL

ABCDEFGHIJKLMNOPQRSTUVWXYZ
abcdefghijklmnopqrstuvwxyz

MELIOR

ABCDEFGHIJKLMNOPQRSTUVWXYZ
abcdefghijklmnopqrstuvwxyz

BOOKMAN

ABCDEFGHIJ
KLMNOPQRST
UVWXYZ&

abcdefghijklmn
opqrstuvwxyz

1234567890

LINING FIGURES

fi fl .,'' -:;!?

LIGATURES

PUNCTUATION

ABCDEFGHIJ
KLMNOPQRST
UVWXYZ&
abcdefghijklmn
opqrstuvwxyz
1234567890

LINING FIGURES

fi fl .,'' -.:;!?

LIGATURES PUNCTUATION

ABCDEFGHIJK
LMNOPQRSTUV
WXYZ&abcdfghij
klmnopqrstuvwxy
z1234567890.,"-:;!?

ABCDEFGHIJK
LMNOPQRSTUV
WXYZ&abcdefghij
klmnopqrstuvwxy
z1234567890.,"-:;!?

48-POINT
CENTURY EXPANDED

ABCDEFGHIJKLM
NOPQRSTUVWXYZ&
abcdefghijklmnopqrstu
vwxyz1234567890.,"-:;!?

48-POINT
CENTURY EXPANDED ITALIC

ABCDEFGHIJKLM
NOPQRSTUVWXYZ&
abcdefghijklmnopqrstu
vwxyz1234567890.,"-:;!?

36-POINT
CENTURY EXPANDED

ABCDEFGHIJKLMNOPQR
STUVWXYZ&abcdefghijklmn
opqrstuvwxyz1234567890.,'"-:;!?

36-POINT
CENTURY EXPANDED ITALIC

ABCDEFGHIJKLMNOPQR
STUVWXYZ&abcdefghijklmn
opqrstuvwxyz1234567890.,'"-:;!?

30-POINT
CENTURY EXPANDED

ABCDEFGHIJKLMNOPQRST
UVWXYZ&abcdefghijklmnopqr
stuvwxyz1234567890.,"-:;!?

30-POINT
CENTURY EXPANDED ITALIC

*ABCDEFGHIJKLMNOPQRST
UVWXYZ&abcdefghijklmnopqr
stuvwxyz1234567890.,"-:;!?*

24-POINT
CENTURY EXPANDED

ABCDEFGHIJKLMNOPQRSTUVW
XYZ&abcdefghijklmnopqrstuvwxyz
1234567890.,"-:;!?

24-POINT
CENTURY EXPANDED ITALIC

*ABCDEFGHIJKLMNOPQRSTUVW
XYZ&abcdefghijklmnopqrstuvwxyz
1234567890.,"-:;!?*

18-POINT
CENTURY EXPANDED

ABCDEFGHIJKLMNOPQRSTUVWXYZ&
abcdefghijklmnopqrstuvwxyz
1234567890.,"-:;!?

18-POINT
CENTURY EXPANDED ITALIC

*ABCDEFGHIJKLMNOPQRSTUVWXYZ&
abcdefghijklmnopqrstuvwxyz
1234567890.,"-:;!?*

I am the voice of today, the herald of tomorrow. I am type! Of my earli est ancestry neither history nor relics remain. The wedge-shaped sy mbols impressed in plastic clay by Babylonian builders in the dim past, foreshadowed me: from them, on through the hieroglyphs of the anci ent Egyptians, down to the beautiful manuscript letters of the medie val scribes, I was in the making. The ingenious JOHANNES GUTENBERG —with a dream most golden—first applied the principle of casting

I am the voice of today, the herald of tomorrow. I am type! Of my earli est ancestry neither history nor relics remain. The wedge-shaped sy mbols impressed in plastic clay by Babylonian builders in the dim past, foreshadowed me: from them, on through the hieroglyphs of the anci ent Egyptians, down to the beautiful manuscript letters of the medie val scribes, I was in the making. The ingenious JOHANNES GUTENBERG —with a dream most golden—first applied the principle of casting

I am the voice of today, the herald of tomorrow. I am type! Of my earli est ancestry neither history nor relics remain. The wedge-shaped sy mbols impressed in plastic clay by Babylonian builders in the dim past, foreshadowed me: from them, on through the hieroglyphs of the anci ent Egyptians, down to the beautiful manuscript letters of the medie val scribes, I was in the making. The ingenious JOHANNES GUTENBERG —with a dream most golden—first applied the principle of casting

I am the voice of today, the herald of tomorrow. I am type! Of my earli est ancestry neither history nor relics remain. The wedge-shaped sy mbols impressed in plastic clay by Babylonian builders in the dim past, foreshadowed me: from them, on through the hieroglyphs of the anci ent Egyptians, down to the beautiful manuscript letters of the medie val scribes, I was in the making. The ingenious JOHANNES GUTENBERG —with a dream most golden—first applied the principle of casting

I am the voice of today, the herald of tomorrow. I am type! Of my earli est ancestry neither history nor relics remain. The wedge-shaped sy mbols impressed in plastic clay by Babylonian builders in the dim past, foreshadowed me: from them, on through the hieroglyphs of the anci ent Egyptians, down to the beautiful manuscript letters of the medie val scribes, I was in the making. The ingenious JOHANNES GUTENBERG —with a dream most golden—first applied the principle of casting

RECOMMENDED LINELENGTH

1	2	3	4	5	6	7	8	9	10	11	12	13	14	15	16	17	**18**	**19**	**20**	**21**	**22**	**23**	**24**	**25**	**26**	**27**	**28**	**29**	**30**	**31**	**32**	**33**	**34**	**35**	**36**	LINE IN PICAS
2	4	6	8	10	12	14	16	17	19	21	23	25	27	29	31	33	**35**	**37**	**39**	**40**	**42**	**44**	**46**	**48**	**50**	**52**	**54**	**56**	**58**	**60**	**61**	**63**	**65**	**67**	**69**	CHARACTERS PER PICA

APPROXIMATELY 1.9 CHARACTERS PER PICA

MINUS LEADING 12/11

I am the voice of today, the herald of tomorrow. I am type! Of my earliest ancestry neither history nor relics remain. The wedge-shaped symbols impressed in plastic clay by Babylonian builders in the dim past, foreshadowed me: from them, on thro ugh the hieroglyphs of the ancient Egyptians, down to the beautiful manuscript letters of the medieval scribes, I was in the making. The ingenious JOHANNES GUTENBERG—with a dream most golden—first applied the principle of casting me in metal, the profound art of printing with movable types was born. Cold, rigid, *and implacable I may be, yet the first impress of my face brought the divine word*

SOLID 12/12

I am the voice of today, the herald of tomorrow. I am type! Of my earliest ancestry neither history nor relics remain. The wedge-shaped symbols impressed in plastic clay by Babylonian builders in the dim past, foreshadowed me: from them, on thro ugh the hieroglyphs of the ancient Egyptians, down to the beautiful manuscript letters of the medieval scribes, I was in the making. The ingenious JOHANNES GUTENBERG—with a dream most golden—first applied the principle of casting me in metal, the profound art of printing with movable types was born. Cold, rigid, *and implacable I may be, yet the first impress of my face brought the divine word*

1-POINT LEADED 12/13

I am the voice of today, the herald of tomorrow. I am type! Of my earliest ancestry neither history nor relics remain. The wedge-shaped symbols impressed in plastic clay by Babylonian builders in the dim past, foreshadowed me: from them, on thro ugh the hieroglyphs of the ancient Egyptians, down to the beautiful manuscript letters of the medieval scribes, I was in the making. The ingenious JOHANNES GUTENBERG—with a dream most golden—first applied the principle of casting me in metal, the profound art of printing with movable types was born. Cold, rigid, *and implacable I may be, yet the first impress of my face brought the divine word*

2-POINT LEADED 12/14

I am the voice of today, the herald of tomorrow. I am type! Of my earliest ancestry neither history nor relics remain. The wedge-shaped symbols impressed in plastic clay by Babylonian builders in the dim past, foreshadowed me: from them, on thro ugh the hieroglyphs of the ancient Egyptians, down to the beautiful manuscript letters of the medieval scribes, I was in the making. The ingenious JOHANNES GUTENBERG—with a dream most golden—first applied the principle of casting me in metal, the profound art of printing with movable types was born. Cold, rigid, *and implacable I may be, yet the first impress of my face brought the divine word*

4-POINT LEADED 12/16

I am the voice of today, the herald of tomorrow. I am type! Of my earliest ancestry neither history nor relics remain. The wedge-shaped symbols impressed in plastic clay by Babylonian builders in the dim past, foreshadowed me: from them, on thro ugh the hieroglyphs of the ancient Egyptians, down to the beautiful manuscript letters of the medieval scribes, I was in the making. The ingenious JOHANNES GUTENBERG—with a dream most golden—first applied the principle of casting me in metal, the profound art of printing with movable types was born. Cold, rigid, *and implacable I may be, yet the first impress of my face brought the divine word*

RECOMMENDED LINELENGTH

LINE IN PICAS	1	2	3	4	5	6	7	8	9	10	11	12	13	14	15	16	17	18	19	20	21	22	23	24	25	26	27	28	29	30	31	32	33	34	35	36
CHARACTERS PER PICA	3	5	7	9	11	14	16	18	20	22	25	27	29	31	33	36	38	40	42	44	47	49	51	53	55	58	60	62	64	66	69	71	73	75	77	80

APPROXIMATELY 2.2 CHARACTERS PER PICA

I am the voice of today, the herald of tomorrow. I am type! Of my earliest ancestry nei ther history nor relics remain. The wedge-shaped symbols impressed in plastic clay by Babylonian builders in the dim past, foreshadowed me: from them, on through the hiero glyphs of the ancient Egyptians, down to the beautiful manuscript letters of the medieval scribes, I was in the making. The ingenious JOHANNES GUTENBERG—with a dream most golden—first applied the principle of casting me in metal, the profound art of printing with movable types was born. Cold, rigid, and implacable I may be, yet the first impress *of my face brought the divine word to countless thousands. I bring into the light of the*

MINUS LEADING 11/10

I am the voice of today, the herald of tomorrow. I am type! Of my earliest ancestry nei ther history nor relics remain. The wedge-shaped symbols impressed in plastic clay by Babylonian builders in the dim past, foreshadowed me: from them, on through the hiero glyphs of the ancient Egyptians, down to the beautiful manuscript letters of the medieval scribes, I was in the making. The ingenious JOHANNES GUTENBERG—with a dream most golden—first applied the principle of casting me in metal, the profound art of printing with movable types was born. Cold, rigid, and implacable I may be, yet the first impress *of my face brought the divine word to countless thousands. I bring into the light of the*

SOLID 11/11

I am the voice of today, the herald of tomorrow. I am type! Of my earliest ancestry nei ther history nor relics remain. The wedge-shaped symbols impressed in plastic clay by Babylonian builders in the dim past, foreshadowed me: from them, on through the hiero glyphs of the ancient Egyptians, down to the beautiful manuscript letters of the medieval scribes, I was in the making. The ingenious JOHANNES GUTENBERG—with a dream most golden—first applied the principle of casting me in metal, the profound art of printing with movable types was born. Cold, rigid, and implacable I may be, yet the first impress *of my face brought the divine word to countless thousands. I bring into the light of the*

1-POINT LEADED 11/12

I am the voice of today, the herald of tomorrow. I am type! Of my earliest ancestry nei ther history nor relics remain. The wedge-shaped symbols impressed in plastic clay by Babylonian builders in the dim past, foreshadowed me: from them, on through the hiero glyphs of the ancient Egyptians, down to the beautiful manuscript letters of the medieval scribes, I was in the making. The ingenious JOHANNES GUTENBERG—with a dream most golden—first applied the principle of casting me in metal, the profound art of printing with movable types was born. Cold, rigid, and implacable I may be, yet the first impress *of my face brought the divine word to countless thousands. I bring into the light of the*

2-POINT LEADED 11/13

I am the voice of today, the herald of tomorrow. I am type! Of my earliest ancestry nei ther history nor relics remain. The wedge-shaped symbols impressed in plastic clay by Babylonian builders in the dim past, foreshadowed me: from them, on through the hiero glyphs of the ancient Egyptians, down to the beautiful manuscript letters of the medieval scribes, I was in the making. The ingenious JOHANNES GUTENBERG—with a dream most golden—first applied the principle of casting me in metal, the profound art of printing with movable types was born. Cold, rigid, and implacable I may be, yet the first impress *of my face brought the divine word to countless thousands. I bring into the light of the*

4-POINT LEADED 11/15

RECOMMENDED LINELENGTH

| 1 | 2 | 3 | 4 | 5 | 6 | 7 | 8 | 9 | 10 | 11 | 12 | **13** | **14** | **15** | **16** | **17** | **18** | **19** | **20** | **21** | **22** | **23** | **24** | **25** | **26** | **27** | **28** | **29** | **30** | 31 | 32 | 33 | 34 | 35 | 36 | LINE IN PICAS |
| 3 | 5 | 7 | 10 | 12 | 15 | 17 | 19 | 22 | 24 | 27 | 29 | **31** | **34** | **36** | **39** | **41** | **43** | **46** | **48** | **50** | **53** | **55** | **58** | **60** | **62** | **65** | **67** | **70** | **72** | 74 | 77 | 79 | 83 | 84 | 86 | CHARACTERS PER PICA |

APPROXIMATELY 2.4 CHARACTERS PER PICA

MINUS LEADING 10/9

I am the voice of today, the herald of tomorrow. I am type! Of my earliest ancestry neither history nor relics remain. The wedge-shaped symbols impressed in plastic clay by Babylonian builders in the dim past, foreshadowed me: from them, on through the hieroglyphs of the ancient Egyptians down to the beautiful manuscript letters of the medieval scribes, I was in the making. The ingenious JOHANNES GUTENBERG—with a dream most golden—first applied the principle of casting me in metal, the profound art of printing with movable types was born. Cold, rigid, and im placable I may be, yet the first impress of my face brought the divine word to countless thousands I bring. in to the light of the day the precious stores of knowledge and wisdom long hidden in the grave of *ignorance. I coin in the grave of ignorance. I coin for you the enchanting tale, the philosopher's*

SOLID 10/10

I am the voice of today, the herald of tomorrow. I am type! Of my earliest ancestry neither history nor relics remain. The wedge-shaped symbols impressed in plastic clay by Babylonian builders in the dim past, foreshadowed me: from them, on through the hieroglyphs of the ancient Egyptians down to the beautiful manuscript letters of the medieval scribes, I was in the making. The ingenious JOHANNES GUTENBERG—with a dream most golden—first applied the principle of casting me in metal, the profound art of printing with movable types was born. Cold, rigid, and im placable I may be, yet the first impress of my face brought the divine word to countless thousands I bring. in to the light of the day the precious stores of knowledge and wisdom long hidden in the grave of *ignorance. I coin in the grave of ignorance. I coin for you the enchanting tale, the philosopher's*

1-POINT LEADED 10/11

I am the voice of today, the herald of tomorrow. I am type! Of my earliest ancestry neither history nor relics remain. The wedge-shaped symbols impressed in plastic clay by Babylonian builders in the dim past, foreshadowed me: from them, on through the hieroglyphs of the ancient Egyptians down to the beautiful manuscript letters of the medieval scribes, I was in the making. The ingenious JOHANNES GUTENBERG—with a dream most golden—first applied the principle of casting me in metal, the profound art of printing with movable types was born. Cold, rigid, and im placable I may be, yet the first impress of my face brought the divine word to countless thousands I bring. in to the light of the day the precious stores of knowledge and wisdom long hidden in the grave of *ignorance. I coin in the grave of ignorance. I coin for you the enchanting tale, the philosopher's*

2-POINT LEADED 10/12

I am the voice of today, the herald of tomorrow. I am type! Of my earliest ancestry neither history nor relics remain. The wedge-shaped symbols impressed in plastic clay by Babylonian builders in the dim past, foreshadowed me: from them, on through the hieroglyphs of the ancient Egyptians down to the beautiful manuscript letters of the medieval scribes, I was in the making. The ingenious JOHANNES GUTENBERG—with a dream most golden—first applied the principle of casting me in metal, the profound art of printing with movable types was born. Cold, rigid, and im placable I may be, yet the first impress of my face brought the divine word to countless thousands I bring. in to the light of the day the precious stores of knowledge and wisdom long hidden in the grave of *ignorance. I coin in the grave of ignorance. I coin for you the enchanting tale, the philosopher's*

4-POINT LEADED 10/14

I am the voice of today, the herald of tomorrow. I am type! Of my earliest ancestry neither history nor relics remain. The wedge-shaped symbols impressed in plastic clay by Babylonian builders in the dim past, foreshadowed me: from them, on through the hieroglyphs of the ancient Egyptians down to the beautiful manuscript letters of the medieval scribes, I was in the making. The ingenious JOHANNES GUTENBERG—with a dream most golden—first applied the principle of casting me in metal, the profound art of printing with movable types was born. Cold, rigid, and im placable I may be, yet the first impress of my face brought the divine word to countless thousands I bring. in to the light of the day the precious stores of knowledge and wisdom long hidden in the grave of *ignorance. I coin in the grave of ignorance. I coin for you the enchanting tale, the philosopher's*

RECOMMENDED LINELENGTH

LINE IN PICAS	1	2	3	4	5	6	7	8	9	10	11	12	**13**	**14**	**15**	**16**	**17**	**18**	**19**	**20**	**21**	22	23	24	25	26	27	28	29	30	31	32	33	34	35	36
CHARACTERS PER PICA	3	6	8	11	13	16	29	21	24	26	29	32	**34**	**37**	**40**	**42**	**45**	**47**	**50**	**53**	**55**	58	60	63	66	68	71	74	76	79	81	84	87	89	92	95

APPROXIMATELY 2.6 CHARACTERS PER PICA

9 Point Century Expanded

I am the voice of today, the herald of tomorrow. I am type! Of my earliest ancestry neither history nor relics remain. The wedge-shaped symbols impressed in plastic clay by Babylonian builders in the dim past, foresha dowed me: from them, on through the hieroglyphs of the ancient Egyptians, down to the beautiful manu script letters of the medieval scribes, I was in the making. The ingenious JOHANNES GUTENBERG—with a dream most golden—first applied the principle of casting me in metal, the profound art of printing with mov able types was born. Cold, rigid, and implacable I may be, yet the first impress of my face brought the divine word to countless thousands. I bring into the light of the day the precious stores of knowledge and wisdom long hidden in the grave of ignorance. I coin for you the enchanting tale, the philosopher's moralizing, and *the poet's phantasies, I enable you to exchange the irksome hours that come, at times, to everyone, for sweet*

MINUS LEADING 9/8

I am the voice of today, the herald of tomorrow. I am type! Of my earliest ancestry neither history nor relics remain. The wedge-shaped symbols impressed in plastic clay by Babylonian builders in the dim past, foresha dowed me: from them, on through the hieroglyphs of the ancient Egyptians, down to the beautiful manu script letters of the medieval scribes, I was in the making. The ingenious JOHANNES GUTENBERG—with a dream most golden—first applied the principle of casting me in metal, the profound art of printing with mov able types was born. Cold, rigid, and implacable I may be, yet the first impress of my face brought the divine word to countless thousands. I bring into the light of the day the precious stores of knowledge and wisdom long hidden in the grave of ignorance. I coin for you the enchanting tale, the philosopher's moralizing, and *the poet's phantasies, I enable you to exchange the irksome hours that come, at times, to everyone, for sweet*

SOLID 9/9

I am the voice of today, the herald of tomorrow. I am type! Of my earliest ancestry neither history nor relics remain. The wedge-shaped symbols impressed in plastic clay by Babylonian builders in the dim past, foresha dowed me: from them, on through the hieroglyphs of the ancient Egyptians, down to the beautiful manu script letters of the medieval scribes, I was in the making. The ingenious JOHANNES GUTENBERG—with a dream most golden—first applied the principle of casting me in metal, the profound art of printing with mov able types was born. Cold, rigid, and implacable I may be, yet the first impress of my face brought the divine word to countless thousands. I bring into the light of the day the precious stores of knowledge and wisdom long hidden in the grave of ignorance. I coin for you the enchanting tale, the philosopher's moralizing, and *the poet's phantasies, I enable you to exchange the irksome hours that come, at times, to everyone, for sweet*

1-POINT LEADED 9/10

I am the voice of today, the herald of tomorrow. I am type! Of my earliest ancestry neither history nor relics remain. The wedge-shaped symbols impressed in plastic clay by Babylonian builders in the dim past, foresha dowed me: from them, on through the hieroglyphs of the ancient Egyptians, down to the beautiful manu script letters of the medieval scribes, I was in the making. The ingenious JOHANNES GUTENBERG—with a dream most golden—first applied the principle of casting me in metal, the profound art of printing with mov able types was born. Cold, rigid, and implacable I may be, yet the first impress of my face brought the divine word to countless thousands. I bring into the light of the day the precious stores of knowledge and wisdom long hidden in the grave of ignorance. I coin for you the enchanting tale, the philosopher's moralizing, and *the poet's phantasies, I enable you to exchange the irksome hours that come, at times, to everyone, for sweet*

2-POINT LEADED 9/11

I am the voice of today, the herald of tomorrow. I am type! Of my earliest ancestry neither history nor relics remain. The wedge-shaped symbols impressed in plastic clay by Babylonian builders in the dim past, foresha dowed me: from them, on through the hieroglyphs of the ancient Egyptians, down to the beautiful manu script letters of the medieval scribes, I was in the making. The ingenious JOHANNES GUTENBERG—with a dream most golden—first applied the principle of casting me in metal, the profound art of printing with mov able types was born. Cold, rigid, and implacable I may be, yet the first impress of my face brought the divine word to countless thousands. I bring into the light of the day the precious stores of knowledge and wisdom long hidden in the grave of ignorance. I coin for you the enchanting tale, the philosopher's moralizing, and *the poet's phantasies, I enable you to exchange the irksome hours that come, at times, to everyone, for sweet*

4-POINT LEADED 9/13

RECOMMENDED LINELENGTH

1	2	3	4	5	6	7	8	9	10	11	12	**13**	**14**	**15**	**16**	**17**	**18**	**19**	**20**	**21**	22	23	24	25	26	27	28	29	30	31	32	33	34	35	36		LINE IN PICAS
3	6	9	12	15	18	21	24	26	29	32	35	**38**	**41**	**44**	**47**	**50**	**53**	**56**	**58**	**61**	64	67	70	73	76	79	82	85	87	90	93	96	99	102	105		CHARACTERS PER PICA

APPROXIMATELY 2.9 CHARACTERS PER PICA

8 and 7 Point Century Expanded

MINUS LEADING

I am the voice of today, the herald of tomorrow. I am type! Of my earliest ancestry neither history nor relics remain. The wedge-shaped symbols impressed in plastic clay by Babyloni an builders in the dim past foreshadowed me: from them, on through the hieroglyphs of the ancient Egyptians, down to the beautiful manuscript letters of the medieval scribes, I was in the making. The ingenious JOHANNES GUTENBERG— with a dream most golden— first applied the principle of cast ing me in metal, the profound art of printing with movable *types was born. Cold, rigid, and implacable I may be, yet the*
8/7

I am the voice of today, the herald of tomorrow. I am type! Of my earli est ancestry neither history nor relics remain. The wedge-shaped sy mbols impressed in plastic clay by Babylonian builders in the dim past, foreshadowed me: from them, on through the hieroglyphs of the anc ient Egyptians, down to the beautiful manuscript letters of the medie val scribes, I was in the making. The ingenious JOHANNES GUTEN BERG—with a dream most golden—first applied the principle of cast ing me in metal, the profound art of printing with movable types were born. Cold, rigid, and implacable I may be, yet the first impress of my face brought the divine word to countless thousands. I bring into the *light of the day the precious stores of knowledge and wisdom long hid*
7/6

SOLID

I am the voice of today, the herald of tomorrow. I am type! Of my earliest ancestry neither history nor relics remain. The wedge-shaped symbols impressed in plastic clay by Babyloni an builders in the dim past foreshadowed me: from them, on through the hieroglyphs of the ancient Egyptians, down to the beautiful manuscript letters of the medieval scribes, I was in the making. The ingenious JOHANNES GUTENBERG— with a dream most golden—first applied the principle of cast ing me in metal, the profound art of printing with movable *types was born. Cold, rigid, and implacable I may be, yet the*
8/8

I am the voice of today, the herald of tomorrow. I am type! Of my earli est ancestry neither history nor relics remain. The wedge-shaped sy mbols impressed in plastic clay by Babylonian builders in the dim past, foreshadowed me: from them, on through the hieroglyphs of the anc ient Egyptians, down to the beautiful manuscript letters of the medie val scribes, I was in the making. The ingenious JOHANNES GUTEN BERG—with a dream most golden—first applied the principle of cast ing me in metal, the profound art of printing with movable types was born. Cold, rigid, and implacable I may be, yet the first impress of my face brought the divine word to countless thousands. I bring into the *light of the day the precious stores of knowledge and wisdom long hid*
7/7

1-POINT LEADED

I am the voice of today, the herald of tomorrow. I am type! Of my earliest ancestry neither history nor relics remain. The wedge-shaped symbols impressed in plastic clay by Babyloni an builders in the dim past foreshadowed me: from them, on through the hieroglyphs of the ancient Egyptians, down to the beautiful manuscript letters of the medieval scribes, I was in the making. The ingenious JOHANNES GUTENBERG— with a dream most golden—first applied the principle of cast ing me in metal, the profound art of printing with movable *types was born. Cold, rigid, and implacable I may be, yet the*
8/9

I am the voice of today, the herald of tomorrow. I am type! Of my earli est ancestry neither history nor relics remain. The wedge-shaped sy mbols impressed in plastic clay by Babylonian builders in the dim past, foreshadowed me: from them, on through the hieroglyphs of the anc ient Egyptians, down to the beautiful manuscript letters of the medie val scribes, I was in the making. The ingenious JOHANNES GUTEN BERG—with a dream most golden—first applied the principle of cast ing me in metal, the profound art of printing with movable types was born. Cold, rigid, and implacable I may be, yet the first impress of my face brought the divine word to countless thousands. I bring into the *light of the day the precious stores of knowledge and wisdom long hid*
7/8

2-POINT LEADED

I am the voice of today, the herald of tomorrow. I am type! Of my earliest ancestry neither history nor relics remain. The wedge-shaped symbols impressed in plastic clay by Babyloni an builders in the dim past foreshadowed me: from them, on through the hieroglyphs of the ancient Egyptians, down to the beautiful manuscript letters of the medieval scribes, I was in the making. The ingenious JOHANNES GUTENBERG— with a dream most golden—first applied the principle of cast ing me in metal, the profound art of printing with movable *types was born. Cold, rigid, and implacable I may be, yet the*
8/10

I am the voice of today, the herald of tomorrow. I am type! Of my earli est ancestry neither history nor relics remain. The wedge-shaped sy mbols impressed in plastic clay by Babylonian builders in the dim past, foreshadowed me: from them, on through the hieroglyphs of the anc ient Egyptians, down to the beautiful manuscript letters of the medie val scribes, I was in the making. The ingenious JOHANNES GUTEN BERG—with a dream most golden—first applied the principle of cast ing me in metal, the profound art of printing with movable types was born. Cold, rigid, and implacable I may be, yet the first impress of my face brought the divine word to countless thousands. I bring into the *light of the day the precious stores of knowledge and wisdom long hid*
7/9

4-POINT LEADED

I am the voice of today, the herald of tomorrow. I am type! Of my earliest ancestry neither history nor relics remain. The wedge- shaped symbols impressed in plastic clay by Babyloni an builders in the dim past foreshadowed me: from them, on through the hieroglyphs of the ancient Egyptians, down to the beautiful manuscript letters of the medieval scribes, I was in the making. The ingenious JOHANNES GUTENBERG— with a dream most golden— first applied the principle of cast ing me in metal, the profound art of printing with movable *types was born. Cold, rigid, and implacable I may be, yet the*
8/12

I am the voice of today, the herald of tomorrow. I am type! Of my earli est ancestry neither history nor relics remain. The wedge-shaped sy mbols impressed in plastic clay by Babylonian builders in the dim past, foreshadowed me: from them, on through the hieroglyphs of the anc ient Egyptians, down to the beautiful manuscript letters of the medie val scribes, I was in the making. The ingenious JOHANNES GUTEN BERG—with a dream most golden—first applied the principle of cast ing me in metal, the profound art of printing with movable types was born. Cold, rigid, and implacable I may be, yet the first impress of my face brought the divine word to countless thousands. I bring into the *light of the day the precious stores of knowledge and wisdom long hid*
7/11

RECOMMENDED LINELENGTH

LINE IN PICAS	1	2	3	4	5	6	7	8	9	10	11	12	13	14	15	16	17	18
CHARACTERS PER PICA	3	6	9	12	15	18	21	24	27	30	33	36	39	42	45	48	51	54

APPROXIMATELY 4 CHARACTERS PER PICA

RECOMMENDED LINELENGTH

LINE IN PICAS	1	2	3	4	5	6	7	8	9	10	11	12	13	14	15	16	17	18
CHARACTERS PER PICA	3	6	9	12	15	18	21	24	27	30	33	36	39	42	45	48	51	54

APPROXIMATELY 4 CHARACTERS PER PICA

Helvetica is a contemporary typeface of Swiss origin. Although typefaces without serifs were used in the nineteenth century, it was not until the twentieth century that they became widely used. Helvetica was introduced in 1957 by the Haas type foundry and was first presented in the United States in the early 1960s. Although Helvetica has a large x-height and narrow letters, its clean design makes it very readable. Sans serif types in general have relatively little stress, and the strokes are optically equal. Because there is no serif to aid the horizontal flow that we have seen is so necessary to comfortable reading, sans serif type should always be leaded.

18-POINT HELVETICA, 6-POINT LEADED

Other well-drawn sans serif typefaces.

ABCDEFGHIJKLMNOPQRSTUVWXYZ
abcdefghijklmnopqrstuvwxyz

FUTURA

ABCDEFGHIJKLMNOPQRSTUVWXYZ
abcdefghijklmnopqrstuvwxyz

NEWS GOTHIC

ABCDEFGHIJKLMNOPQRSTUVWXYZ
abcdefghijklmnopqrstuvwxyz

FOLIO

ABCDEFGHIJKLMNOPQRSTUVWXYZ
abcdefghijklmnopqrstuvwxyz

UNIVERS

ABCDEFGHIJKLMNOPQRSTUVWXYZ
abcdefghijklmnopqrstuvwxyz

FRUTIGER

ABCDEFGHIJK
LMNOPQRSTU
VWXYZ&
abcdefghijklmn
opqrstuvwxyz
1234567890

LINING FIGURES

. , ' ' - : ; ! ?

PUNCTUATION

ABCDEFGHIJK

LMNOPQRSTU

VWXYZ&

abcdefghijklmn

opqrstuvwxyz

1234567890

LINING FIGURES

., ' ' - : ; !?

PUNCTUATION

ABCDEFGHIJKL
MNOPQRSTUVW
XYZ&abcdefghijk
lmnopqrstuvwxyz
1234567890.,"-:;!?

ABCDEFGHIJKLM
NOPQRSTUVW
XYZ&abcdefghijk
lmnopqrstuvwxyz
1234567890.,"-:;!?

ABCDEFGHIJKLMN
OPQRSTUVWXYZ&
abcdefghijklmnopqrstu
vwxyz1234567890.,"-:;!?

ABCDEFGHIJKLMN
OPQRSTUVWXYZ&
abcdefghijklmnopqrstuv
wxyz1234567890.,"-:;!?

ABCDEFGHIJKLMNOPQR
STUVWXYZ&abcdefghijklmno
pqrstuvwxyz1234567890.,"-:;!?

ABCDEFGHIJKLMNOPQR
STUVWXYZ&abcdefghijklmno
pqrstuvwxyz1234567890.,"-:;!?

30-POINT HELVETICA

ABCDEFGHIJKLMNOPQRSTUV WXYZ&abcdfghijklmnopqrstuvw xyz1234567890.,"-:;!?

30-POINT HELVETICA ITALIC

ABCDEFGHIJKLMNOPQRSTU VWXYZ&abcdfghijklmnopqrstu vwxyz1234567890.,"-:;!?

24-POINT HELVETICA

ABCDEFGHIJKLMNOPQRSTUVWXYZ& abcdfghijklmnopqrstuvwxyz 1234567890.,"-:;!?

24-POINT HELVETICA ITALIC

ABCDEFGHIJKLMNOPQRSTUVWXYZ& abcdfghijklmnopqrstuvwxyz 1234567890.,"-:;!?

18-POINT HELVETICA

ABCDEFGHIJKLMNOPQRSTUVWXYZ&
abcdfghijklmnopqrstuvwxyz
1234567890.,"-:;!?

18-POINT HELVETICA ITALIC

*ABCDEFGHIJKLMNOPQRSTUVWXYZ&
abcdfghijklmnopqrstuvwxyz
1234567890.,'-:;!?*

I am the voice of today, the herald of tomorrow. I am type! Of my earli est ancestry neither history nor relics remain. The wedge-shaped sym bols impressed in plastic clay by Babylonian builders in the dim past. foreshadowed me: from them, on through the hieroglyphs of the anci ent Egyptians, down to the beautiful manuscript letters of the medie val scribes, I was in the making. The ingenious JOHANNES GUTENBERG —*with a dream most golden—first applied the principle of casting me*

I am the voice of today, the herald of tomorrow. I am type! Of my earli est ancestry neither history nor relics remain. The wedge-shaped sym bols impressed in plastic clay by Babylonian builders in the dim past. foreshadowed me: from them, on through the hieroglyphs of the anci ent Egyptians, down to the beautiful manuscript letters of the medie val scribes, I was in the making. The ingenious JOHANNES GUTENBERG —*with a dream most golden—first applied the principle of casting me*

I am the voice of today, the herald of tomorrow. I am type! Of my earli est ancestry neither history nor relics remain. The wedge-shaped sym bols impressed in plastic clay by Babylonian builders in the dim past. foreshadowed me: from them, on through the hieroglyphs of the anci ent Egyptians, down to the beautiful manuscript letters of the medie val scribes, I was in the making. The ingenious JOHANNES GUTENBERG —*with a dream most golden—first applied the principle of casting me*

I am the voice of today, the herald of tomorrow. I am type! Of my earli est ancestry neither history nor relics remain. The wedge-shaped sym bols impressed in plastic clay by Babylonian builders in the dim past. foreshadowed me: from them, on through the hieroglyphs of the anci ent Egyptians, down to the beautiful manuscript letters of the medie val scribes, I was in the making. The ingenious JOHANNES GUTENBERG —*with a dream most golden—first applied the principle of casting me*

I am the voice of today, the herald of tomorrow. I am type! Of my earli est ancestry neither history nor relics remain. The wedge-shaped sym bols impressed in plastic clay by Babylonian builders in the dim past. foreshadowed me: from them, on through the hieroglyphs of the anci ent Egyptians, down to the beautiful manuscript letters of the medie val scribes, I was in the making. The ingenious JOHANNES GUTENBERG —*with a dream most golden—first applied the principle of casting me*

RECOMMENDED LINELENGTH

1	2	3	4	5	6	7	8	9	10	11	**12**	**13**	**14**	**15**	**16**	**17**	**18**	**19**	**20**	21	22	23	24	25	26	27	28	29	30	31	32	33	34	35	36	LINE IN PICAS
2	4	6	8	10	12	14	16	17	19	21	**23**	**25**	**27**	**29**	**31**	**33**	**35**	**37**	**39**	40	42	44	46	48	50	52	54	56	58	60	61	63	65	67	69	CHARACTERS PER PICA

APPROXIMATELY 1.9 CHARACTERS PER PICA

12 Point Helvetica

MINUS LEADING 12/11

I am the voice of today, the herald of tomorrow. I am type! Of my earliest ancestry neither history nor relics remain. The wedge-shaped symbols impressed in plastic clay by Babylonian builders in the dim past, foreshadowed me: from them, on through the hieroglyphs of the ancient Egyptians, down to the beautiful manuscript letters of the medieval scribes, I was in the making. The ingenious JOHANNES GUTENBERG—with a dream most golden—first applied the principle of casting me in metal, the profound art of printing with movable types was born. Cold, rigid, and *implacable I may be, yet the first impress of my face brought the divine word to co*

SOLID 12/12

I am the voice of today, the herald of tomorrow. I am type! Of my earliest ancestry neither history nor relics remain. The wedge-shaped symbols impressed in plastic clay by Babylonian builders in the dim past, foreshadowed me: from them, on through the hieroglyphs of the ancient Egyptians, down to the beautiful manuscript letters of the medieval scribes, I was in the making. The ingenious JOHANNES GUTENBERG—with a dream most golden—first applied the principle of casting me in metal, the profound art of printing with movable types was born. Cold, rigid, and *implacable I may be, yet the first impress of my face brought the divine word to co*

1-POINT LEADED 12/13

I am the voice of today, the herald of tomorrow. I am type! Of my earliest ancestry neither history nor relics remain. The wedge-shaped symbols impressed in plastic clay by Babylonian builders in the dim past, foreshadowed me: from them, on through the hieroglyphs of the ancient Egyptians, down to the beautiful manuscript letters of the medieval scribes, I was in the making. The ingenious JOHANNES GUTENBERG—with a dream most golden—first applied the principle of casting me in metal, the profound art of printing with movable types was born. Cold, rigid, and *implacable I may be, yet the first impress of my face brought the divine word to co*

2-POINT LEADED 12/14

I am the voice of today, the herald of tomorrow. I am type! Of my earliest ancestry neither history nor relics remain. The wedge-shaped symbols impressed in plastic clay by Babylonian builders in the dim past, foreshadowed me: from them, on through the hieroglyphs of the ancient Egyptians, down to the beautiful manuscript letters of the medieval scribes, I was in the making. The ingenious JOHANNES GUTENBERG—with a dream most golden—first applied the principle of casting me in metal, the profound art of printing with movable types was born. Cold, rigid, and *implacable I may be, yet the first impress of my face brought the divine word to co*

4-POINT LEADED 12/16

I am the voice of today, the herald of tomorrow. I am type! Of my earliest ancestry neither history nor relics remain. The wedge-shaped symbols impressed in plastic clay by Babylonian builders in the dim past, foreshadowed me: from them, on through the hieroglyphs of the ancient Egyptians, down to the beautiful manuscript letters of the medieval scribes, I was in the making. The ingenious JOHANNES GUTENBERG—with a dream most golden—first applied the principle of casting me in metal, the profound art of printing with movable types was born. Cold, rigid, and *implacable I may be, yet the first impress of my face brought the divine word to co*

RECOMMENDED LINELENGTH

LINE IN PICAS	1	2	3	4	5	6	7	8	9	10	11	12	**13**	**14**	**15**	**16**	**17**	**18**	**19**	**20**	**21**	22	23	24	25	26	27	28	29	30	31	32	33	34	35	36
CHARACTERS PER PICA	3	5	7	9	11	14	16	18	20	23	25	27	**29**	**31**	**34**	**36**	**38**	**40**	**43**	**45**	**47**	49	52	54	56	58	60	63	65	67	69	72	74	76	78	81

APPROXIMATELY 2.3 CHARACTERS PER PICA

I am the voice of today, the herald of tomorrow. I am type! Of my earliest ancestry neither history norrelics remain. The wedge-shaped symbols impressed in plastic clay by Baby lonian builders in the dimpast, foreshadowed me: from them, on through the hieroglyphs of the ancient Egyptians, down to the beautiful manuscript letters of the medieval scribes, I was in the making. The ingenious JOHANNES GUTENBERG—with a dream most golden— first applied the principle of casting me in metal, the profound art of printing with movable types was born. Cold, rigid, and implacable I may be, yet the first impress of my face *brought the divine word to countless thousands. I bring into the light of the day the precio*

MINUS LEADING 11/10

I am the voice of today, the herald of tomorrow. I am type! Of my earliest ancestry neither history norrelics remain. The wedge-shaped symbols impressed in plastic clay by Baby lonian builders in the dimpast, foreshadowed me: from them, on through the hieroglyphs of the ancient Egyptians, down to the beautiful manuscript letters of the medieval scribes, I was in the making. The ingenious JOHANNES GUTENBERG—with a dream most golden— first applied the principle of casting me in metal, the profound art of printing with movable types was born. Cold, rigid, and implacable I may be, yet the first impress of my face *brought the divine word to countless thousands. I bring into the light of the day the precio*

SOLID 11/11

I am the voice of today, the herald of tomorrow. I am type! Of my earliest ancestry neither history norrelics remain. The wedge-shaped symbols impressed in plastic clay by Baby lonian builders in the dimpast, foreshadowed me: from them, on through the hieroglyphs of the ancient Egyptians, down to the beautiful manuscript letters of the medieval scribes, I was in the making. The ingenious JOHANNES GUTENBERG—with a dream most golden— first applied the principle of casting me in metal, the profound art of printing with movable types was born. Cold, rigid, and implacable I may be, yet the first impress of my face *brought the divine word to countless thousands. I bring into the light of the day the precio*

1-POINT LEADED 11/12

I am the voice of today, the herald of tomorrow. I am type! Of my earliest ancestry neither history norrelics remain. The wedge-shaped symbols impressed in plastic clay by Baby lonian builders in the dimpast, foreshadowed me: from them, on through the hieroglyphs of the ancient Egyptians, down to the beautiful manuscript letters of the medieval scribes, I was in the making. The ingenious JOHANNES GUTENBERG—with a dream most golden— first applied the principle of casting me in metal, the profound art of printing with movable types was born. Cold, rigid, and implacable I may be, yet the first impress of my face *brought the divine word to countless thousands. I bring into the light of the day the precio*

2-POINT LEADED 11/13

I am the voice of today, the herald of tomorrow. I am type! Of my earliest ancestry neither history norrelics remain. The wedge-shaped symbols impressed in plastic clay by Baby lonian builders in the dimpast, foreshadowed me: from them, on through the hieroglyphs of the ancient Egyptians, down to the beautiful manuscript letters of the medieval scribes, I was in the making. The ingenious JOHANNES GUTENBERG—with a dream most golden— first applied the principle of casting me in metal, the profound art of printing with movable types was born. Cold, rigid, and implacable I may be, yet the first impress of my face *brought the divine word to countless thousands. I bring into the light of the day the precio*

4-POINT LEADED 11/15

1	2	3	4	5	6	7	8	9	10	11	12	**13**	**14**	**15**	**16**	**17**	**18**	**19**	**20**	**21**	22	23	24	25	26	27	28	29	30	31	32	33	34	35	36	LINE IN PICAS
3	5	8	10	12	15	17	20	22	25	27	29	**32**	**34**	**37**	**39**	**41**	**44**	**46**	**49**	**51**	54	56	58	61	63	66	68	71	73	75	78	80	83	85	88	CHARACTERS PER PICA

APPROXIMATELY 2.5 CHARACTERS PER PICA

10 Point Helvetica

I am the voice of today, the herald of tomorrow. I am type! Of my earliest ancestry neither history nor relics remain. The wedge-shaped symbols impressed in plastic clay by Babylonian builders in the dim past, foreshadowed me: from them, on through the hieroglyphs of the ancient Egyptians, down to the beautiful manuscript letters of the medieval scribes, I was in the making.The ingenious JOHANNES GUTENBERG—with a dream most golden—first applied the principle of casting me in metal, the profound art of printing with movable types was born. Cold, rigid, and implacable I may be, yet the first impress of my face brought the divine word to countless thousands. I bring into the light of the day the precious stores of knowledge and wisdom long hidden in the grave of *ignorance. I coin for you the enchanting tale, the phiosopher's moralizing, and the poet's phantasie*

I am the voice of today, the herald of tomorrow. I am type! Of my earliest ancestry neither history nor relics remain. The wedge-shaped symbols impressed in plastic clay by Babylonian builders in the dim past, foreshadowed me: from them, on through the hieroglyphs of the ancient Egyptians, down to the beautiful manuscript letters of the medieval scribes, I was in the making.The ingenious JOHANNES GUTENBERG—with a dream most golden—first applied the principle of casting me in metal, the profound art of printing with movable types was born. Cold, rigid, and implacable I may be, yet the first impress of my face brought the divine word to countless thousands. I bring into the light of the day the precious stores of knowledge and wisdom long hidden in the grave of *ignorance. I coin for you the enchanting tale, the phiosopher's moralizing, and the poet's phantasie*

I am the voice of today, the herald of tomorrow. I am type! Of my earliest ancestry neither history nor relics remain. The wedge-shaped symbols impressed in plastic clay by Babylonian builders in the dim past, foreshadowed me: from them, on through the hieroglyphs of the ancient Egyptians, down to the beautiful manuscript letters of the medieval scribes, I was in the making.The ingenious JOHANNES GUTENBERG—with a dream most golden—first applied the principle of casting me in metal, the profound art of printing with movable types was born. Cold, rigid, and implacable I may be, yet the first impress of my face brought the divine word to countless thousands. I bring into the light of the day the precious stores of knowledge and wisdom long hidden in the grave of *ignorance. I coin for you the enchanting tale, the phiosopher's moralizing, and the poet's phantasie*

I am the voice of today, the herald of tomorrow. I am type! Of my earliest ancestry neither history nor relics remain. The wedge-shaped symbols impressed in plastic clay by Babylonian builders in the dim past, foreshadowed me: from them, on through the hieroglyphs of the ancient Egyptians, down to the beautiful manuscript letters of the medieval scribes, I was in the making.The ingenious JOHANNES GUTENBERG—with a dream most golden—first applied the principle of casting me in metal, the profound art of printing with movable types was born. Cold, rigid, and implacable I may be, yet the first impress of my face brought the divine word to countless thousands. I bring into the light of the day the precious stores of knowledge and wisdom long hidden in the grave of *ignorance. I coin for you the enchanting tale, the phiosopher's moralizing, and the poet's phantasie*

I am the voice of today, the herald of tomorrow. I am type! Of my earliest ancestry neither history nor relics remain. The wedge-shaped symbols impressed in plastic clay by Babylonian builders in the dim past, foreshadowed me: from them, on through the hieroglyphs of the ancient Egyptians, down to the beautiful manuscript letters of the medieval scribes, I was in the making.The ingenious JOHANNES GUTENBERG—with a dream most golden—first applied the principle of casting me in metal, the profound art of printing with movable types was born. Cold, rigid, and implacable I may be, yet the first impress of my face brought the divine word to countless thousands. I bring into the light of the day the precious stores of knowledge and wisdom long hidden in the grave of *ignorance. I coin for you the enchanting tale, the phiosopher's moralizing, and the poet's phantasie*

RECOMMENDED LINELENGTH

LINE IN PICAS	1	2	3	4	5	6	7	8	9	10	11	12	**13**	**14**	**15**	**16**	**17**	**18**	**19**	**20**	**21**	22	23	24	25	26	27	28	29	30	31	32	33	34	35	36
CHARACTERS PER PICA	3	6	8	11	14	16	19	22	24	27	30	32	**35**	**38**	**41**	**43**	**46**	**49**	**51**	**54**	**57**	59	62	65	67	70	73	75	78	81	83	86	89	92	94	97

APPROXIMATELY 2.7 CHARACTERS PER PICA

9 Point Helvetica

I am the voice of today, the herald of tomorrow. I am type! Of my earliest ancestry neither history nor relics remain. The wedge-shaped symbols impressed in plastic clay by Babylonian builders in the dim past, foreshadowed me: from them, on through the hieroglyphs of the ancient Egyptians, down to the beautiful manuscript letters of the medieval scribes, I was in the making.The ingenious JOHANNES GUTENBERG—with a dream most golden—first applied the principle of casting me in metal, the profound art of printing with mov able types was born. Cold, rigid, and implacable I may be, yet the first impress of my face brought the divine word to countless thousands. I bring into the light of the day the precious stores of knowledge and wisdom long hidden in the grave of ignorance. I coin for you the enchanting tale, the phiosopher's moralizing and the poet's phantasies, I enable you to exchange the irksome hours that come, at times to everyone, for *sweet amd happy hours with books—golden urns filled with all the manna of the past. In books, I present to*

MINUS LEADING 9/8

I am the voice of today, the herald of tomorrow. I am type! Of my earliest ancestry neither history nor relics remain. The wedge-shaped symbols impressed in plastic clay by Babylonian builders in the dim past, foreshadowed me: from them, on through the hieroglyphs of the ancient Egyptians, down to the beautiful manuscript letters of the medieval scribes, I was in the making.The ingenious JOHANNES GUTENBERG—with a dream most golden—first applied the principle of casting me in metal, the profound art of printing with mov able types was born. Cold, rigid, and implacable I may be, yet the first impress of my face brought the divine word to countless thousands. I bring into the light of the day the precious stores of knowledge and wisdom long hidden in the grave of ignorance. I coin for you the enchanting tale, the phiosopher's moralizing and the poet's phantasies, I enable you to exchange the irksome hours that come, at times to everyone, for *sweet amd happy hours with books—golden urns filled with all the manna of the past. In books, I present to*

SOLID 9/9

I am the voice of today, the herald of tomorrow. I am type! Of my earliest ancestry neither history nor relics remain. The wedge-shaped symbols impressed in plastic clay by Babylonian builders in the dim past, foreshadowed me: from them, on through the hieroglyphs of the ancient Egyptians, down to the beautiful manuscript letters of the medieval scribes, I was in the making.The ingenious JOHANNES GUTENBERG—with a dream most golden—first applied the principle of casting me in metal, the profound art of printing with mov able types was born. Cold, rigid, and implacable I may be, yet the first impress of my face brought the divine word to countless thousands. I bring into the light of the day the precious stores of knowledge and wisdom long hidden in the grave of ignorance. I coin for you the enchanting tale, the phiosopher's moralizing and the poet's phantasies, I enable you to exchange the irksome hours that come, at times to everyone, for *sweet amd happy hours with books—golden urns filled with all the manna of the past. In books, I present to*

1-POINT LEADED 9/10

I am the voice of today, the herald of tomorrow. I am type! Of my earliest ancestry neither history nor relics remain. The wedge-shaped symbols impressed in plastic clay by Babylonian builders in the dim past, foreshadowed me: from them, on through the hieroglyphs of the ancient Egyptians, down to the beautiful manuscript letters of the medieval scribes, I was in the making.The ingenious JOHANNES GUTENBERG—with a dream most golden—first applied the principle of casting me in metal, the profound art of printing with mov able types was born. Cold, rigid, and implacable I may be, yet the first impress of my face brought the divine word to countless thousands. I bring into the light of the day the precious stores of knowledge and wisdom long hidden in the grave of ignorance. I coin for you the enchanting tale, the phiosopher's moralizing and the poet's phantasies, I enable you to exchange the irksome hours that come, at times to everyone, for *sweet amd happy hours with books—golden urns filled with all the manna of the past. In books, I present to*

2-POINT LEADED 9/11

I am the voice of today, the herald of tomorrow. I am type! Of my earliest ancestry neither history nor relics remain. The wedge-shaped symbols impressed in plastic clay by Babylonian builders in the dim past, foreshadowed me: from them, on through the hieroglyphs of the ancient Egyptians, down to the beautiful manuscript letters of the medieval scribes, I was in the making.The ingenious JOHANNES GUTENBERG—with a dream most golden—first applied the principle of casting me in metal, the profound art of printing with mov able types was born. Cold, rigid, and implacable I may be, yet the first impress of my face brought the divine word to countless thousands. I bring into the light of the day the precious stores of knowledge and wisdom long hidden in the grave of ignorance. I coin for you the enchanting tale, the phiosopher's moralizing and the poet's phantasies, I enable you to exchange the irksome hours that come, at times to everyone, for *sweet amd happy hours with books—golden urns filled with all the manna of the past. In books, I present to*

4-POINT LEADED 9/13

RECOMMENDED LINELENGTH

1	2	3	4	5	6	7	8	9	10	11	12	**13**	**14**	**15**	**16**	**17**	**18**	**19**	**20**	**21**	22	23	24	25	26	27	28	29	30	31	32	33	34	35	36	LINE IN PICAS
3	6	9	1	3	16	19	22	25	28	31	34	**37**	**40**	**43**	**46**	**49**	**52**	**55**	**62**	**65**	68	71	74	77	80	83	86	89	92	95	98	101	104	107	111	CHARACTERS PER PICA

APPROXIMATELY 3.1 CHARACTERS PER PICA

MINUS LEADING

I am the voice of today, the herald of tomorrow. I am type! Of my earliest ancestry neither history nor relics remain. The wedge-shaped symbols impressed in plastic clay by Babylonian builders in the dim past, foreshadowed me: from them, on through the hieroglyphs of the ancient Egyptians, down to the beautiful manuscript letters of the medieval scribes, I was in the making. The ingenious JOHANNES GUTENBERG—with a dream most golden—first applied the principle of casting me in metal, the profound art of printing with movable types was *born. Cold, rigid, and implacable I may be, yet the first impres*

8/7

I am the voice of today, the herald of tomorrow. I am type! Of my earliest ancestry neither history nor relics remain. The wedge-shaped symbols impressed in plastic clay by Babylonian builders in the dim past, foreshadowed me: from them, on through the hieroglyphs of the ancient Egyptians, down to the beautiful manuscript letters of the medieval scribes, I was in the making. The ingenious JOHANNES GUTENBERG with a dream most golden—first applied the principle of casting me in metal, the profound art of printing with movable types was born. Cold, rigid, and implacable I may be, yet the first impress of my face brought the divine word to countless thousands. I bring into the light of the day *the precious stores of knowledge and wisdom long hidden in the grav*

7/6

SOLID

I am the voice of today, the herald of tomorrow. I am type! Of my earliest ancestry neither history nor relics remain. The wedge-shaped symbols impressed in plastic clay by Babylonian builders in the dim past, foreshadowed me: from them, on through the hieroglyphs of the ancient Egyptians, down to the beautiful manuscript letters of the medieval scribes, I was in the making. The ingenious JOHANNES GUTENBERG—with a dream most golden—first applied the principle of casting me in metal, the profound art of printing with movable types was *born. Cold, rigid, and implacable I may be, yet the first impres*

8/8

I am the voice of today, the herald of tomorrow. I am type! Of my earliest ancestry neither history nor relics remain. The wedge-shaped symbols impressed in plastic clay by Babylonian builders in the dim past, foreshadowed me: from them, on through the hieroglyphs of the ancient Egyptians, down to the beautiful manuscript letters of the medieval scribes, I was in the making. The ingenious JOHANNES GUTENBERG with a dream most golden—first applied the principle of casting me in metal, the profound art of printing with movable types was born. Cold, rigid, and implacable I may be, yet the first impress of my face brought the divine word to countless thousands. I bring into the light of the day *the precious stores of knowledge and wisdom long hidden in the grav*

7/7

1-POINT LEADED

I am the voice of today, the herald of tomorrow. I am type! Of my earliest ancestry neither history nor relics remain. The wedge-shaped symbols impressed in plastic clay by Babylonian builders in the dim past, foreshadowed me: from them, on through the hieroglyphs of the ancient Egyptians, down to the beautiful manuscript letters of the medieval scribes, I was in the making. The ingenious JOHANNES GUTENBERG—with a dream most golden—first applied the principle of casting me in metal, the profound art of printing with movable types was *born. Cold, rigid, and implacable I may be, yet the first impres*

8/9

I am the voice of today, the herald of tomorrow. I am type! Of my earliest ancestry neither history nor relics remain. The wedge-shaped symbols impressed in plastic clay by Babylonian builders in the dim past, foreshadowed me: from them, on through the hieroglyphs of the ancient Egyptians, down to the beautiful manuscript letters of the medieval scribes, I was in the making. The ingenious JOHANNES GUTENBERG with a dream most golden—first applied the principle of casting me in metal, the profound art of printing with movable types was born. Cold, rigid, and implacable I may be, yet the first impress of my face brought the divine word to countless thousands. I bring into the light of the day *the precious stores of knowledge and wisdom long hidden in the grav*

7/8

2-POINT LEADED

I am the voice of today, the herald of tomorrow. I am type! Of my earliest ancestry neither history nor relics remain. The wedge-shaped symbols impressed in plastic clay by Babylonian builders in the dim past, foreshadowed me: from them, on through the hieroglyphs of the ancient Egyptians, down to the beautiful manuscript letters of the medieval scribes, I was in the making. The ingenious JOHANNES GUTENBERG—with a dream most golden—first applied the principle of casting me in metal, the profound art of printing with movable types was *born. Cold, rigid, and implacable I may be, yet the first impres*

8/10

I am the voice of today, the herald of tomorrow. I am type! Of my earliest ancestry neither history nor relics remain. The wedge-shaped symbols impressed in plastic clay by Babylonian builders in the dim past, foreshadowed me: from them, on through the hieroglyphs of the ancient Egyptians, down to the beautiful manuscript letters of the medieval scribes, I was in the making. The ingenious JOHANNES GUTENBERG with a dream most golden—first applied the principle of casting me in metal, the profound art of printing with movable types was born. Cold, rigid, and implacable I may be, yet the first impress of my face brought the divine word to countless thousands. I bring into the light of the day *the precious stores of knowledge and wisdom long hidden in the grav*

7/9

4-POINT LEADED

I am the voice of today, the herald of tomorrow. I am type! Of my earliest ancestry neither history nor relics remain. The wedge-shaped symbols impressed in plastic clay by Babylonian builders in the dim past, foreshadowed me: from them, on through the hieroglyphs of the ancient Egyptians, down to the beautiful manuscript letters of the medieval scribes, I was in the making. The ingenious JOHANNES GUTENBERG—with a dream most golden—first applied the principle of casting me in metal, the profound art of printing with movable types was *born. Cold, rigid, and implacable I may be, yet the first impres*

8/12

I am the voice of today, the herald of tomorrow. I am type! Of my earliest ancestry neither history nor relics remain. The wedge-shaped symbols impressed in plastic clay by Babylonian builders in the dim past, foreshadowed me: from them, on through the hieroglyphs of the ancient Egyptians, down to the beautiful manuscript letters of the medieval scribes, I was in the making. The ingenious JOHANNES GUTENBERG with a dream most golden—first applied the principle of casting me in metal, the profound art of printing with movable types was born. Cold, rigid, and implacable I may be, yet the first impress of my face brought the divine word to countless thousands. I bring into the light of the day *the precious stores of knowledge and wisdom long hidden in the grav*

7/11

RECOMMENDED LINELENGTH

LINE IN PICAS	1	2	3	4	5	6	7	8	9	10	11	12	13	14	15	16	17	18
CHARACTERS PER PICA	4	7	11	14	19	21	24	28	31	35	38	42	45	49	52	55	59	62

APPROXIMATELY 3.5 CHARACTERS PER PICA

RECOMMENDED LINELENGTH

LINE IN PICAS	1	2	3	4	5	6	7	8	9	10	11	12	13	14	15	16	17	18
CHARACTERS PER PICA	4	8	12	16	20	24	28	32	36	40	44	47	51	55	59	63	67	71

APPROXIMATELY 4.0 CHARACTERS PER PICA

Designing with type is the process of selecting a typeface, deciding which words or phrases should be emphasized, and determining how the type should be arranged on a page. The final design will be influenced by the copy you work with, the intended audience, your understanding of the principles of typography, and consideration of how we read. This holds true whether your goal is to make the experience of reading as comfortable as possible or to challenge accepted typographic conventions.

9. Selecting Text Type

With so many text typefaces available, how do you go about selecting the appropriate one? First, begin by becoming familiar with the individual characteristics of the five classic typefaces presented in Part Two. It is much easier to establish a knowledge of typefaces by building upon proven classics. Eventually, through use and experimentation and by researching examples of fine typography in design publications and exhibitions, you will develop an eye for the typographic qualities that are appealing to both you and your audience. In time, like most professional designers, you will develop a preference for a relatively small number of text typefaces.

The following are some of the factors you need to consider when selecting a text typeface.

Legibility and Readability

The typeface you choose should be legible, that is, it should be read without effort. Sometimes legibility is simply a matter of typesize; more often, however, it is a matter of typeface design. Generally speaking, typefaces that are true to the basic letterforms are more legible than typefaces that have been condensed, expanded, embellished, or abstracted. Therefore always start with a legible typeface.

Keep in mind, however, that even a legible typeface can become unreadable through poor setting and placement, just as a less legible typeface can be made more readable through good design.

Legibility and readability

involve not only the typeface

but also how the type is set.

11/18 HELVETICA LIGHT

Esthetics

There is no formula for defining beauty in a typeface or type arrangement, but there are standards of typographic excellence that have been established over the centuries. For example, early typesetters and printers would always strive for the highest level of legibility and readability through careful consideration of typeface design, letterspacing, wordspacing, linespacing, and other typographic refinements that will be discussed in this part.

Today these considerations continue to play a significant role in determining excellence in typography. Esthetic choices tend to be dictated by these standards, as well as the designer's taste and experience.

Appropriateness

Designers often begin a project by choosing a typeface that appeals to them. This choice is highly personal; Bodoni may appeal to one designer, Helvetica to another. Regardless of your choice, be certain that the typeface is not only well designed but also appropriate to both the audience and the project.

Typefaces have personalities and convey different moods. While a single, well-drawn typeface can be utilized for a variety of jobs, there are occasions when specific projects seem to dictate a particular typeface or typestyle. For example, an advertisement for cosmetics may suggest an elegant typeface such as Bodoni rather than a bold sans serif. A logo for industrial machinery might call for the opposite.

Consider the audience. If the reader is either very young or very old, you should choose a simple, well-designed typeface that is easy to read and set in a large size—larger than the type you are now reading. On the other hand, young people, such as teenagers and college students, are generally more receptive to experimental—or even outlandish—typography.

The length of the copy is another factor: an appropriate typeface for a caption or blurb may not be a practical choice for a lengthy novel or vice versa. □

Type can be letterspaced and wordspaced to produce *normal, tight, very tight,* or *open* settings. The spacing you select will depend very much on the typeface, typestyle, and type size.

Although the letterspacing and wordspacing you choose are based on personal preference, your first priority should be readability. Most text is set normal, that is, without additional spacing considerations. If you choose to customize the setting, consider that regular text sizes can be set with either normal or tight spacing, while smaller text sizes require slightly more open spacing. A condensed typeface can be set tighter than a regular or extended typeface. In nearly all cases, designers are consistent in their specifications; if they tighten the wordspacing, they also tighten the linespacing.

If you decide to use tight letterspacing, remember that there is a limit to how much space can be removed before the letters start to touch or overlap. Check the round letters first, such as the *o*'s and *c*'s; they will overlap before the straight letters, such as the *i*'s and *l*'s.

Besides overall letterspacing, there is also selective letterspacing, or *kerning.* This affects only certain letter combinations that are improved with a reduction of space, such as *AT, TI, LV, Te, Wo,* and *Ya.* (See page 22.)

Spacing can have a dramatic effect on the "color" of the typesetting. The tighter the spacing, the blacker the setting; conversely, the looser the spacing, the grayer the effect. The majority of jobs are set with either normal or tight spacing.

Optimal Spacing

What is the desirable amount of space between letters and words? Type that runs together and type that is too far apart are both unsatisfactory. In general, too much or too little wordspacing is conspicuous: it diverts attention away from the text to the way words are placed.

Words placed too close together force the reader to work harder to distinguish one word from another (**1**). In text settings, words placed too far apart leave large spaces that look like "rivers" running down the page—creating a vertical emphasis that disrupts the movement of the eye from left to right (**2**). These rivers are especially apparent in newspapers, where narrow columns make even wordspacing difficult. Proper wordspacing creates greater readability and is more pleasing esthetically (**3**). The page of text appears as orderly strips of black and white instead of looking like a field full of potholes.

Whatisthedesirableamountofspacebetween words?Toomuchortoolittlemakesreading difficult.Wordsplacedtooclosetogetherforce thereadertoworkhardertodistinguishoneword fromanother.Ontheotherhand,wordsplaced toofarapartcreatewhitespacesthatrundownthe pageas"rivers"anddisruptthenaturalmovement oftheeyefromlefttoright.Properwordspacing notonlycreatesgreaterreadabilitybutismore pleasingesthetically.

9/13 HELVETICA LIGHT

1. Extremely tight wordspacing can confuse the reader because the words appear to run together.

What is the desirable amount of space between words? Too much or too little makes reading difficult. Words placed too close together force the reader to work harder to distinguish one word from another. On the other hand, words placed too far apart create white spaces that run down the page as "rivers" and disrupt the natural movement of the eye from left to right. Proper wordspacing not only creates greater readability but is more pleasing esthetically.

9/13 HELVETICA LIGHT

2. When wordspacing is too loose, the words become disjointed and visually weaken the block of text.

What is the desirable amount of space between words? Too much or too little makes reading difficult. Words placed too close together force the reader to work harder to distinguish one word from another. On the other hand, words placed too far apart create white spaces that run down the page as "rivers" and disrupt the natural movement of the eye from left to right. Proper wordspacing not only creates greater readability but is more pleasing esthetically.

9/13 HELVETICA LIGHT

3. Optimal wordspacing is sensitive to both readability and esthetics. The text is pleasing to the eye and easy to read.

4. Wordspacing is equal throughout the text when type is set unjustified (flush left, rag right).

What is the desirable amount of space between words? Too much or too little makes reading difficult. Words placed too close together force the reader to work harder to distinguish one word from another. On the other hand, words placed too far apart create white spaces that run down the page as "rivers" and disrupt the natural movement of the eye from left to right. Proper wordspacing not only improves readability but is more pleasing esthetically.

9/13 HELVETICA LIGHT

5. Wordspacing will vary from line to line when type is set justified.

What is the desirable amount of space between words? Too much or too little makes reading difficult. Words placed too close together force the reader to work harder to distinguish one word from another. On the other hand, words placed too far apart create white spaces that run down the page as "rivers" and disrupt the natural movement of the eye from left to right. Proper wordspacing not only improves readability but is more pleasing esthetically.

9/13 HELVETICA LIGHT

6. Adding letterspacing in order to justify a line of type results in an irregular texture.

What is the desirable amount of space between words? Too much or too little makes reading difficult. Words placed too close together force the reader to work harder to distinguish one word from another. On the other hand, words placed too far apart create white spaces that run down the page as "rivers" and disrupt the natural movement of the eye from left to right. Proper wordspacing not only improves readabil-
→ ity but is more pleasing esthetically.

9/13 HELVETICA LIGHT

Justified and Unjustified Settings

The two most common methods of setting type are generally referred to as *justified* or *unjustified*. Justified settings have equal linelength, with each of the lines aligning on both the left and the right sides of a column (such as the type you are now reading). Unjustified is composed of lines of unequal length that are usually aligned on the left but can also be aligned on the right. (The captions used in this book are unjustified.)

Wordspacing Considerations. One critical difference between justified and unjustified type is the effect on wordspacing.

Ideally, type should be set with uniform wordspacing. When type is set unjustified (flush right or flush left), this is the case (**4**). However, when type is set justified, equal letterspacing is no longer possible because extra space must be inserted between the words in the shorter lines to extend them to the same length as the longer lines (**5**). As a result, the wordspacing is no longer equal.

If the lines of type are of sufficient length, the unequal wordspacing is not noticeable. Unequal wordspacing is less apparent in long lines of type because the extra space is distributed between many words, whereas in short lines the space is distributed between a few words.

When setting type justified, you may be tempted to introduce additional letterspacing in order to compensate for overly generous wordspacing (**6**). Resist the temptation. While this method may improve the wordspacing, it may also draw unwanted attention to the irregular letterspacing, which can be even more objectionable than the irregular wordspacing.

There are more appropriate options. First, consider an unjustified setting, which will ensure even wordspacing. Or you might try increasing the measure to allow more characters per line, which helps to equalize the wordspacing. If the problem exists only on one or two lines, the solution may simply be the use of hyphenation. Finally, you could even have the copy rewritten or edited to fit, provided you are not setting Shakespeare! □

11. Linespacing

As a general guide, text settings are improved with the addition of one or two points of linespacing. It is important, however, to avoid excessive leading because the lines tend to drift apart, which makes the setting appear grayer and affects the pace at which the type is read. In shorter settings, such as in advertisements, this effect can be desirable, but it is not recommended for sustained reading. Alternatively, if your choice is minus linespacing, be aware that when too much space is removed between lines of type, the ascenders and descenders may overlap. The settings will also become very dense.

Factors Affecting Linespacing
Proper linespacing not only improves readability but has an important esthetic function. Unfortunately, there is no formula to determine optimal linespacing. If you consider the following factors involved in determining linespacing, you can see why the decision is more a matter of visual judgment than of mathematics.

Type Size. Average text sizes are usually set with one or two points of linespacing. A smaller text size generally requires more linespacing to make it readable (**1**).

X-height. Some typefaces, such as Helvetica and Century Expanded, have large x-heights and therefore have very little white space between lines when set solid (**2**). Such typefaces require more linespacing than those with small x-heights, such as Garamond and Bodoni.

Linelength. When setting long lines (more than 75 characters), extra linespacing is recommended (**3**). When long lines are set too close, there is a tendency to read the same line twice, called *doubling*. Increasing linespacing helps prevent this.

Linespacing, or leading, like wordspacing and letterspacing, can be used to improve readability. Your choice of typeface, type size, linelength, and copy will all affect the amount of linespacing. With so many factors involved, you can see why proper linespacing is more a matter of visual judgment than of mathematics.

8/12 GARAMOND

1. Additional leading allows lines of small type to be more easily distinguished from one another.

Linespacing, or leading, like wordspacing and letterspacing, can be used to improve readability. Your choice of typeface, type size, linelength, and copy will all affect the amount of linespacing. With so many factors involved, you can see why proper linespacing is more a matter of visual judgment than of mathematics.

12/18 CENTURY EXPANDED

2. Typefaces with larger x-heights require more leading because the lines appear to be closer together.

3. To prevent the same line being read twice, long lines require extra leading.

Linespacing, or leading, like wordspacing and letterspacing, can be used to improve readability. Your choice of typeface, type size, linelength, and copy will all affect the amount of linespacing. With so many factors involved, you can see why proper linespacing is more a matter of visual judgment than of mathematics.

11/20 HELVETICA LIGHT

4. To maintain a horizontal emphasis, type with strong vertical stress requires more leading.

Linespacing, or leading, like word-spacing and letterspacing, can be used to improve readability. Your choice of typeface, type size, linelength, and copy will all affect the amount of linespacing. With so many factors involved, you can see why proper linespacing is more a matter of visual judgment than of mathematics.

12/18 BODONI

5. Typefaces without serifs benefit from additional leading because they lack the horizontal flow that serifs provide.

Linespacing, or leading, like wordspacing and letterspacing, can be used to improve readability. Your choice of typeface, type size, linelength, and copy will all affect the amount of linespacing. With so many factors involved, you can see why proper linespacing is more a matter of visual judgment than of mathematics.

10/15 HELVETICA LIGHT

6. By adjusting the leading, you can easily control the amount of space the copy requires.

Linespacing, or leading, like wordspacing and letterspacing, can be used to improve readability. Your choice of typeface, type size, linelength, and copy will all affect the amount of linespacing. With so many factors involved, you can see why proper linespacing is more a matter of visual judgment than of mathematics.

10/9 HELVETICA LIGHT

Linespacing, or leading, like wordspacing and letterspacing, can be used to improve readability. Your choice of typeface, type size, linelength, and copy will all affect the amount of linespacing. With so many factors involved, you can see why proper linespacing is more a matter of visual judgment than of mathematics.

10/20 HELVETICA LIGHT

Vertical Stress. Letters with a strong vertical stress, such as Bodoni, also require more linespacing (**4**). The strong vertical emphasis draws the eye down the page, which tends to compete with the horizontal flow required of reading. To alleviate this condition, you might consider increasing the linespacing.

This is also the case with condensed typefaces, which tend to have even greater vertical emphasis and therefore may require additional linespacing.

Sans Serif. Some sans serif typefaces, such as Helvetica, may require more linespacing because of their large x-height and lack of serifs. Additional linespacing helps promote a stronger horizontal flow to facilitate reading (**5**). Even sans serif typefaces with smaller x-heights, such as Futura and Univers, benefit from additional leading.

Perhaps the most extreme case is a condensed sans serif with a large x-height, such as Helvetica Condensed. You must take into account not only the x-height and lack of serifs but also the extreme vertical stress.

Copy Length. The amount of copy can also affect linespacing decisions (**6**). You can fit more copy into a given area if the type is set solid or is set with minus linespacing. This can be helpful on jobs where space is a consideration, such as classified ads. However, if a great deal of copy must fit in a small space, the designer must carefully consider the type and arrangement in order to maintain readability.

On the other hand, short copy can be made to fit a larger area by increasing the linespacing. This is a common practice in advertising, where the designer wishes to slow down the reader while adding a touch of elegance.

Be aware, when dealing with generous linespacing, that there is a point beyond which excessive linespacing will cause the setting to lose its sense of unity and to simply appear as a page full of scattered lines.

Designers must continually deal with situations in which the copy is too lengthy, in which case the allotted space will be inadequate. In a case in which no design solution is acceptable, you may suggest to the client that the copy be reworked to resolve the design problem. ☐

12. Length of Lines

In general, the length of a line of type should be comfortable to read: too short and it breaks up words or phrases; too long and the reader must search for the beginning of each line, which can be tiring (**1, 2**). If you have ever found yourself reading the same line twice, the lines were probably too long and the text insufficiently linespaced.

From a design point of view, linelength is dictated by such factors as type size and the amount of copy to be set. In general, the larger the type, the longer the measure should be. For example, a 30-pica line of 11-point type would be acceptable, whereas a 30-pica line of 6-point type would be difficult to read. A reasonable amount of copy set on a very short or very long measure will not present a problem for most readers.

If you are uncertain about linelength, a good rule of thumb is to set the type with 35 to 70 characters per line. Settings within this range are the most comfortable to read (**3**). □

The length

of a line

should be

comfortable

to read:

too short

and it

breaks up

words or

phrases;

too long

and the

reader must

search for the

beginning of

each line.

11/17 HELVETICA LIGHT

1. A very short line-length is difficult to justify and should be set flush left, rag right. Ease of reading will be determined by how carefully the word breaks are handled.

2. Excessively long lines of type are tiring because readers tend to lose track of their place in the text.

3. The optimum line-length allows the type to be set uniformly while remaining esthetically pleasing and comfortable to read.

The length of a line should be comfortable to read: too short and it breaks up words or phrases; too long and the reader must search for the beginning of each line. If you are uncertain about linelength, a good rule of thumb is to set the type with 35 to 70 characters per line.

11/17 HELVETICA LIGHT

The length of a line should be comfortable to read: too short and it breaks up words or phrases; too long and the reader must search for the beginning of each line. If you are uncertain about linelength, a good rule of thumb is to set the type with 35 to 70 characters per line.

11/17 HELVETICA LIGHT

13. Type Arrangements

With an understanding of wordspacing, line-length, and linespacing, we can now consider ways of arranging lines of type on a page. Whether type aligns on the left, the right, or both may at first appear to be a subtlety, but in fact this choice has a great impact on how viewers respond to a design. How you choose to arrange type is a critical decision that affects all typographic communication. Nearly all settings are variations or combinations of six basic arrangements. Let us consider the advantages and disadvantages of each.

1. Justified (flush left, flush right)

2. Flush left, rag right

3. Flush right, rag left

4. Centered

5. Random, or asymmetrical

6. Special settings

Justified (Flush Left, Flush Right)
The most common method of arranging lines of type is called justified. In this arrangement all the lines of text are the same length, so that they align on both left and right (**1**).

Because all the lines of type are the same length and the margins are even, a page of justified type assumes a quiet look. Most reading matter is set justified because this arrangement is best suited for sustained reading comfort. The text does not distract the reader. Its predictability allows for concentration on content rather than design. Justified type is usually employed for material that is lengthy or serious, such as in newspapers, books, or magazines.

One drawback of justified type is the possibility of uneven wordspacing, which can result in "rivers" running through the column of text. This can be avoided if the lines are of sufficient length and the type is properly set. However, if the pica measure is too narrow, wordspacing is difficult to control.

Flush Left, Rag Right
When type is set with even wordspacing, the lines will vary in length. If we align the lines of type on the left, the edges on the right will appear ragged, or "feathered." This arrangement is referred to as flush left, rag right (**2**). Poetry and typewritten copy normally appear this way.

Because of the equal wordspacing, the type has an even texture. The risk of white rivers flowing down the page is eliminated. This is especially appealing when the type is to be set in narrow columns. Moreover, since the lines can run either short or long, hyphenating words may not be necessary. As with justified type, the reader has no difficulty locating the beginning of a new line because the lines are aligned at the left. The ragged edge on the right also adds visual interest to the page.

It is important that the ragged edge create a pleasing silhouette, with no adjacent lines set the same length or set in such a way that a long line is followed by an extremely short one. Be aware that type set rag right can run slightly longer than justified type set to the same measure.

Flush Right, Rag Left
In this instance, the lines are aligned at the right, so that the left side is ragged. This arrangement is referred to as flush right, rag left (**3**).

Because it is used infrequently, this arrangement may create an interesting layout, particularly for short copy such as a caption running along the left side of a picture. As with flush left, ragged right, you have the advantage of maintaining even wordspacing.

Although visually interesting, this setting is more demanding of the reader. Since we are accustomed to reading from left to right, a ragged left edge forces us to pause momentarily in search of the beginning of each line, which is why this arrangement is usually reserved for very short copy.

Centered
Another way to arrange type is by centering lines of uneven length, one over the other, so that both left and right edges are ragged (**4**). Like other ragged settings, centered type has even wordspacing and visual interest. Centered type can give the page a look of quiet dignity.

Centered lines should vary enough to create an interesting silhouette, so avoid stacking lines of the same or similar lengths. Generous linespacing is also recommended—it adds to the dignity of the setting and assists the reader in locating the beginning of each line.

Reading centered lines is demanding, which means it is better suited to small amounts of copy, such as announcements and invitations. Try to break the lines for sense. Keeping phrases and related thoughts on separate lines facilitates comprehension and creates a pleasing shape.

There are six ways of arranging lines of type on a page. The first is justified: all the lines are the same length and align both on the left and on the right. The second is unjustified: the lines are of different lengths and align on the left and rag on the right. The third is a similar arrangement, except now the lines align on the right and rag on the left. The fourth possibility is centered: the lines are of unequal lengths with both sides ragged. The fifth possibility is a random, or asymmetric, arrangement with no predictable pattern in the placement of the lines. The sixth arrangement, special settings, is limited only by the designer's imagination and the computer's capabilities.

JUSTIFIED: 10/14 HELVETICA LIGHT

There are six ways of arranging lines of type on a page. The first is justified: all the lines are the same length and align both on the left and on the right. The second is unjustified: the lines are of different lengths and align on the left and rag on the right. The third is a similar arrangement, except now the lines align on the right and rag on the left. The fourth possibility is centered: the lines are of unequal lengths with both sides ragged. The fifth possibility is a random, or asymmetric, arrangement with no predictable pattern in the placement of the lines. The sixth arrangement, special settings, is limited only by the designer's imagination and the computer's capabilities.

FLUSH LEFT, RAG RIGHT: 10/14 HELVETICA LIGHT

There are six ways of arranging lines of type on a page. The first is justified: all the lines are the same length and align both on the left and on the right. The second is unjustified: the lines are of different lengths and align on the left and rag on the right. The third is a similar arrangement, except now the lines align on the right and rag on the left. The fourth possibility is centered: the lines are of unequal lengths with both sides ragged. The fifth possibility is a random, or asymmetric, arrangement with no predictable pattern in the placement of the lines. The sixth arrangement, special settings, is limited only by the designer's imagination and the computer's capabilities.

FLUSH RIGHT, RAG LEFT: 10/14 HELVETICA LIGHT

There are six ways
of arranging lines of type on a page.
The first is justified: all the lines are the same length
and align both on the left and on
the right. The second is unjustified:
the lines are of different lengths and align on the left
and rag on the right. The third is a similar
arrangement, except now the lines align
on the right and rag on the left.
The fourth possibility is centered:
the lines are of unequal lengths with both
sides ragged. The fifth possibility
is a random, or asymmetric, arrangement
with no predictable pattern in the placement of
the lines. The sixth arrangement, special settings, is
limited only by the designer's imagination
and the computer's capabilities.

CENTERED: 10/20 HELVETICA LIGHT

1. Justified is the most neutral and traditional setting. Because all lines are the same length, the wordspacing is uneven. If the line-length is adequate, however, the variation is minimal.

2. Flush left, rag right is the second most common setting. More visually active than justified, it has the advantage of even wordspacing. Care should be taken to achieve a good rag.

3. Flush right, rag left arrangements are effective for short amounts of copy such as captions and special text. It is increasingly common in magazines.

4. Centered settings usually signify formal messages. They require generous leading and a careful eye for balancing the length of each line for a pleasing, effective shape.

There are six ways

of arranging lines of type on a page.

The first is justified: all the lines are the same length and align both on the left and on the right.

The second is unjustified: the lines are of different lengths and

align on the left and rag on the right.

The third is a similar arrangement,

except now the lines align on the right and rag on the left.

The fourth possibility is centered: the lines are of unequal lengths with both

sides ragged. The fifth possibility is a random, or asymmetric,

arrangement with no predictable pattern in the placement of the lines.

The sixth arrangement, special settings,

is limited only by the designer's imagination and

the computer's capabilities.

RANDOM: 10/20 HELVETICA LIGHT

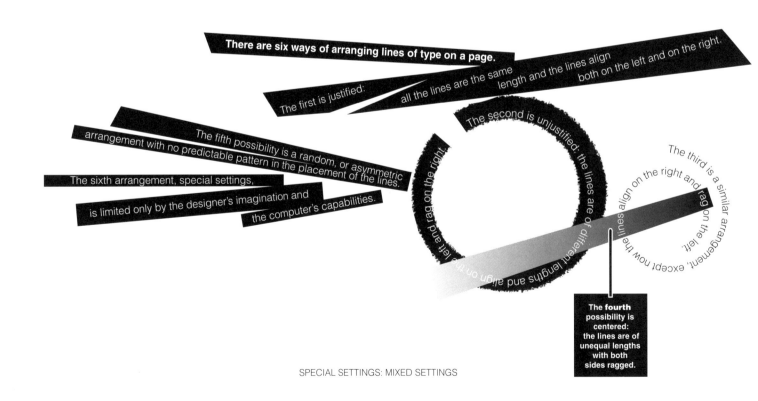

SPECIAL SETTINGS: MIXED SETTINGS

Random, or Asymmetrical

This broad category of type arrangement is a dramatic departure from the other four, as random settings reflect no predictable pattern in length, placement, or arrangement of the lines (**5**). Thanks to their unusual arrangements, random settings can be visually exciting. Although not recommended for textbooks or lengthy reading matter, they provide a dramatic effect when type is used to attract attention. For this reason, random settings are widely used for posters, book jackets, flyers, and advertisements.

With random settings there are no rules to follow. Just set the lines so they look "right." A random arrangement allows for great flexibility and individuality, since no two designers will set the same lines in exactly the same manner. If handled carelessly, a random arrangement can be an unfortunate choice: too much type set randomly can be difficult to read and distract from the message. To avoid such problems, pay close attention to wordspacing, linespacing, and the overall arrangement of the elements.

Special Settings

In addition to the more traditional arrangements discussed in this chapter, modern typesetting is open to complete experimentation, made possible by the advent of the computer. This means unique typographic options can be developed through trial and error, and immediate effects can be judged directly on the monitor. Type no longer needs to be set in straight lines; it can be made to follow elaborate curves, spirals, and waves or to create complex patterns. How well the type can be read is a question that has to be weighed carefully against the esthetic value created by special effects (**6**).

Two more conventional special settings are referred to as *runarounds* and *contour settings* (**7**). A runaround, as the name suggests, is type that surrounds an image, a display initial, or even an empty space. The opposite is a contour setting, where the type takes on the shape of an object with a recognizable silhouette: a ball, vase, lightbulb, or geometric shape, for example. If readability is not a first priority, this setting can be employed.

When planning either a runaround or a contour setting, always make sure there is an adequate amount of type to fit your layout. Try to keep your type evenly spaced. Holes and uneven spacing can be distracting and and will minimize the effectiveness of the intended shape. □

7. Runarounds and contour settings allow the designer to customize the shape of a block of text to a specific purpose.

There are six ways of arranging lines of type on a page. The first is justified: all the lines are the same length and align both on the left and on the right. The second is unjustified: the lines are of different lengths and align on the left and rag on the right. The third is a similar arrangement, except now the lines align on the right and rag on the left. The fourth possibility is centered: the lines are of unequal lengths with both sides ragged. The fifth possibility is a random, or asymmetric, arrangement with no predictable pattern in the placement of the lines. The sixth and the final arrangement, special settings, is limited only by the designer's imagination and the computer's capabilities.

RUNAROUND AND CONTOUR SETTING

There are six ways of arranging lines of type on a page. The first is justified: all the lines are the same length and align both on the left and on the right. The second is unjustified: the lines are of different lengths and align on the left and rag on the right. The third is a similar arrangement, except now the lines align on the right and rag on the left. The fourth possibility is centered: the lines are of unequal lengths with both sides ragged. The fifth possibility is a random, or asymmetric, arrangement with no predictable pattern in the placement of the lines. The sixth arrangement, special settings, is limited only by the designer's imagination and the computer's capabilities.

14. Indicating Paragraphs

1. There are many ways of indicating paragraphs. The two most common are indenting the first line and adding extra linespacing between paragraphs.

1-EM INDENT

The reader must be able to distinguish where one paragraph ends and another begins. This is done in a number of ways.

The most common method of indicating a paragraph is to indent the opening line with a 1-em space, which is a square of the type size.

3-EM INDENT

Indents larger than 1-em can also be used. This paragraph begins with a 3-em indent.

1-LINE SPACE

Paragraphs can also be separated by a half-line or a full-line space. Or a combination of indent and space may be used.

HANGING INDENT

One unusual method is the hanging indent, where the first line of each paragraph begins to the left of the main body of text. This is commonly used in directories.

NO INDENT

Another method is to use neither indent nor space. In this case the only indication that a new paragraph has begun is that the previous line falls short of the full measure. ■ Still another possibility is to

PARAGRAPH MARK

run the paragraphs together in a solid block of type and indicate the start of each paragraph with a typographic device such as a paragraph mark or a box.

10/15 HELVETICA LIGHT

Clear indications of paragraph changes should be provided for readers (**1**). The most common method is to start each new paragraph with a 1-em indent. The text you are now reading is set in this manner. When type is set to a wide measure or a particular effect is desired, larger indents can be used, such as 2 ems or more. Non-traditional paragraph indents may be specified in picas, millimeters, or inches instead of ems.

Paragraphs can also be indicated through additional spacing—usually a half line or full line between paragraphs. Using full-line spaces between paragraphs has an advantage in that lines of type in adjacent columns will always align with each other, which will not happen if you use half line spaces. It is also possible to combine line spaces and indents; variations of this style are quite common in contemporary magazines, books, and advertising.

Another approach is no indentation, that is, to use neither an indent nor additional space between paragraphs. In this case the signal of a new paragraph depends solely on the length of the last line of the previous paragraph. The last line must be shorter than the full measure. If a paragraph ends with a full or almost full line, the reader will be uncertain as to where one paragraph ends and another begins.

A more unusual method of starting a new paragraph is with a hanging indent. The first line of the paragraph is set to the full measure and subsequent lines are indented. This is commonly used for dictionaries and other reference sources.

Another possibility for paragraphing is the method used by early printers: all paragraphs were run together to form a solid block of type, and a typographic device indicated the start of each new paragraph. The traditional paragraph mark looks like this ¶, but any graphic device can be used. One of the most common devices is a square bullet or the traditional leaf or flourish, which looks like this: ❧

While these solutions represent traditional methods of indicating paragraphs, today's technologies provide opportunities to experiment. Paragraphs can be set in unusual shapes or indicated by alternating typefaces, changing type sizes, inserting rules, introducing color, or combining any of the above in countless ways (**2**). In all cases the designer must be sensitive to balance the impact of creativity against any loss of readability. See page 141 for two additional ways of setting the same five paragraphs. □

Johannes Gutenberg was born in Mainz, Germany, sometime around 1397. Little is known about his early years, but it is clear that he was the right man in the right place at the right time.

Gutenberg was the right man because of his familiarity with the craft of the goldsmith and the die maker. He was in the right place because Mainz was a cultural and commercial center. It was the right time because the Renaissance thirst for knowledge was creating a growing market for books that could not be satisfied with traditional handwritten manuscripts.

Handwritten manuscripts were made to order and were usually expensive. They were laboriously copied by scribes who had to either read from a manuscript or have it read to them while copying. This process not only was time-consuming but led to many errors, which had to be corrected. Adding to the expense was the scarcity and high cost of vellum and parchment. As a result, these handwritten manuscripts were limited to a select few: clergymen, scholars, and wealthy individuals.

A relatively inexpensive means of producing multiple copies of books seems to have been developed just a little before Gutenberg began his experiments with printing. This was the so-called block book, whose pages had illustrations and minimal text cut together on the same block. The carved blocks were inked, and images were transferred onto paper.

Gutenberg's genius was realizing that printing would be more efficient if, instead of using a single woodblock to print an entire page, the individual letters were cast as separate blocks and then assembled into pages. In this manner, pages could be corrected more rapidly, and after printing, the type could be cleaned and reused.

6/8 HELVETICA LIGHT

Johannes Gutenberg was born in Mainz, Germany, sometime around 1397. Little is known about his early years, but it is clear that he was the right man in the right place at the right time. Gutenberg was the right man because of his familiarity with the craft of the goldsmith and the die maker. He was in the right place because Mainz was a cultural and commercial center. It was the right time because the Renaissance thirst for knowledge was creating a growing market for books that could not be satisfied with traditional handwritten manuscripts. Handwritten manuscripts were made to order and were usually expensive. They were laboriously copied by scribes who had to either read from a manuscript or have it read to them while copying. This process not only was time-consuming, but led to many errors, which had to be corrected. Adding to the expense was the scarcity and high cost of vellum and parchment. As a result, these handwritten manuscripts were limited to a select few: clergymen, scholars, and wealthy individuals. A relatively inexpensive means of producing multiple copies of books seems to have been developed just a little before Gutenberg began his experiments with printing. This was the so-called block book, whose pages had illustrations and minimal text cut together on the same block. The carved blocks were inked, and images were transferred onto paper. Gutenberg's genius was realizing that printing would be more efficient if, instead of using a single woodblock to print an entire page, the individual letters were cast as separate blocks and then assembled into pages. In this manner, pages could be corrected more rapidly, and after printing, the type could be cleaned and reused.

6/8 HELVETICA LIGHT
WITH 10-POINT HELVETICA BLACK

Johannes Gutenberg was born in Mainz, Germany, sometime around 1397. Little is known about his early years, but it is clear that he was the right man in the right place at the right time. Gutenberg was the right man because of his familiarity with the craft of the goldsmith and the die maker. He was in the right place because Mainz was a cultural and commercial center. It was the right time because the Renaissance thirst for knowledge was creating a growing market for books that could not be satisfied with traditional handwritten manuscripts.

Handwritten manuscripts were made to order and were usually expensive. They were laboriously copied by scribes who had to either read from a manuscript or have it read to them while copying. This process not only was time-consuming, but led to many errors, which had to be corrected. Adding to the expense was the scarcity and high cost of vellum and parchment. As a result, these handwritten manuscripts were limited to a select few: clergymen, scholars, and wealthy individuals.

A relatively inexpensive means of producing multiple copies of books seems to have been developed just a little before Gutenberg began his experiments with printing. This was the so-called block book, whose pages had illustrations and minimal text cut together on the same block. The carved blocks were inked, and images were transferred onto paper.

Gutenberg's genius was realizing that printing would be more efficient if, instead of using a single woodblock to print an entire page, the individual letters were cast as separate blocks and then assembled into pages. In this manner, pages could be corrected more rapidly, and after printing, the type could be cleaned and reused.

6/8 HELVETICA LIGHT

15. Creating Emphasis

1. Italic is the traditional method of creating emphasis within a block of roman text. It is distinctive without being assertive.

Switching from roman to italic type is probably the most common way to draw attention to a particular word or phrase. And because italic is the same size and weight as roman, it does not disturb the overall appearance of the printed page. *Italic is a quiet way of attracting attention.*

14/16 GARAMOND

2. Capitals provide commanding emphasis but may appear overpowering. Small caps, if available, can be used. If this is too subtle, caps and small caps can be combined.

Caps are more assertive than italics; in fact, at times they may border on a command: BUY THIS PRODUCT NOW!

Small caps offer an alternative. Like italics, small caps are UNASSERTIVE because they are small and there are no ascenders or descenders. In fact, they may get lost in the text unless set as CAPS AND SMALL CAPS.

14/16 GARAMOND

Very few jobs are set without some word or phrase requiring emphasis, but which words are to be emphasized and to what degree? Too many words emphasized in too many ways can create an effect opposite from the one intended. The reader, instead of getting the message, will be confused or simply ignore the emphasis.

The number of words and their position within the copy may also affect the degree of emphasis required: a single word buried in the middle of the copy will need more emphasis than a lengthy phrase at the beginning of a paragraph.

Having determined the words to be emphasized, the designer must then decide upon the appropriate degree of emphasis. The following are a few of the more popular methods of creating emphasis. These possibilities range from subtle to assertive.

Roman with Italic

Most text is set in roman type, which means that the most common way to emphasize a word is by changing it from roman to italic (**1**). Italic type is the standard method of indicating such items as titles and foreign words. Because italic is the same size and weight as roman, it does not disturb the overall appearance of the printed page. Italic is a quiet way to attract attention. Be aware that sans serif italics are not always easy to distinguish from their roman counterpart.

Capitals or Small Caps

Another common type change is simply to switch from lowercase to all caps. Capitals are more assertive on the page than italics. In fact, text set in all caps may be misread as a command (**2**). One of the advantages of using capitals is that they enable you to stay within the same font and point size. If you find the caps too assertive, consider setting them one size smaller than the text. Be certain that this reduced type size does not appear too light in juxtaposition to the regular type.

A more refined option is small caps. Small caps can be substituted for capitals in instances where regular caps would be overly assertive and distracting. Because small caps are about the same height as the lowercase letters, they contribute to the uniformity of the page. If small caps lack the desired level of assertiveness, you may wish to combine regular caps with small caps, or letterspace the small caps to create emphasis. Be aware that very few fonts are available with true small caps.

Regular with Bold

An effective way to create strong emphasis is by staying within the same type size and changing the typestyle from regular to bold. Being a heavier version of the regular typeface, bold attracts more attention than either italics or caps. When used in small quantities, bold type can be very effective. However, when dealing with lengthy copy, consider how the excessive blackness will affect the look of the setting and ultimately its readability.

This setting demonstrates how effective a single line or phrase of bold type can be when set within a block of regular type (**3**).

Varying Type Size

A dramatic change in type size is a design approach commonly used for print ads, posters, book jackets, and other applications where strong emphasis is required. But this technique can also be used in text by introducing a larger type size within the copy (**4**). The appropriate size will depend on the degree of emphasis you wish to create and the given linespacing. If an increase in type size within the text is too great, the lines of type will overlap. Normally, increasing or decreasing the type size is reserved for heads, chapter titles, callouts, folios, and related items that do not generally appear within the body of text.

Condensed or Expanded

Emphasis can also be achieved by using condensed or expanded typefaces from within the same family (**5**). This approach is generally limited to sans serif families in which a wider selection of typestyles is available. As always, be aware that if the copy is lengthy, changing the typestyle will alter the "color" of the setting, which may or may not be a desirable effect.

There is a difference between "true" condensed and expanded typefaces and variations produced by the computer. Traditionally, the condensed and expanded typefaces were individually designed as members of a specific type family and not digitally modified.

Today, through digital computer processing, a regular typeface can be subjected to unlimited degrees of compression and expansion often at the expense of the integrity of the original design and its legibility. Where possible, always choose a true-drawn typeface designed as a companion to the roman.

Next to italics, bold type is most widely used for emphasis. Being a heavier version of the regular type, bold attracts more attention than either italics or caps. **It is difficult to ignore words set in bold type!**

14/16 GARAMOND

3. Bold type is more assertive than italics when emphasis is needed.

A dramatic type size change will always draw attention and is a very common design device used in advertising, especially with headlines and blurbs. Be aware that there is a limit to the size increase within text—the larger type may overlap the line above.

14/16 GARAMOND

4. Type size changes can be effective, but careful arrangement of the text is necessary to prevent characters from overlapping.

The use of condensed and expanded type for emphasis is usually limited to the sans serif families, such as Helvetica and Univers, in which a wide selection of typestyles is available.

12/16 HELVETICA LIGHT

5. Condensed and expanded types can be combined with regular type to create varying levels of visual or editorial distinction.

6. When mixing typefaces, strive for contrast. If the typefaces are too similar, the purpose is defeated.

When mixing type within a text setting, choose typefaces that present a contrast. Mixing Garamond with Baskerville is not as effective as mixing Garamond with **Helvetica**.

14/16 GARAMOND

7. The effect of color can be created through the use of tints, which are specified by screen percentages.

8. The underscore, overscore, and strike-through provide visual interest without changing the typeface.

UNDER
OVER STRIKE THROUGH

9. Rules can help organize information or be used to add character.

Garamond	Old Style	1617
Baskerville	Transitional	1757
Bodoni	Modern	1788
Century	Slab Serif	1895
Helvetica	Sans Serif	1957

14/21 GARAMOND WITH 1/2-POINT RULES

Mixing Typefaces

When mixing typefaces, choose two that present some contrast with each other (**6**). A marked difference will make the effect appear deliberate rather than accidental. For example, mixing Bodoni with Baskerville or Baskerville with Garamond may be too subtle and not provide sufficient contrast. And worse, this might even create the impression that you have mistakenly used the wrong font. A better combination might be Garamond and Helvetica.

Color

Color is perhaps the most dramatic means of attracting attention. Even a single letter of any size printed in color cannot be ignored. Color can also help to establish a mood. There is an emotional difference suggested by every color, whether it be fire-engine red, sky blue, or baby pink.

If a job is limited to a single color and you are using larger text sizes, you can create the effect of a second color through the use of screens (**7**). Always output samples to see the tint each screen produces. Often what you see on the monitor does not match the printed piece. The appropriate screen will be determined by such factors as the effect you want to create and how the tint is utilized. Traditionally, tints were produced in values of ten: 10%, 20%, 30%, etc. Now any value can be specified.

Underscores

Underscoring is another way to create emphasis (**8**). In most cases the underscore falls just below the baseline and breaks for descenders. If you want the underscore to fall below the descenders, make sure there is enough linespacing to accommodate it. Besides underscores, you might also consider overscores and strike-throughs.

Rules

Rules can help to visually organize material and add character to a printed piece. The weight of a rule, like linespacing, is specified in points and fractions of points (**9**). Some rules are also referred to by name; for example, a 1/4-point rule is commonly referred to as a hairline rule (see page 20). Rules can also be created as a series of dots, dashes or of varying weights, which you can see in the rule above the caption for figure 9. When using rules, always consider the amount of space you want above and below the rule. The length of the rule, like linelength, can be specified in picas, as well as inches or centimeters.

Reversed Type

Type dropped out of a black (or color) background is known as *reversed type* and is a common means of creating emphasis (**10**). However, there are drawbacks to this effect. Reversed type has a tendency to sparkle, and long passages may go unread.

When reversing type, special considerations must be given to selecting the right typeface. Normally, when type is printed black on white, the black ink tends to spread, making the strokes heavier. This is called "ink squeeze." When the type is reversed, the black ink now spreads into the white type areas, making the strokes narrower and in some cases nonexistent.

Reversing type becomes even more critical when type is dropped out of a full-color image; in this case the type must not only drop out of all four color plates but also print in perfect register in order to be legible.

These cautions are not meant to suggest that you should never reverse type, but they may serve as a warning, especially if you are using small typefaces or typefaces having exceptionally fine strokes or serifs, such as Bodoni.

Boxes

Boxes or squares can be generated in two basic styles: as open, or outlined, boxes and as solid, or filled-in, boxes (**11**). They have a number of typographic uses, the most common being for order forms and checklists. In this book an outline box is used at the end of each chapter.

Boxes can be created in any size. The traditional box is a square of the type size: a 12-point box is 12 points square. When set, it aligns with the top of the ascender and the bottom of the descender. Therefore it will appear much larger than the text. If this is undesirable, you may prefer a box that is the square of the cap height. This is slightly smaller than the traditional box and can be set base-aligning. A further option is a box that matches the x-height and base-aligns, which attracts attention but does not overpower the text.

On the other hand, if you are setting a box for a practical purpose, such as checking off items, make sure it is large enough to fulfill its function.

Occasionally you may prefer to emphasize a word or phrase by drawing a custom box and framing the copy. The borders of these framed boxes can be specified in any weight or thickness and created in a wide range of styles.

When reversing type,

consider the typeface carefully.

Avoid small typefaces or

typefaces having exceptionally fine strokes

or serifs, as they tend to fill in

when printed.

10. Reversed type is an effective means of creating emphasis, as long as its use is limited and the type is large enough to read.

11. Boxes can be customized to fill any purpose.

□ 14 point type with open x-height box.

■ 14 point type with solid x-height box.

☐ 14 point type with 14 point outline box.

■ 14 point type with 14 point solid box.

14 point type with oversize box.

14 point type with drop-shadow box.

14 point type with custom box.

14 point type with reverse box.

12. Bullets generally
look best when centered
on the line of type.

• 12 point Garamond with small bullet.

• 12 point Garamond with medium bullet.

● 12 point Garamond with large bullet.

13. Because leaders
guide the eye across a
page, they are often
used in a table
of contents.

. .

DOT EVERY 6 POINTS

.

DOT EVERY 12 POINTS

.

DOT EVERY 24 POINTS

14. Type set in an
unexpected manner
will attract attention.

Although not type, handwriting can be an excellent means of attracting attention.

Bullets

Bullets are solid round dots or squares that can be created in any size and used to emphasize items in a list (**12**). The size you choose is dictated in part by esthetics and in part by how strongly you want to emphasize a given item. The best position for a bullet is centered on the lowercase characters (x-height). If the bullet is fairly large, you may prefer to center it on the cap height.

Leaders

Leaders are a series of dots designed to guide the eye across a page, for example, in a table of contents, price list, or timetable (**13**).

The size and distance between the dots can vary, but it is important that the dots fall into a predictable pattern. There are two basic leader patterns: aligning leaders (where dots align vertically down the page) and diamond leaders (where dots are staggered to form a diamond pattern vertically).

Position

One of the simplest methods of attracting attention is by positioning copy in a place or manner that is unexpected. For example, it is impossible to ignore graffiti scribbled on a wall or a poster. It may be disturbing but it attracts attention. Because most type is set horizontally, simply setting the copy at an angle will set it apart (**14**). This approach is usually restricted to small amounts of copy, such as heads, as no one wishes to read lengthy copy set in this manner.

Handwriting

Although this chapter is concerned primarily with the creative use of type, you should not dismiss handwriting as a means of creating emphasis, particularly for headlines and short statements. There is a quality to handwriting that is difficult to overlook. It may be its spontaneity, personal touch, or elegance. Whatever the reason, the informal character of handwritten script not only attracts attention but serves as a contrast to structured typography.

Dingbats

Over the centuries, hundreds of typographic dingbats and ornaments have been designed for every imaginable purpose (see page 158). There are brackets, braces, flourishes, decorative borders, and countless other images that, when used appropriately, can be an effective way of attracting attention.

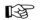 Who can ignore a pointing finger? □

ith virtually unlimited display typefaces available, the designer has opportunities that did not exist a generation ago. New technologies allow for typographic expressions from the traditional to the most outlandish. In some cases display type may even serve strictly as a design element whose primary purpose is not conveying information but simply attracting attention or creating an interesting texture.

Although this section deals primarily with larger display sizes, this does not mean that type used for display is restricted to 16 points and above. A text size type, by its position, color, or surrounding white space, may function successfully as display.

16. Selecting Display Type

Many of the design principles appropriate for text type can also be applied to display type. Since display type's primary purpose is to attract attention, however, you must consider additional factors as well.

First, consider the various ways you may be using display type. For example, the display type selected for a chapter title in a book serves a very different function from the type used in magazines, advertisements, and billboards. In the first instance, the reader is already involved in the book, and the display type merely signals a new chapter. In a magazine the display type generally reflects the spirit of an article. In an advertisement the display type is meant to attract the attention of readers, engage their interest in the copy, and entice them to buy a product while simultaneously competing with other ads. On a highway billboard the type must be read quickly while the viewer travels by in a moving vehicle.

Next, consider your audience: is the reader a child buying a candy bar, a driver looking for a road sign, a scientist studying a reference book, or a consumer seeking information on cosmetics? All the above will influence both the selection of typeface and your final design.

Harmony or Contrast

When selecting a display type, first consider the relationship between it and the text type. Will it be from the same family as the text type, or will it be in contrast to it? For example, if the text is Bodoni, the display type could be a larger size of Bodoni. Or it could be a variation of Bodoni, such as Bodoni Bold, Bodoni Condensed, or Ultra Bodoni, which would create harmony between display type and text.

If you prefer contrast, select a typeface from a different family. To be effective, the contrast should be obvious—a bold sans serif display type with a roman serif text face, for example.

Not all combinations are successful. As a rule, two similar typefaces from different families may produce a weak result because of their lack of contrast. It would be ineffective to combine Garamond with Baskerville, for example. The same weak contrast (see page 112) is also produced when mixing two similar sans serif typefaces, such as Helvetica and Futura.

Expressive Display Type

Display types have personalities: they can create a wide range of expressions, from solemn to shocking. As you work with display type, you will become aware of these attributes. Roman typefaces, like ancient Roman inscriptions, are dignified, austere, and graceful. Egyptian and slab serif typefaces have a strong presence; they are forceful and assertive. Sans serif faces create a modern, businesslike quality, an efficient, no-nonsense feeling, while the moods created by script typefaces are as varied as the handwritings they simulate.

Study the words *Rome, circus,* and *steel* (**1**). They are set in three different display faces. Decide which face you feel is the most appropriate for each word. You will probably find that most people will agree with your choice.

Ornate Display Type

If the copy is a short or easily recognizable word or phrase, the typeface can be ornate or decorative and still communicate its meaning. Easily identified words are almost indestructible. For example, the word *Sale* is recognizable regardless of the typeface (**2**). On the other hand, if the words are lengthy or unfamiliar, an ornate display face may confuse the reader or go unread (**3**).

Text Type as Display Type

Type used for display need not be 16 points or larger. A text-size type, by its position, color, or surrounding white space, may function successfully as display. The notion that the larger the type, the greater the success in attracting attention is not necessarily true. Bigger is not always better. □

Display type

does not have to be large

to attract attention.

ROME **CIRCUS** **STEEL**

ROME CIRCUS STEEL

ROME CIRCUS STEEL

SALE SALE SALE

SALE SALE SALE

SALE SALE SALE

ENCYCLOPEDIA

17. Arranging Display Type

1. The first consideration when using display type is to determine which letters should be capitalized.

DESIGNING WITH DISPLAY TYPE
ALL CAPS

designing with display type
ALL LOWERCASE

Designing With Display Type
CAP THE FIRST LETTER OF EVERY WORD

Designing with Display Type
CAP FIRST LETTER OF IMPORTANT WORDS

Designing with display type
CAP FIRST LETTER OF FIRST WORD ONLY

Having reviewed some of the factors determining your choice of display types, now consider ways of setting and arranging the type. First, let's begin with five basic settings of a single line of type, using the words *designing with display type* (**1**). The basic choices are as follows:

1. All caps
2. All lowercase
3. Cap first letter of every word
4. Cap first letter of important words
5. Cap first letter of first word only

Don't be misled by what seems to be only a slight difference between the last three settings. The use of capitals in a word may seem insignificant, but remember that caps can change not only the way the word looks but also its impact. Consider, for example, the impact of your name written in lowercase letters. In typography even the most subtle changes in settings can produce very noticeable differences.

Once you have determined how you wish to set the type, now consider its arrangement. Suppose you have decided to work with all caps. Here are six possible ways to arrange the words:

1. Type set on one line
2. Flush left, rag right
3. Flush right, rag left
4. Centered
5. Random, or asymmetrical
6. Special settings

Using the first five arrangements, you can see the wide range of possibilities available to you (**2**). For special settings see page 126. Notice how the various settings differ in terms of readability and character. These examples are a mere inventory of basic ways to create a typographic effect and should serve simply as a point of departure. Your final selection will depend on the needs of the specific project.

In spite of the many solutions possible, the majority of typographic problems are solved by one of the first two arrangements: type set on one line or on more than one line as flush left, rag right. These arrangements do not suggest a lack of imagination on the part of designers. They happen to be the most adaptable while being easy to read. □

2. Once you have determined which letters to capitalize, display type can be arranged according to a number of basic styles.

DESIGNING WITH DISPLAY TYPE

FLUSH LEFT, RAG RIGHT

DESIGNING WITH
DISPLAY TYPE

DESIGNING
WITH
DISPLAY TYPE

DESIGNING
WITH
DISPLAY
TYPE

FLUSH RIGHT, RAG LEFT

DESIGNING WITH
DISPLAY TYPE

DESIGNING
WITH
DISPLAY TYPE

DESIGNING
WITH
DISPLAY
TYPE

CENTERED

DESIGNING WITH
DISPLAY TYPE

DESIGNING
WITH
DISPLAY TYPE

DESIGNING
WITH
DISPLAY
TYPE

RANDOM, OR ASYMMETRICAL

DESIGNING
WITH
DISPLAY TYPE

DESIGNING
WITH
DISPLAY
TYPE

DESIGNING WITH DISPLAY TYPE

18. Letterspacing and Wordspacing

1. Delete space between circular letters and add space between vertical letters to achieve optical letterspacing.

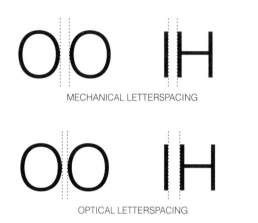

MECHANICAL LETTERSPACING

OPTICAL LETTERSPACING

2. For characters with angular or overhanging strokes, delete space to achieve optical letterspacing.

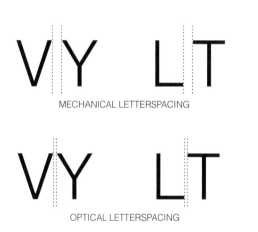

MECHANICAL LETTERSPACING

OPTICAL LETTERSPACING

3. All-caps settings, particularly those with serif letterforms, lend themselves to generous letterspacing. Lowercase settings are less commonly treated in this manner.

N A P O L E O N

n a p o l e o n

Since display type is generally large, any inconsistency in letterspacing or wordspacing is distracting and tends to hinder readability. This is seldom a problem with lowercase letters because they tend to set evenly, but words set in all caps often have inconsistent letterspacing. To correct this, you must open up some letter combinations and tighten others.

Most design programs have an automatic kerning feature to ensure that letters fit together properly. Despite the sophistication of these programs, you may still need to adjust some letters individually. Let your trained eye, not the computer, be the final judge.

Equal *mechanical* letterspacing does not ensure equal *optical* letterspacing. Here are some guidelines regarding specific letter combinations and recommended letter adjustments.

Between circular letters, such as two *O*'s, less space is required than between straight letters, such as an *I* and an *H* (**1**). Angular letters and letters that have overhanging strokes, such as *V*, *Y*, *L*, *A*, and *T*, also require less space and, in some cases, extreme kerning (**2**).

Whether you add or delete space, most adjustments will be subtle, but they will appear to make a difference. Remember, if you adjust the letterspacing, you must also adjust the wordspacing so that both are compatible.

Words set in all caps, such as heads or titles, are generally improved by open letterspacing. Generous spacing between uppercase letters seems to enhance the dignity of the setting. Letterspacing lowercase letters is less common and therefore can also be very effective (**3**). □

Display initials (or initial caps) can be an effective typographic device to attract attention and direct the eye to the opening of a paragraph or section. A display initial may be raised, inset, or hung in the margin. Other methods of using display initials are probably variations on these three. In all instances, optical alignment plays an important part in a successful treatment.

Raised Initials

A raised initial base-aligns with the first line of text (**1**). The amount of indent is dictated by the width of the display initial and by your eye to achieve the desired effect. Although the initial is usually set to align with the text on the left, you may prefer to indent the initial so that it is positioned well inside the measure.

Consider also the space following the raised initial. Display letters that do not finish with a vertical stroke, such as *T*, *V*, and *F*, may create too much space between the display initial and the following letter. This can be corrected by tightening the space between the display initial and the text type to ensure the first word is unified.

Inset Initials

An inset, or drop, initial is set into the text (**2**). A number of lines must be indented equally to allow space for the initial. The exact number of lines and the amount of the indent are dictated by the width and depth of the initial. An inset initial looks best when it aligns at the top with the cap height of the first line of type and on the bottom with the baseline of another line of type.

There are many variations on inset initials. For example, with a cap *A* you may wish to set the first line of the text closer to the initial than the lines that follow. Or with a cap *V* you may prefer to have the type follow the contour of the letter rather than have the initial sitting in a rectangular white space.

Hung Initials

The hung initial is probably the least common of the display initials. It is usually positioned in the left margin outside the measure and aligns with the first line of type, although the hung initial can be placed along the column wherever it seems to work best (**3**). The distance between the initial and the text can be determined mechanically or optically. □

Display initials offer the designer an effective method of embellishing a printed piece. Simply by adding a display initial, the designer can completely change the look, feeling, and character of a printed piece. Display initials fall into three basic categories: raised, inset, and hung. Other methods of using display initials are variations on these.

9/13 HELVETICA LIGHT WITH 45-POINT FETTE FRAKTUR

1. Raised initial: letterform sits on the first line and projects above the block of text.

Display initials offer the designer an effective method of embellishing a printed piece. Simply by adding a display initial, the designer can completely change the look, feeling, and character of a printed piece. Display initials fall into three basic categories: raised, inset, and hung. Other methods of using display initials are variations on these.

9/13 HELVETICA WITH 50-POINT ARNOLD BÖCKLIN

2. Inset initial: letterform is custom-fitted into the block of text.

display initials offer the designer an effective method of embellishing a printed piece. Simply by adding a display initial, the designer can completely change the look, feeling, and character of a printed piece. Display initials fall into three basic categories: raised, inset, and hung. Other methods of using display initials are variations on these.

9/13 HELVETICA WITH 65-POINT GREYMANTLE

3. Hung initial: letterform is hung in the left margin.

20. Optical Considerations

1. When centering or aligning elements, the eye is sometimes better than the ruler.

MECHANICAL CENTER

OPTICAL CENTER

2. Some letters require adjusting in order to align optically.

IRREGULAR
CAP LETTERS,
SUCH AS A, J,
C, O, T, V,
AND W, MUST
BE ALIGNED
OPTICALLY.

18/22 HELVETICA LIGHT

3. The linespacing in upper- and lower-case settings may have to be adjusted in order to appear optically equal.

TYPE SET IN
ALL CAPS CREATES
EQUAL LEADING,
but when type is set in
lowercase, the leading
may appear irregular.

18/22 HELVETICA

Designers spend a great deal of time fine-tuning their designs by adding or removing space between letters and lines of type to achieve a desired effect. They understand that just because the space between letters or words is *mechanically* equal, it may not appear *optically* or visually balanced. By the same principle, a dot set in the center of a square is *mechanically* centered, but to look *visually* centered, the dot must be raised slightly above center (**1**).

The same principle applies to a line of type, or the crossbar on the cap *H*, or any image you want to center on a page. There should always be fractionally more white space below the image than above.

Two situations that require similar optical considerations are, first, the vertical alignment of caps and, second, the space between lines having too many, too few, or no ascenders and descenders.

Optical Alignment

When lines of display type are set flush left, the vertical alignment may seem irregular, especially when the first letter in each line is a cap. Letters having straight vertical strokes, such as *B, E, F, H, I, M, N, P,* and *R,* align perfectly, while irregular letters, such as *A, J, O, T, V,* and *Y,* may seem out of alignment even though the type is mechanically correct. To achieve better alignment, move the letters slightly left or right until they appear optically correct (**2**).

There are times when no amount of adjusting seems to work. For example, the cap *T* can be awkward; no matter what you do, it will not appear to align. If you align the vertical stroke, the crossbar juts into the margin. If you align the crossbar, the letter appears indented. Neither solution is satisfactory. You will need to experiment by visually adjusting the characters until the result looks acceptable.

Optical Linespacing

Just as there are optical discrepancies when you align display type flush left, there may also be optical irregularities in linespacing (**3**). When display type is set in all caps, the linespacing appears equal because there are no ascenders and descenders. With lowercase type, however, ascenders and descenders can play tricks on your eyes, making some of the lines appear closer together. In such cases, the space between certain lines may have to be increased or decreased mechanically until you feel the linespacing looks optically correct. □

How you handle punctuation, whether in display or text settings, can have a decided visual impact on your design and in some cases even affect readability. Here are some design considerations you should keep in mind when working with display type where punctuation is highly visible.

Hung Punctuation

Small punctuation marks (commas, periods, hyphens, apostrophes, asterisks, and quotation marks) have less weight than full-size characters and, when set inside the measure, may create visual indents in the flush vertical alignment. For this reason, you may wish to consider setting small punctuation marks outside the measure in order not to disturb the vertical type alignment. When punctuation marks are set outside the type measure, they are referred to as "hung" punctuation (**1**).

Larger punctuation marks (colons, semicolons, question marks, and exclamation points), which have the same visual weight as full-size characters, are set within the measure. The em-dash, because of its length, is also set within the measure.

Keep in mind that hanging punctuation is not an automatic feature available in many design programs. In these instances, the designer must manually create this refinement.

Space After Periods

Normally, a single wordspace is required after a period. This is fine for the end of a sentence but too generous when periods follow an abbreviation. With display type, always use less-than-normal wordspacing when setting abbreviations. In some cases, because of the configuration of the letters, abbreviations can be set with no wordspacing at all, as in U.S.A. (**2**).

Enlarging Punctuation Marks

Punctuation marks can be used as a design element to emphasize a point. For example, a quote can be made more dramatic by setting the quotation marks in a larger type size than the quote itself, or an oversized question mark can be used to bring attention to a query (**3**). Exclamation marks also lend themselves to dramatization.

It is also possible, though less common, to reduce punctuation marks when there is either an unusual amount of punctuation or the copy is set in bold type. To create a better visual balance between the punctuation and the copy, consider setting the punctuation marks one or two sizes smaller than the display type.

1. Hung punctuation can make a justified setting more attractive.

"When punctuation marks are set outside the type measure, they are referred to as 'hung' punctuation. Hanging punctuation in the margin preserves the straight vertical edge created by flush lines of type. Small punctuation, such as commas, periods, hyphens, apostrophes, asterisks, and quotation marks, have less weight than full-size characters, and when set inside the measure they may create 'holes' in the flush alignment. This can be distracting, especially for small amounts of type in highly visible areas, such as ads."

10/14 HELVETICA LIGHT

2. Space after periods often requires adjusting.

Ms. S.L. Chong, N.Y.C., N.Y.

Ms. S.L. Chong, N.Y.C., N.Y.

18-POINT HELVETICA LIGHT

3. Enlarged punctuation marks can add drama to a quotation.

"A quote can be dramatized by setting the quotation marks larger than the type.**"**

14/20 HELVETICA LIGHT WITH 65-POINT POSTER BODONI QUOTES

5. Some long dashes
may require adjusting.

Many designers feel that
the em-dash—being too
long—creates a hole in the
text. They prefer to use a
shorter dash—with a small
amount of additional space
on either side of it.

14/17 HELVETICA LIGHT

6. When copy is set in all
caps, some punctuation
may require adjustment.

(SET-WIDTH)

(SET-WIDTH)

18-POINT BODONI

7. Try to make the setting
easy to read and
pleasant to look at.

BREAK COPY

NOT ONLY

FOR THE SHAPE

BUT ALSO

AS A MEANS

OF IMPROVING

READABILITY.

18/30 HELVETICA LIGHT

Short and Long Dashes

Most typefaces have two standard dashes: the
em-dash and the *en-dash*, also referred to as the
long dash and the *short dash*. Some designers
feel that the em-dash creates a hole in the text,
so they use an en-dash or even a hyphen. But
these dashes are editorially inappropriate.

It is better to customize the em-dash by com-
pressing it approximately 25% and adding a
small amount of extra space on either side (**5**).
Remember that dashes have specific editorial
uses. You may need to check with the client
or copywriter before you decide to use cus-
tomized dashes.

Hyphens

Hyphens are designed to be centered on the x-
height. This is ideal for lowercase letters but too
low for words set in all caps. When setting
hyphenated words in all caps, center the hyphen
on the cap height. The same applies when setting
dashes and parentheses (**6**).

When reviewing typeset copy, check for
excessive or awkward hyphenation. In general,
try to avoid hyphenation with unjustified type,
where the option exists to vary the linelength.

In justified settings, where hyphenation is
necessary, try to avoid two consecutive lines in
which hyphens occur. In all cases, three or more
consecutive lines ending with a hyphen is con-
sidered bad typography. Also avoid hyphenating
a proper name that you cannot verify, and always
consult a dictionary if you are uncertain about a
specific word break.

Breaking Lines

When setting unjustified copy, study it carefully
and decide where you want to break the lines.
The preferred treatment is to "break for sense,"
that is, so that words can easily be read while
forming an interesting pattern on the page (**7**).

To accomplish this, you may have to reconsid-
er your design or request that the copy be
altered. Obviously, the latter can be a problem
when you are dealing with classic literature or
other forms of copy that cannot be altered. In
most cases, however, there is great deal of give
and take between designers, copywriters, and
editorial personnel. □

Until now we have dealt with the more fundamental ways of setting and arranging type. Once you understand these basics, you should begin to explore the many fascinating possibilities when designing with type. With today's technologies, there are many inventive ways of drawing attention to your message.

Technology has always played a major role in the creative life of the designer. Over the centuries innovations in printing and typesetting have made it possible for designers to explore new typographic expression. With the improved printing presses and smoother papers of the eighteenth century, typefaces became more refined. In the early nineteenth century, wood type enabled designers to create large customized lettering. In the 1970s the widespread use of phototype freed design from the restrictions of metal type by ushering in an era of freeform typography.

However, no technological innovation of the past has provided more opportunities for creative experimentation than digital typography.

Digital Typography

Like many artists, graphic designers continually challenge tradition. In recent years many designers have rejected traditional type design and conventional standards of typographic excellence. They have demanded new typefaces and standards to replace what they consider to be old typefaces and old conventions.

The introduction of digital typography has placed typographic control directly in the hands of designers. Now a computer is all they need in order to experiment with layouts, manipulate type, or even design a new typeface.

From this innovation has come a dizzying array of new typefaces, the likes of which had never been seen before (1). Some are quirky, intentionally imperfect, and others are very personal. Many challenge the limits of legibility. Designers have seized upon these new tools and are generating a new and exciting approach to typography.

Computer Applications

Most design applications have been created to provide graphic designers with total typographic control. With keyboard, mouse, and monitor, they can change typefaces, size, weight, and spacing and print in minutes, all without the need

1. Some of the innovative typefaces that help to expand the boundaries of what is acceptable.

for outside services. With illustration and image-editing applications, they can achieve special effects, distortions, and custom type manipulation (**2**). Almost any design that can be imagined can be produced through the use of these applications.

With this control come new responsibilities. Designers can no longer rely upon the expertise of outside typesetters. Decisions that contribute to typographic excellence, such as spacing, kerning, and hyphenation, are now the designer's responsibility.

For example, when it comes to selecting a typestyle, there is a difference between *true* typestyles and those created by the "style" feature in computer programs. Garamond Bold selected from the alternative typeface menu is a true boldface drawn as a companion to Garamond Roman, while Garamond Bold selected through the style feature is a poor imitation. The same applies to italics, caps and small caps, and a number of other typestyles.

2. Through the use of computer applications and specific filters, alone or in combination, the designer can explore and create unlimited typographic distortions.

Today it is a challenge for designers to avoid being seduced by technology. You should not expect the computer to provide the design solution. As sophisticated as computer applications may be, they are only tools for the creative mind. Truly successful designs begin with ideas and concepts. As you execute your designs on the computer, your knowledge of typography, combined with your trained eye and esthetic judgment, will provide the path to the most creative solution.

Typography Today

As each generation of designers contributes something new and innovative, typography as an art continues to grow and change, drawing both criticism and praise. This scrutiny is not unprecedented; typographic change and experimentation have been criticized throughout history. Gutenberg's type was too cold and lacked the warmth of handwritten scripts. Transitional typefaces like Baskerville were hard on the eyes and made the reader dizzy. Modern typefaces like Bodoni had too much contrast. Sans serif typefaces were too hard to read.

The controversy about typography continues. No longer is type required to be "invisible," that is, to serve as a quiet vehicle for extending the meaning of the text. Now type can be visually exciting, entertaining, challenging, and in the best examples, fine art, but not always without provoking criticism. Some designers seem to base their choice of typefaces and settings more on a quirky personal esthetic than on a more practical and readable one. In such cases the designer may destroy the text and frustrate the reader. As a result, the message fails to be communicated.

As some designers welcome change and the freedom to experiment, others believe that the old should be discarded in favor of the new. Still others believe the old and the new can coexist, which will lead to a richer, more diverse world of typographic expression.

In conclusion, there is no universal design solution when it comes to typography. Students should keep an open mind, embrace all forms of typographic expression, and from this perspective develop their own personal esthetic.

Hopefully, each new generation of graphic designers will continue to redefine the boundaries and conventions of their art. Some innovations will withstand the test of time, while others will simply represent passing fashions. All will add to the rich history of typography. □

At one time, comping, character counting, copyfitting, and specifying type were fundamental skills practiced by every graphic designer. Today's technologies have certainly reduced the need for these traditionally indispensable skills. Although most designers set their own type today, the benefits of understanding these traditional skills far outweigh the investment of time required to learn them.

23. Comping Type

1. An enlarged diagram showing how the pencil lines match the x-height of a specific typeface.

2. A good comp simulates printed type. The lines should be evenly spaced and match the x-height of the type you are representing.

USE SHORTER LINES TO END PARAGRAPH

1-EM INDENT

3. A quick method to indicate type is to draw a series of wavy lines.

Comping is a method of representing the look of printed type with a pencil and paper. Comping requires little time to learn and offers an ideal way to become familiar with the individual characteristics of various typefaces. Creating comps also teaches discipline and develops hand skills. Only a few tools are required for comping: pencils (ideally HB and 2H), paper, tape, type gauge, T-square, and triangles.

Comping Text Type

When comping text type, you need only suggest the lines of type, not render each individual letter and word. This is accomplished by drawing two parallel lines for every line of type. The distance between the lines should match the x-height of the specific typeface, *not the cap height or the point size of the type* (**1**).

Let's assume you wish to make a comp of 20 lines of 10/12 Helvetica by 16 picas, flush left, rag right, in two paragraphs with a 1-em indent.

First, square the paper and tape it firmly to the work surface. Draw a box 16 picas wide by 20 picas deep. (These guidelines represent the text area and should be drawn lightly. They do not appear on the printed page and can be distracting.) Next, using a type gauge (see page 133), draw a small dot every 12 points down the left side. These dots represent the baseline-to-baseline measurement (10 points of type plus 2 points of linespacing).

To establish the x-height, use a 10-point x from the Helvetica specimen on page 94. Lining up a piece of scrap paper alongside the type specimen, mark the x-height along the edge of the paper with two small dots, one for the baseline and one for the meanline.

Next transfer the x-height to your comp, lining up the baseline you marked on the scrap of paper with the baselines you drew on your comp. Now add dots to indicate meanlines, this will allow you draw x-height spaced lines.

Using your T-square, draw in the lines as indicated (**2**). Try to keep all the lines the same weight to create the uniform appearance of printed type. Since you want the effect of rag right type, do not draw the lines completely across the measure. The ragged edge should be visually interesting. If the type is justified, lines of equal length should be drawn, approximating the appearance of the printed type.

A far more rapid, less precise method of indicating text type is to simply draw a series of wavy lines. As long as you maintain the approximate x-height and linespacing, you will have an adequate representation of actual type (**3**).

Comping Display Type

When comping display type, you must carefully trace each letter so the copy is readable and the typeface recognizable. You will need tracing paper, sharp pencils, and a printed specimen of the typeface you intend to comp, preferably one that shows the complete alphabet in both uppercase and lowercase letters. We will use 72-point Helvetica (see page 86) to comp the word *Typography* in both upper and lowercase and in all caps (**4**).

First, lightly draw the baseline on the tracing paper. Next, lay the tracing paper over the letter to be traced, making sure the baselines are properly aligned. Using a sharp pencil (2H or 4H), trace the outline of the first letter carefully, then move the tracing paper and trace the second letter. As you do this, consider the letterspacing carefully; try to keep the spacing between letters visually even (see page 120). Rounded letters, such as *O*, *C*, or *G*, should fall slightly below the baseline in order to appear optically aligned.

When the comp is finished, fill in the letterforms with a softer pencil (HB or 2B). Be aware that the type, when set, will appear blacker and more assertive than your comp. However, there is no need to finish the comp in ink; pencil is adequate. Inking the letterforms tends to exaggerate any imperfections. ☐

4. When comping display type, pay particular attention to letterspacing. The spacing between letterforms must be visually, not mechanically, balanced.

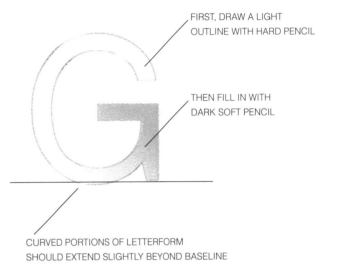

FIRST, DRAW A LIGHT
OUTLINE WITH HARD PENCIL

THEN FILL IN WITH
DARK SOFT PENCIL

CURVED PORTIONS OF LETTERFORM
SHOULD EXTEND SLIGHTLY BEYOND BASELINE

TIGHT LETTERSPACING
BETWEEN FORMS THAT OVERLAP

TIGHT LETTERSPACING
BETWEEN TWO CURVED STROKES

OPEN LETTERSPACING
BETWEEN TWO VERTICAL STROKES

CURVED FORMS EXTEND
SLIGHTLY BEYOND BASELINE

TIGHTER LETTERSPACING
WITH ANGLED STROKES

Copyfitting is the process of calculating how much space typewritten copy, called *hard copy*, will occupy when set in type. It is essential that any designer working with a manuscript know how to copyfit, since it makes no sense to select a particular typeface and type arrangement if you are not certain the type will fit the intended space. To determine this, you must first establish the number of characters in the manuscript.

Electronic Character Counting

The most efficient method of copyfitting is to have the client provide the copy in electronic form, on disk or via e-mail. Most often, opening these files within a word processing program will automatically give you the exact number of characters. Otherwise, the number can easily be ascertained by bringing the copy into a design processing program.

Another simple method of character counting is to scan the manuscript and have the copy converted by OCR (optical character recognition) software. This not only eliminates the chore of retyping the text but also supplies a character count. (Bear in mind, however, that OCR scanning may introduce typographic errors. The copy must be very carefully proofread afterward.)

Traditional Character Counting

In the event that electronic files are unavailable, copy may be supplied to you in the form of a typed manuscript. In this case the character counting must be done manually. It would take an endless amount of time to count each character of a large manuscript, but there is a simpler method to arrive at an accurate character count.

The computer and the traditional typewriter produce hard copy in one of three formats: 10 pitch, referred to as *pica* (not to be confused with the typographic term!); 12 pitch, referred to as *elite*; and *variable pitch* (**1**). The 10 pitch produces rather large characters at the rate of 10 per inch. The 12 pitch produces smaller characters at the rate of 12 per inch. Variable-pitch systems do not produce a uniform number of characters per inch, since each character occupies varying amounts of space.

Character Counting a Line

If you study the 10-pitch format, you will see that each character occupies the same amount of space, regardless of whether the character is a letter, punctuation mark, or wordspace. For example, the small *i*, the capital *M*, the period, or a wordspace requires 1/10 of an inch to set (10

characters to the inch). The same principle applies to the 12 pitch, where each character, regardless of its size, occupies 1/12 inch (12 character to the inch).

To arrive at a total character count, use a ruler to measure the line to the nearest inch and multiply this figure by the number of characters per inch. This will provide an average character count very quickly. For greater accuracy, add the remaining characters to the total.

On the line typed with the 10-pitch typewriter (or generated by computer), draw a vertical line at 6 inches, as shown opposite (**1**). You know there are 10 characters per inch, so there must be 60 characters in 6 inches. Now simply add the 6 characters that extend beyond the indicated line. This will give you a total of 66 characters. Notice that we counted not only the letters but all the spaces and punctuation marks as well.

On the 12-pitch example, a vertical line is drawn at 5 inches. As there are 12 characters to the inch, there are 60 characters in 5 inches. There are 8 characters left over for a total of 68.

Character Counting a Page

Now let's count the characters in a block of typed copy on a single page (**2**). You will notice that the length of lines in the copy varies. Find a line of average length and draw a vertical line through the page, as we have done here. Using your ruler, establish the number of characters up to the vertical line. In this case, you have 5 inches or 50 characters per line. Now count the number of lines on the page. There are 18 lines of copy. Multiply this by the number of characters per line (50) for a total of 900 characters. This is an approximate count only, adequate where extreme accuracy is not required.

Where accuracy is critical, you must adjust the count of 900. Go back and add all the characters that extend beyond the vertical line (49), and subtract all the characters that fall short of it (24). You will find that by adding 49 characters and subtracting 24 from your approximate total of 900 characters, you will get an exact total of 925 characters.

When dealing with more than one page or a lengthy manuscript, check all the pages for inconsistencies. Then take an average page and count the characters. Multiply this number of characters by the total number of pages. Do not let the large number of characters intimidate you. In time you will get used to working with character counts that run into the hundreds of thousands, especially in book design.

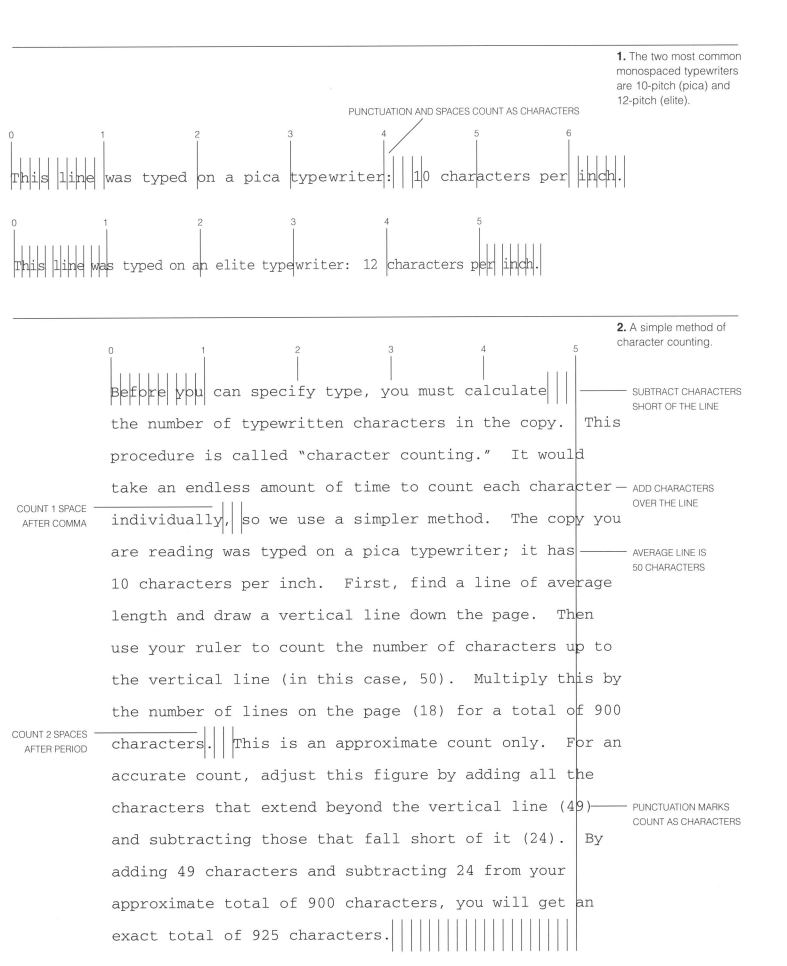

1. The two most common monospaced typewriters are 10-pitch (pica) and 12-pitch (elite).

PUNCTUATION AND SPACES COUNT AS CHARACTERS

0 1 2 3 4 5 6

This line was typed on a pica typewriter: 10 characters per inch.

0 1 2 3 4 5

This line was typed on an elite typewriter: 12 characters per inch.

2. A simple method of character counting.

0 1 2 3 4 5

Before you can specify type, you must calculate — SUBTRACT CHARACTERS SHORT OF THE LINE

the number of typewritten characters in the copy. This

procedure is called "character counting." It would

take an endless amount of time to count each character — ADD CHARACTERS OVER THE LINE

COUNT 1 SPACE AFTER COMMA — individually, so we use a simpler method. The copy you

are reading was typed on a pica typewriter; it has — AVERAGE LINE IS 50 CHARACTERS

10 characters per inch. First, find a line of average

length and draw a vertical line down the page. Then

use your ruler to count the number of characters up to

the vertical line (in this case, 50). Multiply this by

the number of lines on the page (18) for a total of 900

COUNT 2 SPACES AFTER PERIOD — characters. This is an approximate count only. For an

accurate count, adjust this figure by adding all the

characters that extend beyond the vertical line (49) — PUNCTUATION MARKS COUNT AS CHARACTERS

and subtracting those that fall short of it (24). By

adding 49 characters and subtracting 24 from your

approximate total of 900 characters, you will get an

exact total of 925 characters.

3. Copy from previous
page converted into
typeset copy, set solid.

Before you can specify type, you must calculate the number of typewritten characters in the copy. This procedure is called "character counting." It would take an endless amount of time to count each character individually, so we use a simpler method. The copy you are reading was typed on a pica typewriter; it has 10 characters per inch. First, find a line of average length and draw a vertical line down the page. Then use your ruler to count the number of characters up to the vertical line (in this case, 50). Multiply this by the number of lines on the page (18) for a total of 900 characters. This is an approximate count only. For an accurate count, adjust this figure by adding all the characters that extend beyond the vertical line (49) and subtracting those that fall short of it (24). By adding 49 characters and subtracting 24 from your approximate total of 900 characters, you will get an exact total of 925 characters.

9/9 HELVETICA

4. The same typeset
copy as above but set
with additional leading.

Before you can specify type, you must calculate the number of typewritten characters in the copy. This procedure is called "character counting." It would take an endless amount of time to count each character individually, so we use a simpler method. The copy you are reading was typed on a pica typewriter; it has 10 characters per inch. First, find a line of average length and draw a vertical line down the page. Then use your ruler to count the number of characters up to the vertical line (in this case, 50). Multiply this by the number of lines on the page (18) for a total of 900 characters. This is an approximate count only. For an accurate count, adjust this figure by adding all the characters that extend beyond the vertical line (49) and subtracting those that fall short of it (24). By adding 49 characters and subtracting 24 from your approximate total of 900 characters, you will get an exact total of 925 characters.

9/12 HELVETICA

The Copyfitting Process

Now that you have arrived at a total of 925 characters, how do you determine how much space these characters will occupy when they are converted into type?

Let's assume that the copy is to be set in 9-point Helvetica solid and justified in a measure 16 picas wide. First, determine how many characters fit into a single line. Refer to the chart for 9-point Helvetica on page 95. Note that a linelength of 16 picas contains approximately 46 characters. Next, to find the number of lines the copy will occupy, divide the total number of characters (925) by 46. You will find that the copy should require 20 full lines with 5 characters left over.

Although we estimated 20 full lines with 5 characters left over, notice that the copy set on 19 lines with 33 characters left over (**3**). This slight difference of 18 characters between the estimate and the actual setting is normal and to be expected. The number of characters per pica is only an average.

Predetermining the Depth. To determine the depth of the setting before the job has been set, simply multiply the number of lines you counted by the point size of the type. Based on our previous example, this would be 20 lines x 9 points for a total of 180 points. Since this number is cumbersome in points, convert it into picas, just as you convert inches into feet for clarity. To convert the points into picas, divide 180 by 12 to get 15 picas. Measure the block of type in figure 3 and you will see that it is 15 picas deep.

Suppose you decide to add some linespacing between the lines of type, say 3 points. How deep would the page be then? Simply multiply the number of lines (20) by 12 (9 points for the type and 3 points for the additional linespacing): this will give you 240 points. This, converted into picas, would be 20 picas. Now measure the block of type (**4**). (Remember, additional space between lines will not affect the total number of lines of type, only the depth of the column.)

Setting Unjustified Type. The above examples were based on the assumption that the type was to be set with lines of equal length (justified). If the type is to be set with lines of unequal length (unjustified), you must estimate the number of characters per line by using the length of an average line. For example, if you specify that the longest line is to be 16 picas and the shortest is to be 10, the average line will be 13. A column of unjustified type generally sets deeper than justified type because of variations in linelength.

Writing to Fit

On occasion you may be asked to instruct a copywriter how much text to write to fill the space you have predetermined.

Suppose you have just designed an ad in which you have allowed a space for copy that measures 16 picas wide by 20 picas deep. You intend to use 9-point Helvetica with an additional 3 points leading (9/12). How much copy must be written to fill that space?

First you must determine how many lines you can fit into a space 20 picas deep. Convert the pica depth into points: 20 picas become 240 points. Divide 240 points by 12 (the typesize plus the leading) and you will get exactly 20 full lines of type.

Now turn to page 95, where you will find that 9-point Helvetica by 16 picas has 46 characters per line. If you multiply the number of lines previously obtained, 20, by 46 characters per line, you will obtain the total number characters you need. The result is 920 characters. You can instruct the copywriter to write 920 characters.

A more convenient method for the copywriter is to be given the instructions in the number of words to be written instead of characters. As the average word in the English language has 5 letters, you divide the character total of 920 by 5 and ask the copywriter to supply you with approximately 184 words of copy.

Type Gauges for Shortcuts

Figuring the depth of a column of type mathematically not only is time-consuming but can lead to errors. It is much simpler and more accurate to use a type gauge, which is calibrated in points and covers all the more popular text sizes. These increments represent the baseline-to-baseline measurement, that is, typesize if set solid, or type plus leading.

There are a number of type gauges on the market, made of durable plastic with easy-to-read scales. The 12-point scale is placed on the outside, where it serves as a pica rule as well (12 points = 1 pica). See page 160 for more information on gauges and rulers.

In the above example of writing to fit, you wanted to know how many lines of 9/12 type would fit into a type area 20 picas deep. Simply refer to the 20-unit marker on the 12-point scale. The result is 20 lines (**5**). To see how deep the type would set with other amounts of leading, go to the appropriate point size on the gauge. ☐

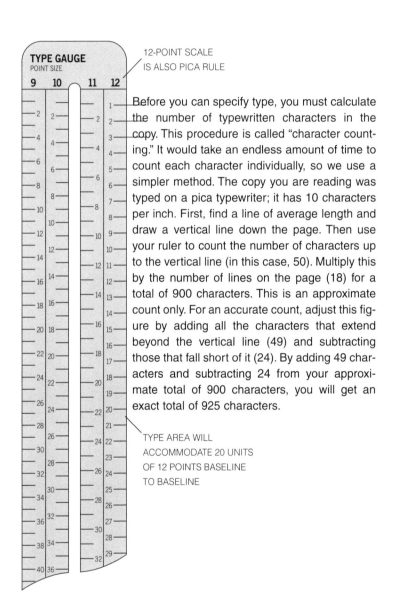

5. Type gauges allow you to quickly measure how deep a column of type will be.

Before you can specify type, you must calculate the number of typewritten characters in the copy. This procedure is called "character counting." It would take an endless amount of time to count each character individually, so we use a simpler method. The copy you are reading was typed on a pica typewriter; it has 10 characters per inch. First, find a line of average length and draw a vertical line down the page. Then use your ruler to count the number of characters up to the vertical line (in this case, 50). Multiply this by the number of lines on the page (18) for a total of 900 characters. This is an approximate count only. For an accurate count, adjust this figure by adding all the characters that extend beyond the vertical line (49) and subtracting those that fall short of it (24). By adding 49 characters and subtracting 24 from your approximate total of 900 characters, you will get an exact total of 925 characters.

25. Preparing Copy and Specifying Type

1. Proper copy preparation minimizes typesetting errors.

SET IN
9/12
HELVETICA
x 16½
PICAS

FL LFT/
RG RT.

Preparing copy for the typesetter is a crucial procedure. Copy should be typed on standard 8 1/2 x 11 bond paper with a 10- or 12-pitch typewriter. A good column width is about 6 inches, which gives the page a generous margin. The lines should be double-spaced, each having approximately the same number of characters. Every page should contain the same number of lines. Corrections should be made neatly in pencil or ink. Make sure all pages are numbered consecutively in case the sheets get separated. Also make sure the job title appears on every page to prevent the copy from being mixed up with another job.

() CLOSE UP

INDENT
1-EM

(tr)

Write your own instructions, using the standard set of proofreader's marks shown on page 136. Remember, typesetters are terribly literal: they will follow only the instructions you give them; you cannot expect them to make design decisions.

Although most copy today is transmitted through digital files, there may be occasions when you will be required to work with or submit typewritten copy. Regardless of the format, you must prepare the copy properly to avoid errors.

Digital Files
Ask that the files be supplied without unnecessary coding, such as word-processing italic or bold fonts, preset margins, or indents. Undesirable coding will invariably lead to extra work and lost time.

Although it may be common practice to insert two spaces after a period in typing business letters, copy prepared on a computer for typesetting should contain only a single space after a period. If you receive copy that has two spaces after punctuation, search for and delete all the excess spaces.

Be sure to properly input inch marks and quote marks or apostrophes—they are not the same.

Typewritten Copy
It is good practice to discuss copy preparation with the client before beginning the job. In general, copy should be delivered as double- or triple-spaced manuscript on standard 8 1/2 x 11-inch bond paper in a column about six inches wide, with a generous margin on the left for design and/or editorial notations (**1**). Each page should contain approximately the same number of lines and characters per line and should be numbered consecutively, with the job title indicated on each sheet as well. It's preferable to leave a full line of space between paragraphs rather than using indents to indicate new paragraphs. The word *end* should appear on the last page.

All editing should be written on the original manuscript, not on a photocopy. Mark any corrections clearly, preferably in red ink or pencil. A clean manuscript should be prepared if corrections are extensive.

Specifying Type
Although the vast majority of jobs are now set by the designer, there are still occasions when hard copy is sent out to a typographer or service bureau for computer typesetting. In such cases the typewritten manuscripts must be accurately marked up with the type specifications.

Your instructions to the typesetter should be clear and precise. Group your instructions in the left-hand margin of the manuscript, using a minimum number of words. Always write legibly to avoid any risk of your instructions being overlooked or misinterpreted.

When specifying a typeface, always give the precise name of the desired typeface as it appears on the computer or in a type specimen book. Include the manufacturer's name or font foundry in your instructions; for example, for Garamond, specify Adobe Garamond or Monotype Garamond. In addition, note the weight and style of the type, such as Monotype Garamond Bold Condensed. This is important because each font is slightly different in design and the number of characters per pica; these differences can affect your final setting.

It is also a good practice to include an accurate comp of your design with type specifications in order to give the typesetter or service bureau an idea of how you intend the final piece to look.

Proofreaders' Marks

The symbols used to communicate editorial and design instructions to the professional typesetter are called proofreaders' marks. These symbols, shown on the following page (3), are used by everyone associated with copy or type: copywriters, editors, designers, typesetters, and proofreaders. You will notice there are two distinct sets of marks: one is written in the margin and the other indicated directly on the type. Although you may use only a dozen or so of the proofreaders' marks, it helps if you are familiar with all of them.

AA's and PE's

When a typesetter sends proofs to you, check them carefully against your layout to make certain there are no errors; check the typeface, the linespacing, and the pica measure. In short, make certain that all your instructions were followed. The copy should also be proofread for spelling or grammatical errors.

Very few jobs are typeset without requiring some corrections and/or modifications. This entails additional work and charges. Changes can be divided into two categories: AA's and PE's. AA's, or "author's alterations," represent changes or corrections made by the designer or client. The costs and responsibility for the changes are the designer's. PE's or "printer's errors," represent errors and/or omissions on the part of the typesetter or service bureau. The costs involved in correcting such errors should be absorbed by the supplier. When corrections or changes have been clearly indicated using proofreaders' marks, the proofs are returned to the typesetter (2). After the corrections have been made, the final proofs are sent to you for approval. □

2. All changes and corrections should be marked clearly for the typesetter. You should also indicate AA (author's alteration) or PE (printer's error).

Preparing copy for the typesetter is a crucial procedure. Copy should be typed on standard 8 1/2 x 11 bond paper with a 10- or 12-pitch typewriter. A good column width is about 6 inches, which gives the page a generous margin. The lines should be double-spaced, each having approximately the same number of characters. Every page should contain the same number of lines. Corrections should be made neatly in pencil or ink. Make sure all pages are numbered consecutively in case the sheets get separated. Also make sure the job title appears on every page to prevent the copy from being mixed up with another job. Write your own instructions, using the standard set of proofreaders' marks shown on page 136. Remember, typesetters are terribly literal: they will follow only the instructions you give them; you cannot expect to make design decisions.

(BF) (AA)
3 (PE)
(REBREAK) (AA)
(PE)
run-in (AA)
them (ital)
(PE / AA)

Preparing copy for the typesetter is a crucial procedure. Copy should be typed on standard 8 1/2 x 11 bond paper with a 10- or 12-pitch typewriter. A good column width is about 6 inches, which gives the page a generous margin. The lines should be double-spaced, each having approximately the same number of characters. Every page should contain the same number of lines. Corrections should be made neatly in pencil or ink. Make sure all pages are numbered consecutively in case the sheets get separated. Also make sure the job title appears on every page to prevent the copy from being mixed up with another job. Write your own instructions, using the standard set of proofreaders' marks shown on page 136. Remember, typesetters are terribly literal: they will follow only the instructions you give them; *you cannot expect them to make design decisions.*

3. Proofreaders' marks are used by designers, editors, and typesetters. All changes or corrections must be indicated in the margin, as well as the line of type.

Explanation	Mark	Example
Set in italic.	*ital*	I am the voice of today.
Set in roman.	*rom*	I am the *voice* of today.
Set in small caps.	*sc*	I am the voice of today.
Set in caps.	*caps*	I am the voice of today.
Set in boldface.	*BF*	I am the voice of today.
Set in lowercase.	*lc*	I am the VOICE of today.
Insert period.	⊙	I am the voice of today∧
Insert comma (letter, word, etc.)	⌃	I am the voice of today∧
Insert space.	#	I am the voice of today.
Insert word	the/	I am voice of today.
Insert hyphen.	=	I am the voice of twenty one days.
Insert em-dash.	⅟m	I am the voice of today and tomorrow.
Insert en-dash.	⅟n	I am the voice of the 1980/1990 generation.
Insert parentheses.	(/)	I am the voice of today and tomorrow.
Insert colon.	⊙	I am the voice of today∧
Insert semicolon.	;	I am the voice of today∧
Insert question mark.	*SET* ?	I am the voice of today∧
Insert quotation marks.	''/''	I am the voice of today.
Delete or take out.	ℨ	I am the voice of of today.
Delete and close up.	ℨ	I am the voice of today.
Make space between words equal.	*eq* #	I am the voice of today.
Spell out words in circle.	*sp*	I am the voice of the (U.S.)
Let it stand.	*stet*	I am the voice of today.
Query by editor.	''/'' (?)	I am the voice of today.
Transpose words or letters.	*tr*	I am voice the of today.
Close up.	⌣	I am the voice of today.
Move to left.	⊏	⊏ I am the voice of today.
Move to right.	⊐	⊐ I am the voice of today.
Center type.	*ctr.*	⊐ I am the voice of today. ⊏
Start new paragraph.	¶	¶ I am the voice of today.
Indent 1-em.	☐	☐ I am the voice of today.
Indent 2-ems.	☐☐	☐☐ I am the voice of today.
No paragraph; run in.	*run-in*	...was yesterday. I am the voice of today.

good design project must challenge students' creative abilities while expanding their typographic knowledge. These projects range from simple to complex: from the typographic enhancement of a single word to the design of an eight-page brochure. All projects can be completed within an intensive one-semester course.

Solutions to the projects should be creative yet practical. Overly experimental approaches at this early stage tend to subvert the goal of developing a strong fundamental understanding of typography. For this reason the students should be limited to the five families of type introduced in this book, with the exception of typefaces selected for display applications.

26. Solving Design Problems

There are many ways of solving design problems. Some designers like to think about the problem for days before putting pencil to paper. Others look for inspiration in design publications, while still others prefer to begin the process immediately by creating thumbnails or experimenting on the computer. Some even start by photocopying design elements in a variety of sizes and then physically moving them around.

Regardless of the method you choose, try to begin the design process as soon as possible. By all means, experiment. Start by thinking, doing research, and making thumbnails, but once you arrive at the most promising idea, begin to develop it.

Try to avoid spending excessive amounts of time discussing or philosophizing about what you might do, since this is a highly developed form of procrastination and reflects an uncertainty of just how to proceed. This is also true for spending too much time developing thumbnails and sketches. Above all, do not expect a computer design program to solve the problem for you.

To get started, draw upon the basic principles you have learned in other classes—design principles involving line, form, scale, contrast, proximity, texture, repetition, figure/ground, and color.

As you begin to resolve the design, study the results carefully, not simply from an esthetic perspective but for its effectiveness and readability. Does the design attract attention? Can the type be read comfortably? Are you getting your idea across? If not, can the piece be saved or should you start over? You can gain a great deal by asking these simple questions.

Digital Design

There is often a significant difference in the character of design solutions arrived at traditionally (with pencil and paper) and those created through the aid of computer programs. In the first case the results are limited by the medium itself and the designer's skill and imagination. In the second case the computer often becomes co-designer, producing solutions that are far beyond the designer's imagination or comping skills. Today some of the most creative designs are those that were started with pencil and paper and resolved on the computer. Keep in mind that, as impressive as computer-aided design may appear, it will never be a substitute for human creativity.

Project One: Copyfitting and Comping

Purpose. To offer students an excellent opportunity to combine the procedures of character counting, copyfitting, comping, and arranging type with an understanding of the five classic typefaces presented in this book.

Assignment. Since you must work with typewritten copy, use hard copy created from the introductions to each of the five typefaces found on pages 37, 49, 61, 73, and 85. Some copy should be produced in a 10-pitch format and others in a 12-pitch format via typewriter or computer. In this way you can become familiar with character counting from both formats.

Before you begin comping, make an accurate character count of each of the five typewritten essays (see *Copyfitting*, page 130). Next, using copyfitting skills and the type specifications on the opposite page, determine the number of lines the copy will occupy (see the charts in Part Two). Then produce an accurate pencil comp of each essay (see *Comping Type*, page 128).

While comping, pay particular attention to capturing the subtle qualities inherent in each typeface. Comp the display type with uniform density, sharp edges, and even letterspacing. Comp the text type also for uniform density, consistent linelength or pleasing rags, and accurate linespacing.

Despite the fact that the assignment is easily accomplished on the computer, comping with pencil and layout paper is recommended as the most appropriate way for you to become familiar with the anatomy and structure of the individual typefaces while acquiring traditional skills at the same time.

Should you execute these assignments on the computer, watch the hyphenation and break lines for sense—especially when type is centered.

1. Garamond: Justified.
Comp the word "Garamond" twice:
Once in 72-point Garamond display: U/lc.
Once in 72-point Garamond display: all caps.
Set solid, 72 points baseline to baseline.
Flush left, rag right.
Comp Garamond text:
11/14 by 13 picas: justified.
Allow 72 points from baseline of display type
to the baseline of first line of text.

2. Baskerville: Flush Left, Rag Right.
Comp the word "Baskerville" twice:
Once in 72-point Baskerville display: U/lc.
Once in 72-point Baskerville display: all caps.
Set solid, 72 points baseline to baseline.
Flush left, rag right.
Comp Baskerville text:
11/13 by 20 picas: flush left, rag right.
Allow 72 points from baseline of display type
to the baseline of first line of text.
Set as two paragraphs with one line between.

3. Bodoni: Flush Right, Rag Left.
Comp the word "Bodoni" twice:
Once in 72-point Bodoni display: U/lc.
Once in 72-point Bodoni display: all caps.
Set solid, 72 points baseline to baseline.
Flush right, ragged left.
Comp Bodoni text:
12/16 by 18 picas: flush right, rag left.
Allow 72 points from baseline of display type
to the baseline of first line of text.

4. Century Expanded: Centered.
Comp the word "Century" twice:
Once in 72-point Century display: U/lc.
Once in 72-point Century display: all caps.
Set solid, 72 points baseline to baseline.
Display type should be centered.
Comp Century text:
10/16 centered by 24 picas maximum.
Allow 72 points from baseline of display type
to the baseline of first line of text.

5. Helvetica: Random.
The display word "Helvetica" can be comped in
any size and combination of upper and lower-
case, roman or italic, extended or condensed,
light or bold, etc. The Helvetica text can also be
in any text size and leading, but the arrange-
ment must be random, not justified; flush left,
rag right; flush right, rag left; or centered. Type
does not necessarily have to be in a single block
but can be in multiple groupings.

1. Five hand-comped layouts. Each piece requires character counting, copyfitting, comping, and arranging type according to the specifications provided.

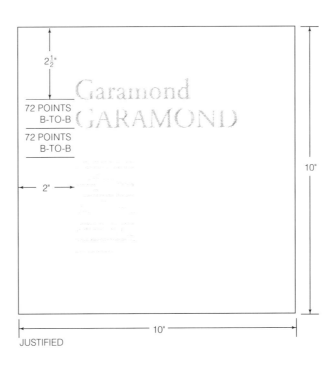

2½"

72 POINTS
B-TO-B

72 POINTS
B-TO-B

2"

10"

10"

JUSTIFIED

FLUSH LEFT, RAG RIGHT

FLUSH RIGHT, RAG LEFT

CENTERED

RANDOM

1. Roman

A love of letters is the beginning of typographical wisdom. That is, the love of letters as literature and the love of letters as physical entities, having abstract beauty of their own, apart from the ideas they may express or the emotions they may evoke.

2. Italic

A love of letters is the beginning of typographical wisdom. That is, the love of letters as literature and the love of letters as physical entities, having abstract beauty of their own, apart from the ideas they may express or the emotions they may evoke.

3. Bold

A love of letters is the beginning of typographical wisdom. That is, the love of letters as literature and the love of letters as physical entities, having abstract beauty of their own, apart from the ideas they may express or the emotions they may evoke.

4. All caps

A LOVE OF LETTERS IS THE BEGINNING OF TYPOGRAPHICAL WISDOM. THAT IS, THE LOVE OF LETTERS AS LITERATURE AND THE LOVE OF LETTERS AS PHYSICAL ENTITIES, HAVING ABSTRACT BEAUTY OF THEIR OWN, APART FROM THE IDEAS THEY MAY EXPRESS OR THE EMOTIONS THEY MAY EVOKE.

5. Caps and small caps

A LOVE OF LETTERS IS THE BEGINNING OF TYPOGRAPHICAL WISDOM. THAT IS, THE LOVE OF LETTERS AS LITERATURE AND THE LOVE OF LETTERS AS PHYSICAL ENTITIES, HAVING ABSTRACT BEAUTY OF THEIR OWN, APART FROM THE IDEAS THEY MAY EXPRESS OR THE EMOTIONS THEY MAY EVOKE.

Project Two: Typestyles and Readability

Purpose. To encourage students to consider alternatives to upper and lowercase roman type and see how their choices affect both the look and the readability of the setting.

Assignment. Write a short paragraph or select one from your favorite book. Now set the paragraph in the following five ways using the same typeface, type size, leading, and arrangement.

(**1**) Roman
(**2**) Italic
(**3**) Bold
(**4**) All caps
(**5**) Caps and small caps

12/15 GARAMOND
QUOTATION BY JOHN R. BIGGS

Project Three: Paragraph Indications

Purpose. To demonstrate how indicating paragraphs affects the look and readability of a setting.

Assignment. Using a short piece of copy that contains approximately five paragraphs, explore various ways of indicating a paragraph. Solutions should range from traditional to outrageous—taking advantage of all five typefaces and typestyles. Try at least five different ideas. Study the results of your efforts. Examine how the visual effect of your design changes and how readability is altered. Weigh the trade-off between the more traditional approaches and those that are more experimental. (See page 109 for other solutions.)

1. By using less familiar shapes and arrangements, you can go beyond the traditional paragraph indications of indents and linespacing.

Johannnes Gutenberg was born in Mainz, Germany, sometime around 1397. Little is known about his early years, but it is clear that he was the right man in the right place at the right time.

Gutenberg was the right man because of his familiarity with the craft of the goldsmith and the die maker. He was in the right place because Mainz was a cultural and commercial center. It was the right time because the Renaissance thirst for knowledge was creating a growing market for books that could not be satisfied with traditional handwritten manuscripts.

Handwritten manuscripts were made to order and were usually expensive. They were laboriously copied by scribes who had to either read from a manuscript or have it read to them while copying. This process not only was time-consuming but led to many errors, which had to be corrected. Adding to the expense was the scarcity and high cost of vellum and parchment. As a result, these handwritten manuscripts were limited to a select few: clergymen, scholars, and wealthy individuals.

A relatively inexpensive means of producing multiple copies of books seems to have been developed just a little before Gutenberg began his experiments with printing. This was the so-called block book, whose pages had illustrations and minimal text cut together on the same block. The carved blocks were inked, and images were transferred onto paper.

Gutenberg's genius was realizing that printing would be more efficient if, instead of using a single woodblock to print an entire page, the individual letters were cast as separate blocks and then assembled into pages. In this manner, pages could be corrected more rapidly, and after printing, the type could be cleaned and reused.

SMALL

TINY

Project Four: Word Pictures

Purpose. To make the student aware of how the meaning of a single word can be enhanced through typography.

Assignment. Select five words and explore their expressive quality by varying the size, position, spacing, or weight of the individual letters. To achieve the desired effect, avoid simply repeating the words or creating an illustration from the letterforms. The best solutions not only enhance the word's meaning but are clever and esthetically pleasing. Sometimes an unexpected effect can be achieved when the typographic solution contradicts the meaning of the word, setting "big" with small type, for example.

Project Five: Visually Enhanced Quotation

Purpose. To demonstrate how a quotation, song, or short poem can be enhanced typographically.

Assignment. Select a favorite quotation or poem and find a way to express it typographically through the basic design principles discussed earlier. (Whether or not illustrations are permitted should be left up to the individual instructors.)

HELVETICA ROUNDED

THERE IS

NO KEY TO SUCCESS;

BUT SURELY

THE FORMULA FOR FAILURE

IS TRYING TO PLEASE

Everyone

ALL THE TIME.

GARAMOND WITH MIXED TYPEFACES

HELVETICA INSERAT AND HELVETICA LIGHT

Every word
that is
uttered,
evokes
the idea
of its
opposite.
Goethe

BASKERVILLE

1. Through considered arrangement of a single font or the juxtaposition of different fonts, quotations can be enhanced typographically to extend their meaning.

Project Six: Ransom Note

Purpose. To allow the student to discover the design potential in "found typography." Type specimens should be cut or torn from newspapers, magazines, and printed materials, and assembled into a ransom note.

Assignment. Create a dramatic typographic effect by composing a short, humorous ransom note stating your actions, demands, and ultimatums (**1**). It should be evident to the reader that the note has been created by a graphic designer. In other words, be sure there is a design or esthetic rationale to your letter, not just a random selection and arrangement of type. In this assignment images may also be incorporated into the design.

LisTEN Up! I'M holding Your pet GeRbil. ReTurN My iguANa, oR elSE○Max

Project Seven: Early Letterform

Purpose. To provide the student with a comprehensive overview of all stages of the graphic design process. These include copywriting, proofreading, designing, copyfitting, specifying type, preparing mechanicals, generating high-quality comps, and where budget permits, producing the final printed pieces.

Assignment. This is a two-color project involving text type, display type, and an illustration. All design elements should be two-dimensional so that the finished piece will resemble a graphic poster rather than an illustrated text. Remember to consider white space as an equally important design element. The suggested format is 10" x 10" (25 x 25 cm).

Although this project involves some research and writing, it is important that you maintain the design as the major focus and keep the research and writing to a practical minimum. Perhaps the instructor can direct students to specific resources, beginning with Chapter 1 of this book.

1. Choose one letter from either the Phoenician alphabet illustrated on this page or the Greek alphabet found on page 11.

2. Research the origin/history of the letter and write an essay of approximately 100 words (500 characters). The content need not be dry, historical data but can be a humorous or entertaining essay based upon some historical fact.

3. Type the essay on a 10-pitch or 12-pitch typewriter or computer. Copy should be double-spaced with generous margins for marking type specifications (see page 134). Include the title of the essay (Alpha, Delta, etc.) along with your name.

4. Submit the original copy to an editor, proofreader, or instructor for editing while retaining a duplicate copy.

5. Using the duplicate copy, count the characters. Next, select one of the five typefaces for your design.

6. Create three comps, each distinctively different. In the first comp the symbol should be the most prominent element (**1**). In the second the display type should be the most prominent element (**2**). In the third the text type should be the most prominent element (**3**).

The symbol can be reproduced in its entirety, duplicated, abstracted, or shown in detail. In all three comps indicate how color is to be used. If you are comping by hand, use colored pencils or markers. Use white pencil for reverse type.

Comps should accurately represent the amount of copy you have written. Make sure you have copyfitted the text and chosen a setting that works well with your design.

7. Discuss all solutions during class, then refine the designs or develop new concepts.

8. The return of the original edited copy offers an excellent opportunity to review proofreaders' marks (see page 136).

9. If you are sending the copy out for typesetting, mark up the original copy with your type specifications. If not, set the copy on a computer.

10. Proofread the type carefully to make sure there are no errors, and check the setting, i.e., letterspacing, wordspacing, linespacing, ragged edges, and hyphenation.

11. Although the job would most likely be printed from the electronic file, you still might wish to prepare a traditional mechanical in order to better understand the printing process.

12. When all aspects of your final design have been resolved, print out the design on a high-quality color printer or carefully hand-comp a presentation piece. Trim to final size.

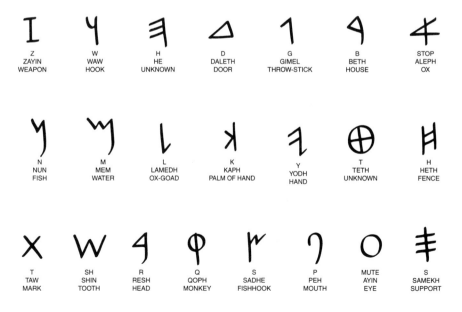

1. Early letterform project in which the symbol is the most prominent element.

2. In these examples the display type is the most important element.

3. Depending on the type setting, text can also be the most dominant element.

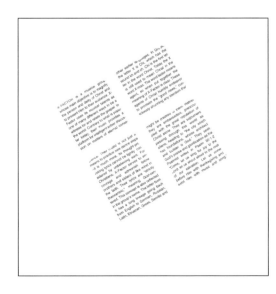

Project Eight: Eight-Page Brochure

Purpose. To help the student understand how grids are used to organize type and images in publication design. The student will be working with display type, text type, captions, folios, halftones (square and silhouette), line art, and full-color art. This project can be time-consuming if it is not approached in an organized manner. Proper preparation is essential.

Assignment. The suggested format is 10" x 10" (25 x 25 cm) with a minimum of eight pages, including the front and back covers, although your instructor may prefer specifying a standard magazine format. While the grid may be individually designed, the results seem to be more successful when students are assigned a common grid, usually three columns.

Since there should be a considerable amount of body text, you can use "dummy type" from photocopies or generate the type by computer. Write out and set the display type, such as titles, heads, subheads, captions, and folios. This gives the finished brochure a more professional look.

A well-designed brochure should look effortless. Do not strain for originality at the risk of obscuring the message or destroying design integrity or readability. The elements should relate to one another and to the page. This does not mean they must align and be predictably placed, but they must look "right."

1. Select a topic. The subject can be wide-ranging: flags, ships, automobiles, dolls, tombstones, musical instruments, historical events, famous artists, and so on. As this is only an eight-page brochure, try to focus on a single aspect of your subject. For example, rather than trying to cover all the musical instruments of the past five hundred years, limit yourself to violins of the eighteenth century. The more focused the subject, the better your chances of success.

2. After you have selected a topic, research the subject with a keen eye for appropriate images and related material. This may involve trips to libraries or bookstores. You can cut out photographs and illustrations from old magazines or secondhand books and use them for images. You can also scan and manipulate images or create your own if you prefer. The time you spend doing research is well rewarded. Research increases your design options, making the entire process more engaging and producing better results.

3. Choose a typeface and develop a design that is appropriate to your subject. Prepare two inside spreads (not the cover at this time) that clearly show the typefaces and type sizes you intend to use for text, heads, captions, and folios. Your presentation should demonstrate how type and illustrations relate to the grid. The spreads should reflect a sense of organization that attracts the eye and offers maximum readability. The text can be dummy type, although display type, callouts, and captions must be actual copy.

4. Based on class critique, resolve any conceptual and design problems. Rework your spreads incorporating class suggestions. Your design should evolve in stages, becoming stronger esthetically and conceptually with each critique.

5. After the final critique, resolve the design and prepare tight comps of all the spreads. At this late stage your design concept should be well established, and a sense of consistency should be evident throughout the brochure.

6. Finally, design the front and back covers. These should relate to the inside spreads and be appropriate to the subject matter. Since covers are generally intended to be seen at a distance, consider your design a small poster.

7. Finally, combine the cover and spreads into a finished brochure. One approach is to fold two large sheets of bond layout paper in half, forming an eight-page dummy. Staples (or stitches) in the fold can be carefully inserted by hand to attach the sheets. Mount the cover and each page in place and trim the entire brochure to final size, as illustrated on the following page (**1**). ☐

PAGE 8 (BACK COVER) (FRONT COVER) PAGE 1

1. Inside spreads and
finished brochure.

TEXT

FOLIO

HEAD

SQUARE HALFTONE

LINE ART

CAPTION

SUBHEAD

WHITE SPACE

MAINZ 1455

HANDSETTING TYPE

GUTENBERG'S BIBLE

*Printing from moveable
type revolutionized ways of
thinking and learning*

CALLOUT, OR DECK

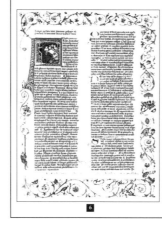

GUTENBERG

Until now we have been concerned mainly with understanding the basics of typography and learning how to design with type. This part introduces historical data and reference material that should be of interest to any serious graphic designer.

Among the items included are additional typeface specimens to supplement the five classic typefaces introduced earlier, as well as a brief history of typesetting methods over the centuries. This is followed by an extended glossary of important graphic design terms, a bibliography, and finally the index.

Additional Type Specimens

This section supplements the classic typefaces provided in Part Two. These specimens will give you some idea of the wide range of typefaces available.

There are also examples of additional typefaces in the familiar classifications of Old Style, Transitional, Modern, Slab Serif, and Sans Serif. Some are variations of typefaces in families you already know. Still others belong to the three major classifications that have not yet been represented: Script, Black Letter, and Decorative. Because some typefaces fall between two categories, sharing characteristics of both, different manufacturers may list them under two different classifications.

Each setting is shown with uppercase characters, lowercase characters, and figures. Each typeface is set in 24 points.

Many of the faces presented here function equally well for text and display purposes, while others are practical only in larger display sizes.

Following is a brief description of the various categories.

Old Style. Serif typefaces based on the earliest examples of printing. Letterforms show minimal thick and thin contrast between strokes, as well as obvious bracketed serifs.

Transitional. Typestyles with more refined serifs and clearly drawn thick and thin main strokes. Historically, this classification was the bridge between Old Style and Modern typefaces.

Modern. Typestyles characterized by strong contrast between thick and thin strokes, fine serifs with minimal bracketing, and strong vertical stress. Modern typefaces are usually modified for text settings to prevent the text from "sparkling." To achieve this, the contrast is reduced by lightening the thick strokes.

Slab Serif. Typefaces characterized by thick, dominating serifs. Sometimes these serifs are equivalent to the thickness of the main strokes. Brackets are minimal or nonexistent. (This classification is also called Egyptian.)

Sans Serif. A basic type classification primarily of twentieth-century origin, characterized by a lack of serifs. Sans serif typefaces usually have minimal variance between thick and thin strokes. Once considered ugly, sans serif typefaces were called "grotesques," a term still used in Great Britain.

Script. Typestyles based on handwriting and calligraphy, especially the formal cursives of eighteenth- and nineteenth-century England. Modern scripts might also include brushstroke and sign-painter's writing.

Decorative. A wide range of custom and specialty typefaces, almost exclusively used for display purposes. This classification is a catch-all for faces that may defy categorization.

Black Letter. Typefaces based on mostly fourteenth- and fifteenth-century manuscripts. Letterforms are dense and compressed, with bold horizontal strokes. Also referred to as Gothic, Old English, or Broken.

Borders and Ornaments. A wide range of devices, including dingbats, brackets, flourishes, tapered rules, and braces. These ornaments, like display initials, offer the designer an opportunity to embellish a printed piece. Some of these typographic devices can be used singly or repeated to create a border or overall pattern. An obvious way of attracting attention is through the use of typographic ornaments. □

Old Style

ALDINE

ABCDEFGHIJKLMNOPQRSTUVWXYZ&
abcdefghijklmnopqrstuvwxyz1234567890

BERLING

ABCDEFGHIJKLMNOPQRSTUVWXYZ&
abcdefghijklmnopqrstuvwxyz1234567890

BERNHARD MODERN

ABCDEFGHIJKLMNOPQRSTUVWXYZ&
abcdefghijklmnopqrstuvwxyz1234567890

CASLON 540

ABCDEFGHIJKLMNOPQRSTUVWXYZ&
abcdefghijklmnopqrstuvwxyz1234567890

DEEPDENE

ABCDEFGHIJKLMNOPQRSTUVWXYZ&
abcdefghijklmnopqrstuvwxyz1234567890

GARAMOND 3

ABCDEFGHIJKLMNOPQRSTUVWXYZ&
abcdefghijklmnopqrstuvwxyz1234567890

PALATINO

ABCDEFGHIJKLMNOPQRSTUVWXYZ&
abcdefghijklmnopqrstuvwxyz1234567890

WEISS

ABCDEFGHIJKLMNOPQRSTUVWXYZ&
abcdefghijklmnopqrstuvwxyz1234567890

BASKERVILLE BT

ABCDEFGHIJKLMNOPQRSTUVWXYZ&
abcdefghijklmnopqrstuvwxyz1234567890

CALEDONIA

ABCDEFGHIJKLMNOPQRSTUVWXYZ&
abcdefghijklmnopqrstuvwxyz1234567890

CENTENNIAL

ABCDEFGHIJKLMNOPQRSTUVWXYZ&
abcdefghijklmnopqrstvwxyz1234567890

FAIRFIELD

ABCDEFGHIJKLMNOPQRSTUVWXYZ&
abcdefghijklmnopqrstuvwxyz1234567890

JANSON TEXT

ABCDEFGHIJKLMNOPQRSTUVWXYZ&
abcdefghijklmnopqrstuvwxyz1234567890

OF BASKERVILLE

ABCDEFGHIJKLMNOPQRSTUVWXYZ&
abcdefghijklmnopqrstuvwxyz1234567890

USHERWOOD

ABCDEFGHIJKLMNOPQRSTUVWXYZ&
abcdefghijklmnopqrstuvwxyz1234567890

ZAPF INTERNATIONAL

ABCDEFGHIJKLMNOPQRSTUVWXYZ&
abcdefghijklmnopqrstuvwxyz1234567890

BERNHARD MODERN

ABCDEFGHIJKLMNOPQRSTUVWXYZ&
abcdefghijklmnopqrstuvwxyz1234567890

BERTHOLD BODONI

ABCDEFGHIJKLMNOPQRSTUVWXYZ&
abcdefghijklmnopqrstuvwxyz1234567890

CRAW MODERN

ABCDEFGHIJKLMNOPQRSTUVWXYZ&
abcdefghijklmnopqrstuvwxyz1234567890

MODERN 735

ABCDEFGHIJKLMNOPQRSTUVWXYZ&
abcdefghijklmnopqrstuvwxyz1234567890

MODERN MT WIDE

ABCDEFGHIJKLMNOPQRSTUVWXYZ&
abcdefghijklmnopqrstuvwxyz1234567890

POSTER BODONI

ABCDEFGHIJKLMNOPQRSTUVWXYZ&
abcdefghijklmnopqrstuvwxyz1234567890

TORINO

ABCDEFGHIJKLMNOPQRSTUVWXYZ&
abcdefghijklmnopqrstuvwxyz1234567890

VENDOME

ABCDEFGHIJKLMNOPQRSTUVWXYZ&
abcdefghijklmnopqrstuvwxyz1234567890

Slab Serif

AACHEN

ABCDEFGHIJKLMNOPQRSTUVWXYZ&
abcdefghijklmnopqrstuvwxyz1234567890

CENTURY SCHOOLBOOK

ABCDEFGHIJKLMNOPQRSTUVWXYZ&
abcdefghijklmnopqrstuvwxyz1234567890

CITY

ABCDEFGHIJKLMNOPQRSTUVWXYZ&
abcdefghijklmnopqrstuvwxyz1234567890

EGYPTIAN 710

ABCDEFGHIJKLMNOPQRSTUVWXYZ&
abcdefghijklmnopqrstuvwxyz1234567890

GLYPHA

ABCDEFGHIJKLMNOPQRSTUVWXYZ&
abcdefghijklmnopqrstuvwxyz1234567890

LUBALIN GRAPH

ABCDEFGHIJKLMNOPQRSTUVWXYZ&
abcdefghijklmnopqrstvwxyz1234567890

SERIFA

ABCDEFGHIJKLMNOPQRSTUVWXYZ&
abcdefghijklmnopqrstuvwxyz1234567890

STYMIE

ABCDEFGHIJKLMNOPQRSTUVWXYZ&
abcdefghijklmnopqrstuvwxyz1234567890

Sans Serif

ABCDEFGHIJKLMNOPQRSTUVWXYZ&
abcdefghijklmnopqrstuvwxyz1234567890

ABCDEFGHIJKLMNOPQRSTUVWXYZ&
abcdefghijklmnopqrstuvwxyz1234567890

ABCDEFGHIJKLMNOPQRSTUVWXYZ&
abcdefghijklmnopqrstuvwxyz1234567890

ABCDEFGHIJKLMNOPQRSTUVWXYZ&
abcdefghijklmnopqrstuvwxyz1234567890

ABCDEFGHIJKLMNOPQRSTUVWXYZ&
abcdefghijklmnopqrstuvwxyz1234567890

ABCDEFGHIJKLMNOPQRSTUVWXYZ&
abcdefghijklmnopqrstuvwxyz1234567890

ABCDEFGHIJKLMNOPQRSTUVWXYZ&
abcdefghijklmnopqrstuvwxyz1234567890

ABCDEFGHIJKLMNOPQRSTUVWXYZ&
abcdefghijklmnopqrstuvwxyz1234567890

Sans Serif

ABCDEFGHIJKLMNOPQRSTUVWXYZ&
abcdefghijklmnopqrstvwxyz1234567890

ABCDEFGHIJKLMNOPQRSTUVWXYZ&
abcdefghijklmnopqrstuvwxyz1234567890

ABCDEFGHIJKLMNOPQRSTUVWXYZ&
abcdefghijklmnopqrstuvwxyz1234567890

ABCDEFGHIJKLMNOPQRSTUVWXYZ&
abcdefghijklmnopqrstuvwxyz1234567890

ABCDEFGHIJKLMNOPQRSTUVWXYZ&
abcdefghijklmnopqrstuvwxyz1234567890

ABCDEFGHIJKLMNOPQRSTUVWXYZ&
abcdefghijklmnopqrstuvwxyz1234567890

ABCDEFGHIJKLMNOPQRSTUVWXYZ&
abcdefghijklmnopqrstuvwxyz1234567890

ABCDEFGHIJKLMNOPQRSTUVWXYZ&
abcdefghijklmnopqrstuvwxyz1234567890

ABCDEFGHIJKLMNOPQRSTUVWXYZ&
abcdefghijklmnopqrstuvwxyz1234567890

ABCDEFGHIJKLMNOPQRSTUVWXYZ&
abcdefghijklmnopqrstuvwxyz1234567890

ABCDEFGHIJKLMNOPQRST
UVWXYZ&1234567890

AbcdefgHijkLMNopqrstuvWxyz&
abcdefgHijkLMNopqrstuvWxyz123456790

ABCDEFGHIJKLMNOPQRSTUVWXYZ&
abcdefghijklmnopqrstuvwxyz123456790

ABCDEFGHIJKLMNOPQRSTUVWXYZ&
abcdefghijklmnopqrstuvwxyz123456790

ABCDEFGHIJKLMNOPQRSTUVWXYZ&
abcdefghijklmnopqrstuvwxyz123456790

ABCDEFGHIJKLMNOPQRSTUVWXYZ&
abcdefghijklmnopqrstuvwxyz123456790

Black Letter, and Typographic Ornaments

FETTE FRAKTUR

$$\mathfrak{ABCDEFGHIJKLMNOPQRSTUVWXYZ}$$

$$\mathfrak{\&abcdefghijklmnopqrstuvwxyz}1234567890$$

LINOTEXT

$$\mathfrak{ABCDEFGHIJKLMNOPQRSTUVWXYZ}$$

$$\mathfrak{\&abcdefghijklmnopqrstubwxyz}1234567890$$

WOODTYPE ORNAMENTS

ZAPF DINGBATS

BORDERS AND BRACKETS

FLOURISHES

Materials for Designers

No matter how great your imagination and enthusiasm, you must depend on your tools and equipment to convey your ideas. Today designers find themselves with a foot in two worlds: the electronic and the mechanical. Jobs that begin on a computer often end up on the drafting table and vice versa. Although you may be using your T-squares and triangles less frequently, it is still too soon to assign them to the wastebasket. Designers need both good computers and traditional tools to do the best work possible.

When purchasing supplies and equipment, buy only the best. The extra money you spend on quality is a good investment. In the long run, the tools pay for themselves by allowing you to produce work you can be proud of.

Adhesives. For presentation purposes, designers still require adhesives. The most common of these is rubber cement, which is available in one-coat or two-coat varieties. One-coat is used to reposition artwork. Two-coat is for more permanent applications. Since mechanicals are rarely prepared today, spray adhesives, wax, and double-sided adhesive film have all but replaced rubber cement. The drawback to spray adhesives is the environmental factor. Some contain chemicals and solvents that can pose problems for the designer's health and the environment.

Computer. The single most important piece of equipment the designer needs is a good computer. It makes no sense to recommend a particular make or model, as the industry changes so rapidly that any advice is quickly obsolete. Fortunately, most students will be attending a school or working at a company where computers will be supplied. Should you have to purchase a computer, buy the best you can afford and choose a model that can be upgraded as your demands change. (For more information about computers, see page 162.)

Cutting Tools. The most common and effective cutting tools are the single-edged razor blade, the X-acto® knife, and the mat knife. The blades are relatively inexpensive, so buy many and replace them often. Blades dull quickly and can cause accidents.

Single-edged blades and X-acto® knives are used for cutting thin material. For cutting thicker paper, such as illustration board, you will need a mat knife, which has a large handle that you can grasp in your hand, enabling you to apply greater pressure. When using knives, do not apply excessive force; instead, cut gently in multiple passes.

Drafting Table. In addition to your desk, which usually supports your computer, you should have a separate drafting table. This provides a larger, more efficient area for working than your desk. All drafting tables have two features in common: both the height and the angle of the surface can be adjusted.

When you select a drafting table, pay close attention to the manner in which it is supported. Some models are supported simply by crossed pieces of wood and adjusted by a nut-and-bolt method. Although this type is less expensive, the table tends to wobble when pressure is applied. Find a table that is sturdy and more reliable. For general use, a surface that measures at least 24" x 30" (61 x 76 cm) is suitable. If you intend to do professional work and space is not a problem, you might consider a four-post drafting table, which looks very much like a sturdy desk but has an adjustable surface.

Never use your drawing surface for cutting. Nicks and holes produced by razor blades will be a constant nuisance to you later on. Illustration board taped to the drafting table is a sympathetic surface for drawing and good protection for the surface of the table.

Drafting Tape. Drafting tape is indispensable for tacking down art on the drafting surface. Drafting tape comes in a variety of widths, but 1/2" or 3/4" (1.3 or 1.9 cm) is the best for all-around use. The tape also comes in two basic colors, buff and white. Since the white is the same color as the paper, it is less distracting and makes your design look neater when used for presentation purposes. Drafting tape is sometimes confused with masking tape, which has far more adhesive. Although masking tape is less expensive, it should be avoided, as the stronger adhesive easily tears paper when removed.

Drawing Board. If you cannot afford a good drafting table, a simple portable drawing board is a useful alternative. It is preferable to get a board with a true-edge, that is, a metal strip attached to the left-hand edge of the board, which gives you a precise edge for lining up your T-square.

RUBBER CEMENT

CUTTING TOOLS: MAT KNIFE, X-ACTO® KNIFE, AND SINGLE-EDGED RAZOR BLADES

TYPE GAUGE

Erasers. You will need a good eraser when you work. The handiest eraser for the designer is the kneaded eraser, made of pliable rubber, which can be pressed into any shape. By molding it into a slender point, you can erase small details. The kneaded eraser does not leave crumbs of rubber behind. It is ideal for soft pencil lines. For more stubborn lines, you should also have a hard white plastic eraser.

Lighting. Do not underestimate the importance of good lighting. Since designers do detailed work, they must be able to see clearly. Many hours of intense work on the computer or at the drawing table under poor lighting conditions can cause severe eyestrain and headaches. Choose your lighting equipment carefully and position it to avoid reflections on your computer screen.

The best all-around lamp is a floating arm lamp, which enables you to put the light exactly where you want it. They are available with either incandescent, fluorescent, or halogen bulbs. Fluorescent tubes produce a uniform light and give off very little heat—an important factor when you consider how close the lamp might be. Fluorescent tubes are more expensive initially, but they last longer than incandescent bulbs and cost less to burn. You can also combine the best features of both by getting a combination lamp with both incandescent and circline (round fluorescent) bulbs.

T-SQUARE

Also choose a lamp base most suited to your needs. Some lamps have weighted bases that can be set on a table. Others can be clamped or screwed to any surface, enabling you to attach the lamp to your drafting table or desk.

If you are considering a halogen lamp, be certain to try it out first. You may find that the lamp illuminates too small an area and that the light is too intense. Halogens also give off an amazing amount of heat.

TRIANGLES

Papers. For drawing thumbnails and comprehensives, there are two kinds of papers you will find most convenient: tracing and layout. Both tracing and layout paper are readily available in pad form in a wide range of sizes.

Because of its transparency, tracing paper is ideal for tracing type accurately. Because it is relatively inexpensive, the paper can be used generously to sketch and develop thumbnails and ideas, layer by layer. Layout paper is a higher-grade rag-content sheet, whiter and not quite as transparent as tracing paper but still transparent enough to enable you to trace accurately. It is excellent for visualizing and presenting your design.

If you intend to mount your presentations, you may find illustration or bristol board useful. This is actually a very heavy paper, generally available in two finishes—hot press (smooth) or cold press (slightly textured)—and in single or double weight. The smooth surface is best suited for fine illustrations and hand-lettering where detail is important.

Pencils. The most useful pencil for general use is either 2H or HB. Softer pencils—numbers 2B to 6B —are likely to smudge and require sharpening more frequently. Harder pencils, numbers 3H to 9H, are recommended for guidelines, since they produce a sharp light line. Experiment with pencils of different hardnesses until you find the one most comfortable for you.

Pens, Inks, and Markers. A studio equipped with a wide selection of pencils, markers, and felt-tip pens in a variety of colors provides a more creative environment. They are handy for quickly sketching concepts and writing out bold instructions.

One tool that has become practically obsolete is the ruling pen or technical fountain pen. However, if you ever have to draw rules by hand, you will probably need one of these pens. They are used to draw accurate, uniform lines in assorted widths and must be well cared for. Fortunately, the task of creating rules and boxes has been taken over by the computer.

Rulers. A good-quality 12" or 18" (30 or 45 cm) etched steel ruler is well worth the price. Unlike less expensive aluminum, wood, or plastic rulers, the heavier steel ruler won't slip under pressure. It also has the advantage of providing an excellent guide for cutting and trimming with razor blades or mat knives. When you make your selection, be sure the ruler is graduated in inches on one edge and has a pica rule on the other edge. (In the newspaper industry, you need a ruler with an agate measure as well.)

Precision rules are another valuable tool for measuring and layout. These are accurate, flexible, translucent rulers that usually come in sets containing every useful measurement for designers who work with typography. Because the rulers are thin and flexible, they can be used for measuring curved surfaces. Before sending out finished work, always check dimensions for accuracy and consistency. Precision rules allow you to do this confidently. Two companies that make precision rules are Schaedler and Cobalt.

Triangles. Triangles are used to draw and "square" artwork. They come in many sizes, shapes, and even colors. Two good sizes are 6" and 12" (15 an 30 cm). A triangle with 30°, 60°, 90° angles and one with 45°, 45°, 90° angles are standard. Do not use plastic triangles for cutting edges. Once nicked, the plastic triangle is virtually useless.

Type Gauge. A type gauge, such as the Haberule, is an invaluable tool for the student or professional. Type gauges are usually made in hard plastic and are graduated in units of 6 through 15 points. For further convenience, an inch scale is usually added.

T-square. A good T-square is as important as a good ruler. Like rulers, T-squares come in different lengths, the 24" (61 cm) perhaps being the best for all-around use. The length you choose will also depend on the nature of your design work. If you intend to use the T-square as a guide for cutting, buy a steel model; wood and plastic T-squares are for drafting only, and once you nick the plastic edge with a razor blade, you will plagued every time you draw a line. □

Typesetting Methods

Over the centuries type has been set in numerous ways, ranging from the original method of assembling individual pieces of type by hand, one character at a time, to computer-controlled systems capable of generating type at thousands of characters per second. Typesetting methods can be divided into four major categories: handsetting, machine casting, phototypesetting, and digital composition.

Although typesetting methods have changed over time, the criteria for judging good typography have not. So although you should know as much as possible about the various typesetting methods, it is more important to understand what constitutes a well-designed typeface and how type should be arranged on the page.

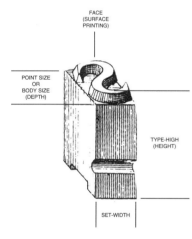

FACE
(SURFACE PRINTING)

POINT SIZE
OR
BODY SIZE
(DEPTH)

TYPE-HIGH
(HEIGHT)

SET-WIDTH

HANDSETTING

MACHINE CASTING

Handsetting. Handset type was introduced in the mid-fifteenth century by Johannes Gutenberg, and until the late nineteenth century, it was the only means of setting type.

In handset type (also called foundry type), every character was cast on a separate piece of metal and stored in a type case. The letters on metal type were reversed so they would appear correct when printed.

To set type, the compositor, or typesetter, held a composing stick in one hand and with the other selected the required pieces of type from the type case. When the job had been set, the type was "locked-up," inked, and printed.

The height of the metal type, referred to as type-high, had to be consistent in order to print evenly (.918 inches). If a piece of type was too low, it would not receive the ink; if too high, the type would press into the paper. After printing, the type characters were cleaned and redistributed into their proper compartments for future use.

Although the compositor worked quickly and instinctively, setting type by hand was slow and time-consuming. Today handsetting type is used mainly by private presses for limited edition art books.

Machine Casting. By the late nineteenth century, machines had been developed that could cast type either as individual characters (Monotype) or as entire lines (Linotype). To cast type, the typesetter operated a keyboard. As each letter was typed, molds (also called matrices) of the letters fell into position, and after each line was finished, the molds were filled with a molten lead alloy that solidified instantly to produce type. After printing, the type was melted down and reused.

Casting type was faster and more efficient than setting type by hand and therefore less expensive. The speed of the setting was limited only by the keyboard operator's typing ability, approximately 50 words per minute. Cast type did not totally replace handset type. They existed side by side, with the smaller text type being set by machine and the larger display type by hand.

Until the 1960s casting was the most widely used method of setting type, but it is no longer used commercially today.

Phototypesetting. In the mid-1960s casting type in hot metal was replaced by the first form of "cold" type, called phototypesetting. This process involved the photographic projection of light through a film negative of the characters onto photosensitive film or paper. The characters to be set were input on a keyboard, stored on a tape, and controlled by large computers.

Since type was no longer restricted by the limitations inherent in metal, letterforms could be manipulated far more easily. Characters could be set close, touching, or overlapping. Furthermore, the letterforms were always exactly the same because the type was all shot from the same negative font. In spite of its many virtues, phototypesetting has been completely superseded by digital technology, which is even faster, more flexible, and less costly.

Digital Composition. By the end of the 1980s, digital composition had become the most efficient method of typesetting. Digital typesetters, or laser imagers, are dramatically different in both storage and output from analog phototypesetting systems. In phototypesetting, characters were generated from photographic fonts. In digital composition systems, the characters are stored electronically as digital data in the computer's memory. The type is then generated as a series of dots or lines. Depending on the requirements, the output may be produced on virtually any surface or material.

The output devices for digital systems are high-speed type-generating machines capable of setting type at the rate of thousands of characters per second. The quality of the type is in direct relationship to the quality of the original drawings, their storage, and the speed of the output.

Because the type is digital, it can be electronically condensed, expanded, slanted, and manipulated.

One of the great advantages of digital technology is the capacity to reproduce any image that can be digitized. This includes not only type but also photographs, illustra-

PHOTOTYPESETTING

DIGITAL COMPOSITION

tions, and other graphic images. This is accomplished through the use of a raster image processor (RIP), which converts the image into a digital file that can then be stored, manipulated, and output as necessary.

Digital Design. The revolution in digital design began with the advent of desktop publishing in 1982, when John Warnock and Charles Geschke developed Adobe PostScript, a standard computer language that could be used for manipulating visual information.

Using this technology in conjunction with the Aldus PageMaker program, Apple Computer, Inc., began to market micro computers that could be operated by people with minimal programming capabilities. Since that time there has been tremendous growth in the industry, with systems offering greater speeds, increased storage, and new programs.

Digital design has become more than just another typesetting or design method. It has essentially brought an end to the traditional typesetting industry by giving "desktop users" the ability to generate typography without relying on outside services. This has dramatically altered the designer's role.

Today the designer has become a combination artist and technician, often responsible for entire jobs ranging from editorial duties to production tasks.

Digital programs give designers the ability to undertake projects in once highly specialized fields. Areas in typography, illustration, photography, moving images, and sound are no longer restricted to specific practitioners. Instead, processes in these disciplines are combined on a single platform.

Working with combined disciplines, or *multimedia,* is perhaps the most significant creative possibility in digital design. Typography can easily be part of an image, photograph, or moving images; it no longer is generated as a separate element to be later combined in a final layout.

QuarkXpress

Adobe Illustrator

Adobe Photoshop

DESIGN APPLICATIONS

Even the printed page, once the major form of typographic expression, is being overshadowed by recent forms of communication like the World Wide Web. Because the digital process is universal to most forms of contemporary communication, digital typography moves easily between print, film, and Website design.

Although there are myriad aspects to working with computers, all the functions can be broken down into four principal areas: input, storage, manipulation, and output. Each of these functions is dependent on three things: the hardware, or equipment itself; the software, or computer applications; and the user's experience and capability.

Input Devices. The entire process begins with some form of data that must be input and initially stored. Input may occur by typing text on a keyboard, scanning text or images, copying outside files, or even through voice recognition programs. The objective is to turn analog data into digital data. Once converted and modified into compatible formats, the information can be stored and prepared to be manipulated to some purpose.

Most studios possess medium-quality scanners and other hardware and software for this purpose. Specialized studios may have sound and video equipment or other input devices for multimedia work.

Storage. One of the most significant developments in the computer industries has been the huge increase in the capacity to store data. Originally, 5-inch floppy disks and hard disk drives handled the storage for micro computers. Early desktop systems held about 80K (80,000 bytes) of information internally and 20K on floppy disks.

Within a decade internal hard drives could hold a gigabyte (a billion bytes) of data, and optical disks nearly as much.

Today storage is so economical that it rarely poses a problem for the professional designer or studio to increase storage capacity.

Manipulation. Programming capabilities allow digital data to be reprocessed into the desired form. This includes the use and application of typography, photography, illustration, and even sound and moving images. Holograms (three-dimensional images) can be created, and even taste and smell are being developed.

Computer data is manipulated using a combination of hardware and software. By working with a keyboard or a mouse, the user can call up programs, issue commands, select typefaces, reduce or enlarge design elements, and position copy. Other manipulating tools include touch screens, pens and tablets.

At the heart of the manipulation process is the operating system. The operating system controls most of the computer's basic chores and facilitates the use of the applications. In turn, the applications perform specific tasks. There are literally thousands of programs created for every purpose: word processing, design, page makeup, slide presentation, animation, video generation, and so on.

Output Devices. As design progresses, the user has two basic ways to view it. First, the design can be viewed on a monitor, or screen, as it develops. For the designer this screen represents the desktop, or working, environment. Second, hard copy can be generated through laser printing, inkjet printing, or another printing process. In fact, there are many methods of generating output, and in the packaging and product fields, even three-dimensional models can be produced.

When the job is completed and approved, it is prepared for final production and distribution. For the graphic designer this could mean printing, distribution through the Internet, or mass production in some digital format. All of these methods rely on varying levels of digital technologies. Some result in a tangible printed piece; others in fleeting images. □

Glossary

A

AA. Author's alteration. An alteration to the original job that incurs additional charges. *Compare to* PE.

Accordion fold. Series of parallel folds in paper in which each fold opens in the opposite direction from the previous fold—in a zigzag pattern.

Acetate. Transparent plastic film used to cover presentations or to make indications over original art.

Adobe PostScript. A computer imaging program language for page description.

A4. The international standard for business stationery. The approximate U.S. equivalent is 8 1/2 x 11 inches.

Against the grain. Folding paper at right angles to the grain. *See also* Grain.

Agate. Unit of measurement used in newspapers to calculate column space: 14 agate lines equal 1 inch.

Align. To line up, or place letters or words on the same horizontal or vertical line.

Alignment. Arrangement of type in straight lines so that different sizes justify at the bottom (base-align) and ends of lines appear even on the page.

Alterations. Any changes in copy after setting. *See also* AA *and* PE.

Ampersand. Name of the type character "&" used in place of "and." Derived from the Latin *et.*

Antique finish. A roughly finished book paper, usually in natural muted colors.

Analog. A language or process using a continuous and variable mechanical or electrical scale—rather than electrical pulses. For example, an electrical current. *Compare to* Digital. A dial phone is analog; a touchtone phone is digital.

Application. A computer program that is used to perform a specific task, such as word processing, page layout, or photographic manipulation.

Arabic numbers. The figure zero and numerals 1 though 9, so called because they originated in Arabia. *Compare to* Roman numerals.

Art. All original copy, whether prepared by an artist, camera, or other mechanical means. Loosely speaking, any copy to be reproduced.

Ascender. The part of the lowercase letter that rises above the body, as in *b, d, f, h, k, l,* and *t.*

Asterisk. Reference mark (*) used to indicate a footnote. Also used to indicate missing letters or words.

Author's alternation. *See* AA.

B

Backbone. Also called a spine. In binding, that part of a book binding that connects the front and back covers.

Backslant. Typeface that slants backward; that is, opposite to italic.

Bad break. A block of text with many hyphenations, a poorly designed rag, or a single word (widow) as the last line of text.

Baseline. Horizontal line upon which all the characters in a given line stand.

Basis weight. The weight of 500 sheets of paper (a ream) cut to a specific size.

Binary. Anything made up of only two units, parts, or options. In computer systems, a base-2 numbering system that uses the digits 0 and 1.

Binding. The fastening together of printed sheets in the form of signatures into books, booklets, magazines, etc. Also, the covers and backing of a book.

Binary digit. *See* Bit.

Bitmapped display. An image on the video screen in which each dot, or pixel, corresponds to one or more bits in the computer's random-access memory (RAM).

Bit. In computer systems, the smallest unit of information representing one binary digit, 0, or 1. The word is derived from the first two letters of binary and the last letter of digit.

Black Letter. Also known as Gothic. A style of handwriting popular in the fifteenth century. Also, the class of typestyles based on this handwriting.

Bleed. Area of image that extends beyond ("bleeds" off) the edge of the paper. Applies mostly to photographs or full areas of color. When a design involves a bleed image, the designer must allow from 1/8" to 1/4" beyond the intended trim size. A slightly larger sheet is required to accommodate bleeds when printing.

Blind embossing. A bas-relief impression made with a regular stamping die, except that no ink or foil is used.

Blowup. An enlargement of copy: photograph, artwork, type, or image.

Blueprint. Also called blues. Inexpensive proofs made from a set of photo negatives, submitted for approval prior to platemaking.

Blurb. Summary of contents of a book presented as jacket copy. Also, a short commentary, such as a caption or the text in comic strip balloons.

Body. In composition, the metal block of a piece of type that carries the printing surface. It is the depth of the body that gives the type its point size.

Body copy. Regular reading matter, or text, as contrasted with display lines. Also called body matter.

Body matter. *See* Body copy.

Body size. The depth of the body of a piece of type measured in points.

Body type. Also called text type. Type, from 6 points to 14 points, is generally used for body copy.

Boldface. A heavier version of a regular typeface, indicated as BF.

Bond paper. A grade of writing and printing paper with a surface treated to take pen and ink well and have good erasure qualities.

BPS. Bits per second.

Brackets. Pair of marks [...] used to set off matter extraneous to the context.

Bullet. A typographic element usually used to highlight specific lines of text.

Byte. Eight bits. In most current systems, one character or symbol is represented by one byte.

ACCORDION FOLD

C

C & sc. Capitals and small capitals. In composition, used to specify words that begin with a capital letter and have the remaining letters in small capitals, which are the same height as the body of the lowercase letters.

California job case. Used in traditional metal typesetting. Tray in which handset type is stored and from which it is set. The individual cubicles are logically arranged so that frequently used letters are most easily accessible.

CALIFORNIA JOB CASE

Calligraphy. Elegant handwriting, or the art of producing such handwriting.

Camera-ready art. Physical copy assembled and suitable for photographing by a process camera or scanner. Mostly replaced by digitally prepared files.

Capitals. Also known as caps or uppercase. Capital letters of the alphabet.

Caps and small caps. *See* C & sc.

Caption. Explanatory text accompanying illustrations.

Cardinal numbers. Identifying sequence of numbers: one, two, three, etc. *Compare to* Ordinal numbers.

Casting. An obsolete typesetting process in which molten metal is forced into type molds (matrices). Type can be cast as single characters or as complete lines.

Casting-off. *See* Character counting.

Cathode ray tube. In typesetting, electronic tube used to display letter image, in the form of dots (computer logic character formation) or lines (character projection), for exposure onto film, photographs, microfilm, or offset plates.

Centered type. Lines of type of varying lengths set centered on the line measure.

Chapter heads. Chapter title and/or number of the opening page of each chapter.

Character count. The number of characters in a line, paragraph, or piece of copy.

Character counting. Calculating the length of manuscript copy in order to determine the amount of space it will occupy when set in a given typeface and measure. *Also called* Casting-off.

Characters. Individual letters, figures, punctuation, etc., of the alphabet.

Character generation. The electrode digital process of generating type and image. Usually by cathode ray tube and positive/negative charge.

Characters per pica (CPP). System of copyfitting that utilizes the average number of characters per pica as a means of determining the length of the copy when set in type.

Cicero. Typographic unit of measurement predominant in Europe: approximately the same as the pica used in the U.S. and Asia.

Clip art. Uncopyrighted images available in printed or digital form. Used when custom artwork is not viable because of cost or time.

CMYK. *See* Four-color process.

Coated paper. Paper with a surface treated with clay or some other compound and adhesive material to improve the finish in terms of printing quality. A coated finish can vary from dull to very glossy and provides an excellent printing surface that is especially suited to fine halftones.

Collate. To arrange sheets or signatures in proper sequence so the pages will be in the correct order before sewing and binding.

Colophon. Inscription in a book that contains information relating to its production. Usually placed at the end of the book.

Color–matching system. Method of specifying flat color by means of numbered color samples available in swatchbooks. The Pantone Matching System® (PMS) is the most popular.

Color proof. Printed color image that the designer and client check to make sure the color is accurate and in register prior to printing multiple copies.

Color separation. The operation of separating artwork into the four process colors by means of filters in a process camera or by electronic scanners. The result is four continuous-tone films (negatives or positives), which are used to make printing plates.

Column inch. A measure commonly used by smaller newspapers based on a space 1" deep and a column wide.

Composing stick. In metal composition, a small metal traylike device used to assemble type when it is being set by hand. It is adjustable so that lines can be set to different measures.

Composition. The process of typesetting.

Comprehensive. More commonly referred to as a comp. An accurate layout showing type and illustrations in position, suitable for use as a finished presentation.

Condensed type. Narrow version of a regular typeface.

Continuous-tone copy. Any image that has a complete range of tones from black to white: photographs, paintings, etc. *Compare to* Line copy.

Contour setting. Type that takes the shape of a recognizable object.

Copy. In design and typesetting, typewritten copy. In printing, all artwork to be printed: type, photographs, etc. *See also* Continuous-tone copy *and* Line copy.

Copyfitting. Determining the area required for setting a given amount of typewritten copy in a specified typeface.

Counter. Space enclosed by the strokes of a letter, such as the bowl of *b, d, p,* etc.

CPS. Characters per second. A measurement referring to the output speeds of typesetting equipment.

CPU. Central processing unit.

Crop. To eliminate portions of an image or illustration so that it fits the page design better. Traditionally done by using cropmarks on the original copy to indicate to the printer where to trim the image.

Cropmarks. In design, the lines that are drawn in the margins of the live image to indicate where the image or artwork should be trimmed.

CRT. *See* Cathode ray tube.

Cursives. Early italic typefaces that resemble handwriting but with the letters disconnected.

D

Data. Information input, output, stored, or manipulated by a computer system.

Database. A structured arrangement of data in a form that can be manipulated in a computer system.

Data bank. A large store of information that can be selectively retrieved from a computer. A font library may be stored in a data bank.

Data processing. A generic term for all systematic operations carried out on computer data.

Deckle edge. Irregular, ragged edge on handmade papers, or the outside edges of machine-made paper.

Definition. The degree of sharpness in a negative or print.

Delete. A proofreaders' mark meaning "take out." See page 136.

Descenders. That part of a lowercase letter that falls below the body of the letter, as in *g, j, p, q,* and *y.*

Desktop publishing. The process whereby personal computers, peripherals, and suitable software are used to produce publication-quality documents.

Didot. Typographic system of measurement used outside the United States. Comparable to our point system.

Die-cutting. A process of custom cutting using a steel die.

Digital. A system for encoding a value using a sequence of digits. A computer is a digital device that uses sequences of bits to encode information. *Compare to* Analog.

Digital printing. Plateless printing direct from digital files.

Direct to press. A digital process in which output is printed directly from computer files, bypassing traditional platemaking processes.

Disk. An information storage medium. Traditionally available in floppy (portable) or hard (computer-installed) formats.

Display type. Type used to attract attention, usually above 14 points in size.

Dithering. A technique, similar to pointillist painting, of using small patterns of a few basic colors to simulate many more colors. Often used on inexpensive displays and printers, dithering reduces the resolution of an image and can introduce unwanted patterns.

Dot leaders. *See* Leaders.

DOS. Disk operating system. Computer program code designed to handle the input, manipulation, storage, and transfer of data.

Drop initial. Display letter that is inset into the text.

Direct to plate. Creating a plate directly from computerized copy without film.

Dummy. The preliminary layout of a printed piece showing how the various elements will be arranged. It may be either rough or elaborate, according to the client's needs. The term *comp* is used more frequently.

Duotone. A photograph printed using two colors, usually black plus one color.

E

Editing. Checking copy for fact, spelling, grammar, punctuation, and consistency of style.

Egyptian. *See* Slab Serif.

Elite. The smallest size of typewriter type: 12 characters per inch, as compared to 10 per inch on the pica typewriter.

Ellipses. Three dots (…) that indicate an omission; often used when shortening copy.

Em. Commonly used shortened term for em-quad. *See also* Em-quad.

Embossing. Producing a raised image on a printed surface. *See also* Blind embossing.

Em-dash. Also referred to as a long dash. A dash the width of an em-quad.

Em-quad. In handset type, a metal space that is the square of the type body size; that is, a 10-point em-quad is 10 points wide. The em gets its name from the fact that in early fonts the M was usually cast on a square body.

En. Commonly used shortened term for en-quad. *See also* En-quad.

En-quad. The same depth as an em but one half the width: the en space of 10-point type is 5 points wide.

Expanded. Also called *extended.* A wide version of a regular typeface.

F

Face. The part of metal type that prints. Sometimes used as an abbreviation for typestyle or typeface.

Facsimile. Full name for fax. A machine or modem capable of transmitting graphic information by phone or wireless method.

Family of type. All the type sizes and typestyles of a particular typeface (roman, italic, bold, condensed, expanded, etc.).

Feathering. A ragged, or feathered, edge on printed type.

EM-QUAD

EN-QUAD

3-TO-THE-EM

4-TO-THE-EM

½	.5
¼	.25
¾	.75
⅛	.125
⅜	.375
⅝	.625
⅞	.875
¹⁄₁₆	.0625
³⁄₁₆	.1875
⁵⁄₁₆	.3125
⁷⁄₁₆	.4375
⁹⁄₁₆	.5625
¹¹⁄₁₆	.6875
¹³⁄₁₆	.8125
¹⁵⁄₁₆	.9375
¹⁄₃₂	.03125
³⁄₃₂	.09375
⁵⁄₃₂	.15625
⁷⁄₃₂	.21875
⁹⁄₃₂	.28125
¹¹⁄₃₂	.34375
¹³⁄₃₂	.40625
¹⁵⁄₃₂	.46875
¹⁷⁄₃₂	.53125
¹⁹⁄₃₂	.59375
²¹⁄₃₂	.65625
²³⁄₃₂	.71875
²⁵⁄₃₂	.78125
²⁷⁄₃₂	.84375
²⁹⁄₃₂	.90625
³¹⁄₃₂	.96875

FRACTIONS TO DECIMALS

GATEFOLD

File. Any collection of information stored on a disk; for example, a document, resource, or application.

Finish. The surface properties of paper.

Fit. Space relationship between two or more letters The fit can be modified into a "tight fit" or a "loose fit" by adjusting the set-width or the tracking.

Flat color. Generally refers to solid colors or tints rather than the four process colors.

Flop. To turn over an image or photograph so that it faces the opposite way.

Flyer. Advertising handbill or circular.

Folder. An electronic file containing documents.

Folio. Page number. Also refers to a sheet of paper when folded once.

Font. Complete assembly of all the characters (upper and lowercase letters, numerals, punctuation marks, points, reference marks, etc.). Traditionally, a font referred to one size of one typeface; today a font is not size specific.

Format. General term for style, size, and overall appearance of a publication.

Formatting. The translation of specification into formats or computer coding.

Foundry type. Metal type characters used in hand composition.

Fractions. In typesetting, a single keystroke or keystroke combination that builds customized fractions.

Four-color process. Method of reproducing full-color copy (original artwork, transparencies, etc.) by separating the color image into its three primary colors—magenta, yellow, and cyan—plus black.

Full color. Process color.

G

Galley. In metal composition, a long tray that holds type prior to printing. Also the name of a proof pulled from a galley tray or any other unpaged proof.

Gatefold. A page that folds into the gutter and, when unfolded, is about twice the size of a normal page.

Gigabyte (GB). 1,000 megabytes, or 1 billion bytes.

Gigo. Garbage in, garbage out. Programming slang for bad input produces bad output.

Grain. Predominant direction of the fibers in a sheet of paper. The direction of the grain is important when it is folded. A sheet folded with the grain folds easily; a sheet folded across the grain does not.

Gray scale. A band of gray tones from white to black, often used as a test strip to measure the quality of a tonal range in photography and printing.

Grid. The cross-ruled guidelines over which all parts of a page or book layout will be assembled.

Gutter. Blank space where two pages meet at the binding or blank space between two columns of type.

Gutter margin. Inner margin of a page on a spread.

Gutenberg, Johannes. German inventor of movable type and letterpress printing (c.1455) as we know it today.

H

Hairline. A fine line or rule, 1/4 point in thickness.

Halftone. The photomechanical reproduction of continuous-tone copy (such as photographs) in which the gradations of tone are created by the relative size and density of tiny solid dots.

Hanging indentation. A type arrangement style in which the first line of copy is set full measure and all the lines that follow are indented.

Hard copy. Typewritten copy or the printed version of a digital file.

Hard disk. *See* Disk.

Hardware. The mechanical and electronic parts that make up a computer. *See also* Software.

Head. The top, as opposed to the bottom, or foot, of a book or a page.

Heading. Bold or display type used to emphasize copy.

Headline. The most important line of type in a piece of printing, enticing the reader to read further or summarizing at a glance the content of the copy that follows.

Head margin. The white space above the first line on a page.

Hot type. Slang expression for type produced by casting hot metal, now obsolete. Linotype was the most popular manufacturer.

Hyphenation. Determining where a word should break at the end of a line. In typesetting, computers are programmed to hyphenate.

I

Icon. A symbol shown on the computer screen to represent an object, concept, or message; for example, a disk, folder, document, trash, etc.

Ideographs. Symbols representing an idea, not an object.

Illustration. General term for any form of drawing, diagram, halftone, or color image that serves to enhance a printed piece.

Imposition. In printing, the arrangement of pages in a press form so they will appear in correct order when the printed sheet is folded and trimmed.

Initial. The first letter of a body of copy, set in display type for decoration or emphasis. Often used to begin a magazine article or a chapter of a book.

Input. In computer composition, the initial data to be processed, usually in the form of text files. Also, any information received by the computer from storage, keyboard, mouse, scanner, etc.

Input device. A scanner, keyboard, mouse, or other hardware that sends information to the computer.

Insert. A separately prepared and specially printed piece that is inserted into another printed piece or a publication.

Italic. Letterform that slants to the right: *looks like this. Compare to* Oblique.

J

Justified type. Lines of type that align both left and right of the full measure.

Justify. The act of justifying lines of type to a specified measure, flush right and left, by putting the proper amount of space between words in the lines to make them all even, or "true."

K

Kerned letters. In metal type, characters in which a part of the letter extends, or projects, beyond the body or shank, thus overlapping an adjacent character.

Kerning. Adjusting the space between letters so that part of one extends over the body of the next. Kerned letters are common in italic, script, and swash fonts.

Keyline. *See* Mechanical.

Kill. To delete unwanted copy or text.

Kilobyte (KB). 1,000 bytes.

L

Laid paper. Paper having a laid pattern: a series of parallel lines simulating the look of the handmade papers.

Layout. Preliminary plan or blueprint of the basic design, usually showing the sizes and kind of type, illustrations, spacing, and general style in their proper positions. Used as a guide for the client or supplier.

LC. Lowercase, or small letters of a font.

Leaders. A row of dots, periods, or dashes used to lead the eye across the page. Leaders are specified as 2, 3, or 4 to the em; in fine typography they are usually arranged to align vertically.

Lead-in. The first words in a block of copy set in a contrasting typeface.

Leading. (Pronounced ledding.) In metal type composition, the insertion of leads between lines of type. The term is still used to indicate space added between lines of type. Also called linespacing.

Leads. (Pronounced leds.) In metal type composition, the thin strips of metal (in thicknesses of 1 to 2 points) used to create space between the lines of type. Leads are less than type-high and so do not print.

Legibility. The quality in typeface design that affects the speed of perception: the faster, easier, and more accurate the perception, the more legible the type.

Letterpress. The printing method used to print directly from cast (hot-metal) type. It is based on relief printing, which means that the image area is raised.

Letterspacing. In composition, adding space between the individual letters in order to fill out a line of type to a given measure or to improve appearance.

Ligature. Two or three characters joined as a single character; ff, fi, fl, ffi, ffl are the most common.

Lightface. A lighter version of a regular typeface.

Line copy. Any copy that is solid black, with no gradation of tones: line art, type, rules, etc. *Compare to* Continuous-tone copy.

Line gauge. Also called a type gauge or pica rule. Used for copyfitting and measuring typographic materials.

Linelength. *See* Measure.

Linespacing. In typesetting, an alternate term for leading.

Lining figures. Numerals that are the same size as caps in a typeface and align on the baseline: 1, 2, 3, 4, 5, 6, 7, 8, 9, 0. Also called modern figures. *Compare to* Old style figures.

Logotype. A specific name or type arrangement trademarked and used as a company or corporate identifier. Usually shortened to logo.

Lowercase. Small letters, or minuscules, as opposed to caps.

M

Magnetic tape. In typewriter composition and photocomposition, a tape or ribbon impregnated with magnetic material on which information may be placed in the form of magnetically polarized spots. Used to store data that can later be further processed and set into type.

Mainframe. A large computer originally manufactured in a modular fashion.

Makeready. The process of arranging the form on the press preparatory to printing so that the impression will be sharp and even.

Makeup. Assembling the typographic elements (type and halftones) and adding space to form a page or a group of pages of a newspaper, magazine, or book.

Manuscript. Copy to be set in type. Usually abbreviated to MS (sing.) and MSS (pl.). Can also refer to handwritten, as opposed to typewritten, material.

Markup. In typesetting, to mark the type specifications on layout and copy for the typesetter. Generally consists of the typeface, size, linelength, leading, etc.

Masthead. Any design or logotype used to identify a newspaper or other publication.

Matte finish. A paper with a dull finish. Also, in photography, a textured, finely grained finish on a photograph or photostat. As opposed to glossy.

Meanline. The line that marks the tops of lowercase letters without ascenders.

Measure. Also called linelength. The length of a line of type, normally expressed in picas and points.

Mechanical. Camera-ready paste-up assembly of all type and design elements pasted on artboard or illustration board in exact position and containing instructions, either in the margins or on an overlay, for the platemaker.

Mechanical letterspacing. Type set with automatic spacing between the characters.

KERNED LETTERS

Megabyte (MB). 1,000 kilobytes.

Memory. The place in the computer's central processing unit where information is stored. *See also* RAM *and* ROM.

Menu. A video display of programs and tasks.

Metric system. Decimal system of measures and weights with the meter and the gram as the bases. Here are some of the more common measures and their equivalents:

kilometer	00.6214 mile
meter	39.37 inches
centimeter	00.3937 inch
millimeter	00.0394 inch
kilogram	02.2046 pounds
gram	00.035 ounce
inch	02.54 cm
foot	00.3048 meter
yard	00.9144 meter
ounce	31.103 grams
pound	00.4536 kilogram

Microchip (or "chip). A silicon wafer typically containing millions of electical components; chips make up the "brains" of the computer and perform such tasks as logical and numerical processing, data storage, and information management.

Minuscules. Smaller letters, or lowercase.

Modem. A hardware component that converts electronic computer signals into audible tones which can then be transmitted through telephone lines. A receiving modem then reconverts the audio tones back to digital data. In this way, files can be transmitted via telelphone.

Modern. Term used to describe the typestyle developed in the late eighteenth century.

Mouse. A hand-held device used to supplement the computer keyboard when working with computers. When it is moved across a flat surface, its motion is simulated on the screen by a cursor.

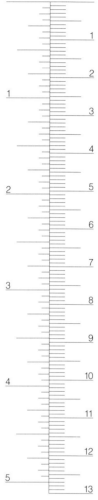

INCHES AND CENTIMETERS

N

Network. A collection of interconnected computers.

Newsprint. A grade of paper containing about 85% groundwood and 15% unbleached sulfite. The weight is from 30 to 45 pounds and the surface is coarse and absorbent. Used for printing newspapers and low-cost flyers.

Noise. Any undesirable signal occurring in an electronic or communications system.

O

Oblique. Roman characters that slant to the right: *looks like this. Compare to* Italic.

OCR. *See* Optical character recognition.

Off-line. Refers to equipment not directly controlled by a central processing unit or to operations conducted out-of-process. As opposed to on-line.

Old Style. A style of type developed in the early sixteenth century.

Old style figures. Numbers that vary in size, some having ascenders and others descenders: 1, 2, 3, 4, 5, 6, 7, 8, 9, 0. *Compare to* Lining figures.

On-line. Connected to the system and readily usable.

Opacity. That quality in a sheet of paper that prevents the type or image printed on one side from showing through to the other: the more opaque the sheet, the less show-through it will have. Also, the covering power of an ink.

Optical center. A point approximately 10% above the mathematical center of a page or layout.

Optical character recognition (OCR). The process of converting typewritten or printed documents into computer text. The document is scanned, then OCR software reads it, and converts it into a word-processing file.

Optical disk. A mass storage device using a laser to record and read digital data.

Ornamented. A typeface that is embellished for decorative effect.

Ordinal numbers. Sequence of numbers related to sequence: first, second, third, etc. *Compare to* Cardinal numbers.

Outline. A typeface with the outline defined.

Output. In typesetting, type that has been set.

Output device. Any device that receives information from the microprocessor, most commonly the monitor.

P

Page description language. The common computer language that ties together the various systems and output devices, such as monitors, keyboards, scanners, printers, and imagesetters.

Pagination. Pages numbered in consecutive order.

Pantone Matching System®. Brand name for a widely used color-matching system. *See also* color matching system *and* PMS.

Paragraph openers. Typographic elements used to direct the eye to the beginning of a paragraph. Often used when the paragraph is not indented.

Paste-up. *See* Mechanical.

PC. Personal computer.

PE. Printer's error, or mistake made by the typesetter, as opposed to AA.

Perfect binding. A relatively inexpensive method of binding in which the pages are held together and fixed to the cover by means of flexible adhesive. Widely used for paperbacks, manuals, textbooks, and telephone books.

Peripheral. An input, output, or storage device used in conjunction, and usually connected by cable, with a computer; for example, a printer, scanner, or zip drive.

Photocopy. A duplicate image, made from the original.

Photostat. Trade name for a photoprint, more commonly referred to as a stat.

Phototypesetting. Also known as photocomposition and erroneously as cold type. The preparation of manuscript for printing by projection of images of type characters onto photosensitive film or paper.

Pica. A typographic unit of measurement: 12 points = 1 pica, and 6 picas = 1". Also used to designate typewriter type 10 characters per inch (as opposed to elite typewriter type, which has 12 characters per inch).

Pi characters. Special characters not usually included in a type font, such as special ligatures, accented letters, and mathematical signs.

Pixel. Short for "picture element." One of the tiny squares or rectangles that make up a screen or printed image. Typical picture files may contain thousands or millions of pixels.

PMS. *See* Pantone Matching System®.

Point. Smallest typographical unit of measurement: 12 points = 1 pica, and 1 point = approximately 1/72 of an inch. Type is measured in terms of points, the standard sizes being 6, 8, 10, 12, 14, 18, 24, 30, 36, 42, 48, 60, and 72 points in body size.

Point systems. There are two major point measuring systems in use today: the English/American System, or pica system, used primarily by the English-speaking world, and the European Didot System, used by the rest of the world.

Preparation. Also called prep work. In printing, all the work necessary in getting a job ready for platemaking: preparing art, mechanicals, shooting film, stripping, proofing.

Pre-press proof. Proof made directly from film before making printing plate.

Press proof. A proof pulled on the actual production press.

Printer font. In desktop publishing, a font a printer can use.

Printer's error. *See* PE.

Process color. Also called full color. Refers to the four-color process reproduction of the full range of colors by the use of four separate printing plates, one for each of the primary colors—magenta (process red), yellow, and cyan (process blue)—and one for black.

Program. A collection of instructions and operational routines, necessary to complete computer commands or functions. *See also* Application.

Proofreader. A person who reads the type that has been set against the original copy to make sure it is correct and who also may read for style, consistency, and fact.

Proofreaders' marks. Shorthand symbols employed by copyeditors and proofreaders to signify alterations and corrections in the copy.

Proof(s). A trial print or sheet of printed material that is checked against the original manuscript and upon which corrections are made. A proof also refers to any output which can be inspected prior to final production.

Q

Quad. A piece of type metal less than type-high used to fill out lines where large spaces are required. An em-quad is the square of the particular type size: a 10-point em-quad is 10 x 10 points. An en-quad is half the width of an em-quad.

R

Rag papers. Papers containing a minimum of 25% rag or cotton fiber. These papers are generally made up in the following grades: 25%, 50%, 75%, and 100%.

RAM. An acronym for "random-access memory." Memory chips that temporarily store data or instructions for immediate processing; when the computer is turned off, the RAM information is lost forever. To save information from RAM, it must be transferred to a permanent storage device such as a hard drive or disk.

Raster image processing (RIP). The conversion of type and images to an arrangement of dots that can be stored in a computer and called up on the screen and manipulated as necessary.

Rasterization. The process of converting image data into output data.

Reader's proof. Also called a printer's proof. A galley proof, usually the specific proof read by the proofreader, which will contain queries and corrections to be checked by the client.

Recto. The right-hand page of an open book, magazine, etc. Page 1 is always on a recto, and rectos always bear the odd-numbered folios. Opposite of verso.

Register marks. Devices, usually a cross in a circle, applied to original copy and film reproductions. Used for positioning negatives in perfect register or, when carried on press plates, for the register of two or more colors in printing.

Resolution. The fixed number of pixels or dots available on an output device (display screen, printer, imagesetter, etc.).

Reversed type. In printing, refers to type that drops out of the background and assumes the color of the paper.

ROM. An acronym for "read-only memory." Memory chips that store information permanently. ROM doesn't vanish when the system is turned off, but it cannot be changed. Information the computer uses for its most basic operations, such as establishing the user interface (or main window) is stored in ROM.

Roman. An upright letterform with serifs derived from Roman stone-cut letterforms.

CYAN

MAGENTA

YELLOW

BLACK

PROCESS COLORS

Roman numerals. Roman letters commonly used as numerals until the tenth century A.D.: I=1, V=5, X=10, L=50, C=100, D=500, and M=1,000. *Compare to* Arabic numerals.

Rough. A sketch or thumbnail, usually done on tracing paper, giving a general idea of the size and position of the various elements of the design.

Rule. A black line used for a variety of typographic effects, including borders and boxes.

Run in. To set type with no paragraph breaks or to insert new copy without making a new paragraph.

Runaround. Type that surrounds an image, display type, or space.

Running head. A book title, chapter head, or other head "run" at the top of every page in a book.

SWASH

S

Scaling. The process of calculating the percentage of enlargement or reduction of the size of original artwork to be reproduced. This can be done by using the geometry of proportions or by the use of a proportion wheel or calculator.

Scanner. Photoelectric equipment for digitizing images (turning hard copy into digital files). Also to produce color separations from full-color copy.

Script. A typeface based on handwritten letterforms. Scripts come in formal and informal styles and in a variety of weights.

Self-cover. Booklets or pamphlets which have the same stock (paper) for both cover and text. Used when the cover stock does not have to be particularly strong or to save cost.

Self-mailer. A printed piece designed to be mailed without an envelope.

Serifs. The opening and closing cross-strokes in the letterforms of some typefaces. Sans serif typefaces, as the name implies, do not have serifs but open and close with no curves and flourishes.

Service Bureau. Graphic production facility where black and white or color output, mounting, scanning, and other services are produced, usually from digital files submitted by the designer.

Set-width. Also called set. In metal type, the width of the body upon which the type character is cast. In digital typesetting, the width of the individual character, including a normal amount of space on either side.

Show-through. The phenomenon in which printed matter on one side of a sheet shows through on the other.

Signature. A printed sheet that is folded, gathered, and trimmed.

Slab Serif. Typestyle recognizable by its heavy, square serifs. *Also called* Egyptian.

Small caps. Abbreviated sc. A complete alphabet of capitals that is the same size as the x-height of the normal typeface.

Software. Computer programs, consisting of instructions telling the computer how to do the different tasks it performs. Application programs, utilities, operating systems, etc., are all software. *Compare to* Hardware.

Solid. In composition, refers to type set with no leading between the lines.

Spec. To specify type or other materials in the graphic arts.

Spread. A pair of facing pages.

Square halftone. Also called a square-finish halftone. A rectangular—not necessarily square—halftone, i.e., one with all four sides straight and perpendicular to one another.

Square serif. A typeface in which the serifs are the same weight or heavier than the main strokes.

SS. Abbreviation for "same size."

Stet. A proofreader's mark that indicates copy marked for correction should stand as it was before the correction was made. Copy to be stetted is always underlined with a row of dots, usually accompanied by the word *stet.*

Stock. Also called substrate. Any material used to receive a printed image: paper, board, foil, etc. In papermaking, pulp that has been beaten and refined and after dilution is ready to be made into paper.

Storage. A device, such as a hard disk, diskette, tape, etc., onto which data may be written for retrieval at a later time.

Swash. A cap letter with an ornamental flourish.

T

Text. The body copy in a book or on a page, as opposed to the headings.

Text type. Main body type, usually 14 points or smaller.

Thumbnails. Small, rough sketches.

Tint. A color obtained by adding white to the solid color. In printing, a photomechanical reduction of a solid color by screening.

Tracking. Used in digital typography to mean overall letterspacing.

Transitional. A typestyle that combines features of both Old Style and Modern (such as Baskerville.)

Transpose. Commonly used term in both editorial and design to designate that one element (letter, word, picture, etc.) and another should change places. The instruction is abbreviated *tr.*

Trim. To cut off and square the edges of a printed piece or of stock.

Trim size. The final size of a printed piece after it has been trimmed. When the form is imposed for printing, allowance must always be made for the final trim size.

Type. The letters of the alphabet and all the other characters used, singly or collectively, to create words, sentences, blocks of text, etc.

Typecasting. Setting type by casting it in molten metal either in individual characters (Monotype) or as complete lines of type (Linotype).

Type family. A range of typeface designs that are all variations of one basic style of the alphabet.

Type gauge. A rule calibrated in points and picas on one edge and inches on the other. Used to measure linelength or baseline to baseline when working with columns of type.

Type-high. The height of a standard piece of metal type: .918" (U.S.).

Typewriter composition. Also called strike-on or direct impression composition. Composition for reproduction produced by a typewriter.

Typographic errors. Commonly called typos. Errors made in copy while inputting.

Typography. The art of designing with type. Today's technology, by mechanizing much of the art, is rapidly making typography a science as well as an art.

U

U & lc. Also written *u/lc.* Commonly used abbreviation for upper and lowercase. Used to specify text that is to be set in caps (usually initial caps) and lowercase letters as written.

Uncoated paper. The basic paper, produced on the papermaking machine with no coating operations.

Unit. A measurement based on the division of the em into equal increments. See page 23.

Unjustified type. Lines of type set at different lengths and aligned on one side (left or right) and left ragged on the other.

Uppercase. The capital letters of a type font: A, B, C, etc.

User-friendly. Any part of a computer system that is easy to use.

V

Value. The degree of lightness or darkness of a color or a tone of gray, based on a scale of graduated tonal values running from pure white through all the gradations of gray to black.

Verso. The left-hand side of a spread, as opposed to the recto, which is the right-hand side of a spread. The verso always carries an even-numbered folio. Also refers to the reverse side of a printed sheet.

Visual. A layout or comp.

Visual display. A visual representation of computer output.

W

WF. *See* Wrong font.

Window. A panel on the computer screen showing toolboxes, menus, icons, etc., that allow the user to easily start programs, open files, and perform specific actions within a program. It is possible to layer multiple windows on the screen, although only the top one is active at any time.

With the grain. A term used to describe the directional character of paper, often applied to the folding of a sheet of paper parallel to the grain. Paper folds more easily and tears straighter with the grain than against the grain.

Woodtype. Type made from wood. Formerly used for the larger display sizes over 1" where the weight of the metal made casting impractical.

Wordspace. The space between words.

Wove paper. An uncoated paper that has a uniform surface with no discernible marks.

Wrong font. An error in typesetting in which the letters of different fonts become mixed. Indicated by proofreader as *wf.*

X

Xerography. An inkless printing process that uses static electricity. Xerox, a trade name for this process, is a good example. Commonly known as photocopy.

X-Height. Height of the body of lowercase letters, exclusive of ascenders and descenders.

UNITIZATION

Bibliography

Several of the books listed here may be out of print, but worth reviewing in libraries.

Alphabet: The History, Evolution, and Design of the Letters We Use Today. Allan Haley. Watson-Guptill, New York.

Alphabets and Elements of Lettering. Frederic W. Goudy. Dover Publications.

American Typography Today. Robert Carter, A. Miller. John Wiley, New York.

American Wood Type: 1828 to 1900. Rob Roy Kelly. Van Nostrand Reinhold.

Asymmetric Typography. Jan Tschichold. Van Nostrand Reinhold, New York.

Basic Typography. James Craig. Watson-Guptill, New York.

Designing Books. Jan Tschichold. Wittenborn, Schultz, Inc.

The Development of Writing. Graphis Press, Inc. Zurich.

Digital Type Design Guide: The Page Designer's Guide to working with Type. Sean Cavanaugh, Ken Oyer. Hayden Books.

The Elements of Typographic Style. Robert Bringhurst. Hartley & Marks Publishers, Point Roberts, Wyoming.

Experimental Typography. Rob Carter. John Wiley, New York.

Encylopedia of Type Faces. Berry, Johnson, and Jaspert. Blandford Press.

Exercises on the Whole Art of Printing. Moxon, Mechanick. Oxford University Press, New York.

Finer Points in Spacing and Arranging of Type. Geoffrey Dowding. Wace.

Five Hundred Years of Printing. Steinbury. Pelican.

G-1 New Dimensions in Graphic Design. Neville Brody. Rizzoli, New York.

Graphic Design Manual. Armin Hofmann. Van Nostrand Reinhold, New York.

The Graphic Language of Neville Brody. John Wozencraft, Neville Brody Universe, New York.

The Grid. Allen Hurlburt. Van Nostrand Reinhold, New York.

A History of Graphic Design. Philip B. Meggs. John Wiley, New York.

The History and Techniques of Lettering. Alexander Nesbitt. Dover Publications.

How Hot Designers Make Cool Fonts. Allan Haley. Rockport Press, Gloucester, Massachusetts.

How to Spec Type. Alex White. Watson-Guptill, New York.

Layout. Allen Hurlburt. Watson-Guptill, New York.

The Letter as a Work of Art. Gerard Knuttel. Typefoundry, Amsterdam.

Lettering and Alphabets. J. Albert Cavanaugh. Dover Publications.

Living by Design. Pentagram. Watson-Guptill, New York.

Magazine Design. Ruari McLean. Oxford University Press, New York.

Manuale Typographicum. Herman Zapf. The M.I.T. Press, Cambridge.

The Modular. Le Corbusier. Faber and Faber.

On Type Designs, Past and Present. Stanley Morison. Benn.

Pasteups & Mechanicals. J. Demoney and S. Meyer. Watson-Guptill, New York.

Photography for Publication. Norman Sanders. R.R. Bowker, New York.

Pioneers of Modern Typography. Herbert Spencer. Lund Humphreys, London.

Pocket Pal. International Paper Company, New York.

Printing Types, Their History, Forms and Use. (2 vols.) Daniel Berkely Updike. The Belknap Press of Harvard University Press, Massachusetts.

Production for the Graphic Designer. James Craig. Watson-Guptill, New York.

Publication Design. Allen Hurlburt. Van Nostrand Reinhold, New York.

Studies in the Legibility of Printed Text (Stockholm Studies in Educational Psychology, Number 1). Bror Zachrisson. Almquist Wiksell, Stockholm.

Thirty Centuries of Graphic Design. James Craig and Bruce Barton. Watson-Guptill, New York.

Treasury of Alphabets and Lettering. Jan Tschichold. Van Nostrand Reinhold, New York.

The 26 Letters. Oscar Ogg. T.Y. Crowell.

Type Sign Symbol. Adrien Frutiger. ABC Edition, Zurich.

Type and Typography. Ben Rosen. Van Nostrand Reinhold, New York.

The Typography of Jan Tschichold. M. Constantine. J.W. Ford.

Typography Now. Edited by Rick Poyner & Edward Booth-Clibborn. L&W Publications, London.

Typography: The Principles. William Bevington. The Cooper Union, New York.

Using Type Correctly. Kurt Hans Volk. University of Chicago Press.

Working with Computer Type. Rob Carter. Watson-Guptill, New York.

Working with Graphic Designers. James Craig and William Bevington. Watson-Guptill, New York.

Annuals and Publications

American Illustration Showcase. American Showcase, New York.

American Photography Showcase. American Showcase, New York.

Art Directors' Annual. The Art Directors Club of New York, New York.

The Art Directors' Club of Toronto Show Annual. Wilcord Publications, Ltd., Toronto, Ontario.

Emigre. 4475 D Street, Sacramento, CA 95819

Graphic Design USA. The Annual of the American Institute of Graphic Arts, New York.

Graphis Annual. Zurich.

Graphis Typography. Zurich.

Illustrators' Annual. The Society of Illustrators, New York.

One Show. Roto Vision S.A. in association with The One Club for Art and Copy, New York.

Penrose Annual. International Revue of the Graphic Arts. Hastings House, New York.

The Society of Illustrators. Madison Square Press, New York.

Typography. The Annual of the Type Directors Club, New York.

Index

Production Notes

The Fourth edition of *Designing with Type* was two years in the making. It was, in every way, a team effort.

The authors always welcome any comments or suggestions for future editions.

James Craig, a well-known author of books on graphic design, was born in Montreal, Canada. He studied fine arts in Montreal and Paris before coming to the United States. Craig received his B.F.A. from The Cooper Union and his M.F.A. from Yale University. He is design director for Watson-Guptill Publications and a member of the New York Art Directors Club. Craig teaches design and typography at The Cooper Union and lectures widely.

William M. Bevington is Chairman of the Communication Design Department of Parsons School of Design and Senior Partner of Spire Integrated Design, a New York firm specializing in Information Design. He worked for Rudolph de Harak & Associates, Peter Schmidt Studios in Hamburg, Germany, and the world renowned Pushpin Group. Mr. Bevington taught design and typography for 14 years at The Cooper Union; other guest teaching positions include Columbia University, SUNY Purchase, and Baruch College.

Susan E. Meyer has been the editor of Designing with Type since its first edition, when she was managing editor at Watson-Guptill Publications. She is the President of Roundtable Press, and independent book production company in New York. The fourth edition has been edited and indexed by **Virginia Croft** and proofread by **Helen Garfinkel**.

Our thanks to **Julie Yee** and **Eugene Smith** for their generous review and insightful comments on the manuscript. Thanks are also due to **Soonho Dho** for her efforts during the early stages of the book.

Gladys Yue provided calculations and expertise in producing the many type specimen pages. Thanks for her many patient hours of kerning type!

Particular thanks must go to **Siu L. Chong** for her perseverance and dedication while providing comp after comp as the book progressed from rough to reality. She also produced the excellent technical illustrations. Her commitment to the project is deeply appreciated.

Over a hundred typefaces were used in the production of *Designing with Type,* the text fonts are Century Expanded and Helvetica.

The book was designed by the authors; typesetting, and design production was handled by **Spire Integrated Design, Inc.**